STREET ART AND THE WAR ON TERROR

Street Art and the War on Terror
Published by Rebellion Books, a subsidiary of
Korero Books LLP

32 Great Sutton Street
Clerkenwell
London
EC1V 0NB
United Kingdom

www.rebellionbooks.co.uk

Page Design Andrew Patterson
Print Production Yahya El-Droubie

ISBN 978 0 955339 88 2
Printed and bound in Portugal by Arvato, Printer Portuguesa

STREET ART AND THE WAR ON TERROR

HOW THE WORLD'S BEST GRAFFITI ARTISTS SAID NO TO THE IRAQ WAR

General Editor **Eleanor Mathieson** Text by **Xavier A. Tàpies**

REBELLION

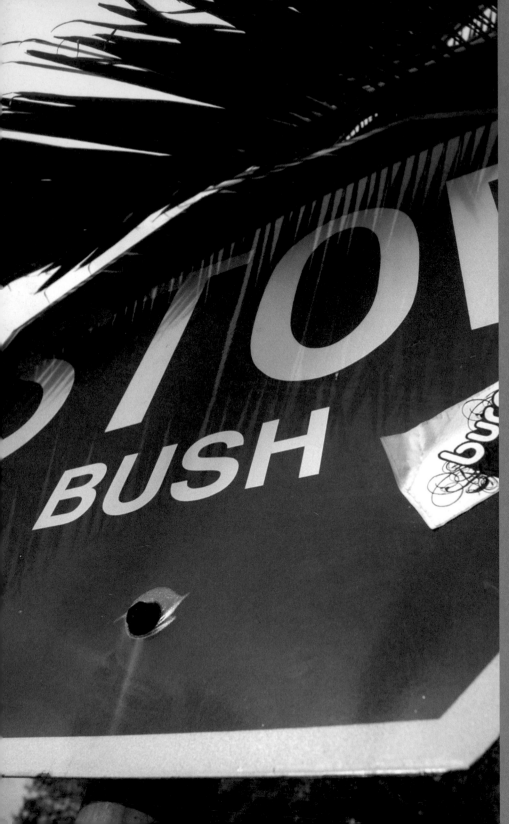

CONTENTS

INTRODUCTION

On September 11th 2001, two 767s slammed into the towers of the World Trade Center, New York City. Shortly afterwards a 757 crashed into the Pentagon. Another 757, United Flight 93, crashed in a field in Pennsylvania, its passengers thwarting an attack on the Capitol. The world looked on in horror and disbelief. Over 2981 (9/11 Commission Report 2004) New York City workers and heroic firefighters, workers in the Pentagon and the passengers and crew on the flights lost their lives.

President George Bush and his White House administration were slow to react. This was an unprecedented attack and the first on US soil since Pearl Harbor in 1941. It seemed that the very essence of the American way of life had been hijacked. The world's only superpower had been stung at its heart and all the firepower that a $350bn annual defence budget could muster, together with all the intelligence capabilities of the CIA, had been incapable of preventing it.

The perpetrators were nineteen committed, Islamic extremists who were willing to die in the attempt. The plot, from what the news media could tell us, was being directed by a Saudi millionaire, Osama bin Laden, from the Tora Bora caves on the Afghanistan-Pakistan border. His organization (we use the term loosely – authoritative journalists have described Al-Qaeda as more of an 'inspiration' or 'concept'), was the conduit and recruiting sergeant. The intention, it seemed, was a declaration of war on the West and all its democratic values. The question was how to react? Doing nothing, given the shock to US public opinion, was not an option. Going after bin Laden was the logical course of action. Yet he was so shadowy a figure and

Al-Qaeda so nebulous, that it would feel like stabbing at shadows. The decision that was taken was to attack Iraq on an unproven charge, that Saddam Hussein possessed weapons of 'mass destruction' – the term was never defined. Bush sought the help, and got it, of his major ally and chum, the United Kingdom and its Prime Minister Tony Blair. The UN was sidelined, Germany and France were ignored.

One year before 9/11 the cabal ruling the USA had produced a document suggesting that now was the time to re-order the Middle East, making use of America's unprecedented position of power. The document suggested that a 'Pearl Harbor-type event' would be a useful catalyst for such a re-ordering. We shall never know whether 9/11 was viewed so cynically, because those are not the type of decisions that get documented. But to many it seemed that the path to war had been decided on long before the events surrounding 9/11.

After 9/11 the US government managed to conflate terrorism and Saddam Hussein in the eyes of US public opinion and the 'War on Terror' was born. The West, with all its military might, was off to fight a concept. The Neo-Cons at the heart of the US government made no secret of their desire to 'sort out' the Middle East.

The UK government had a harder job on its hands. Led by a Prime Minister who had once spoken piously of an 'ethical foreign policy' and who had promised to listen to the electorate, it had to sell the war to a completely sceptical UK public – how?

Blair used all his rhetorical powers, but even he couldn't pull this one off, so he simply ignored his electorate. On February 15th and 16th, 2003, over 10 million people around the world – in New York, San Francisco, Sydney, Melbourne, Barcelona, Madrid, Rome as well as the UK – took to the streets to oppose the coming war; one million were in London – the biggest demonstration in British history *ever*. Blair, and the tiny clique now running the country, ignored it. In the US, Bush, despite only 'beating' Al Gore by the narrowest possible margin, steamed ahead with the Neo-Con project as though he had a 100% mandate. Democracy, listening to the people? Who cared – these Masters of the Universe had a God-given right to do as they pleased. On March 20th, 2003 the Bush/Blair War on Iraq began with strikes on Baghdad.

In the 1970s Street Art had emerged in NYC as a way of claiming individual glory. Post 9/11, it suddenly became one of the few uncensored channels of expression in an almost fascistic political climate, where our democratic institutions had seemingly been neutered, and where much of the media was collaborating with cabal governments to misinform the People. The West had lost any ability to really rebel (compare with the 1960s), but a brilliant bunch of artists used hyper-eloquent graffiti to give voice to the sense of fury most opinion felt at runaway government.

The art in the pages that follow has therefore a raw political significance. Leaders – Bush, Cheney, Rumsfeld, Blair, Australian premier Howard and Spanish premier Aznar – are vilified. The real cause for war – capturing strategic oil reserves – emerges again and again. The ridiculous term 'War on Terror' is exposed as a cynical sham, as is the supposed hunt for bin Laden. In many places abroad, hatred for Bush spills into hatred for the US in general – a direct, if unintended, result of the Neo-Cons' actions. The crushing of debate, the invasion of civil liberties, and the climate of militarism, fear and silent threat created by oppressive right-wing government, pervades much of this work. The obscenities of Abu Ghraib and Guantanamo Bay are highlighted in iconic imagery. Street Art's visual shorthand reveals the chaos and suffering that have resulted. It reminds us that the indirect result of our governments' arrogance and flouting of the spirit of Democracy, has been a terroristic civil war in which between 100,000 and 600,000 civilians and thousands of our troops have died. What on earth for? What has been achieved?

The West will retreat from Iraq; Bush and Blair will go down in history as having failed dismally to execute their mind-numbingly vicious and superficial plan to bomb the Middle East into accepting a template of Capitalist Democracy. Much of the media will be seen as crooks supporting an unjust war. After 9/11 it was only the Street which spoke with an impassioned, uncensored voice: Street Art had claimed its place as the visceral medium for real political expression.

THE AMERICAS

NEW YORK / LOS ANGELES / SAN FRANCISCO / SEATTLE / PORTLAND /
CHICAGO / PHILADELPHIA / MIAMI / ATLANTA / WASHINGTON, DC / MONTREAL
/ TORONTO / VANCOUVER / SÃO PAULO / SANTIAGO / VALPARAISO / BUENOS
AIRES / HAVANA / MEXICO CITY

FADED POSTER ON METAL
ARTIST: ROBBIE CONAL

APRIL 19, 2007

Robbie Conal captures perfectly the feeling that for an out-of-his-depth Bush, and his Neo-Con cohorts, the war they always wanted was akin to little more than a reckless crapshoot, with the Bill of Rights reduced to a paper airplane. Stealth Bombers fly overhead; the bomb blast looks impressive and a youthful Bush laughs his head off, oblivious of the suffering on the ground and unthinking of the aftermath.

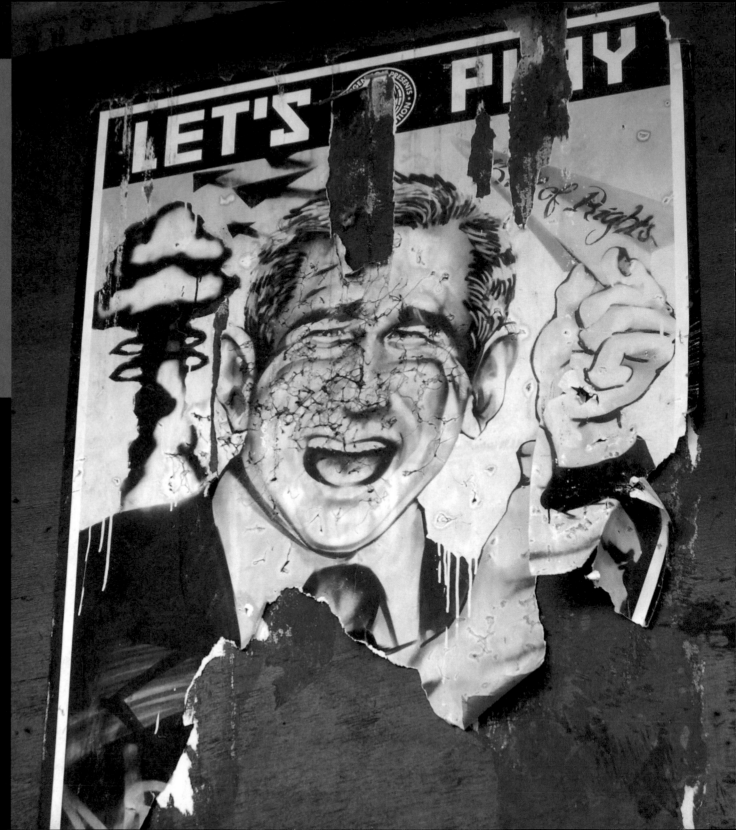

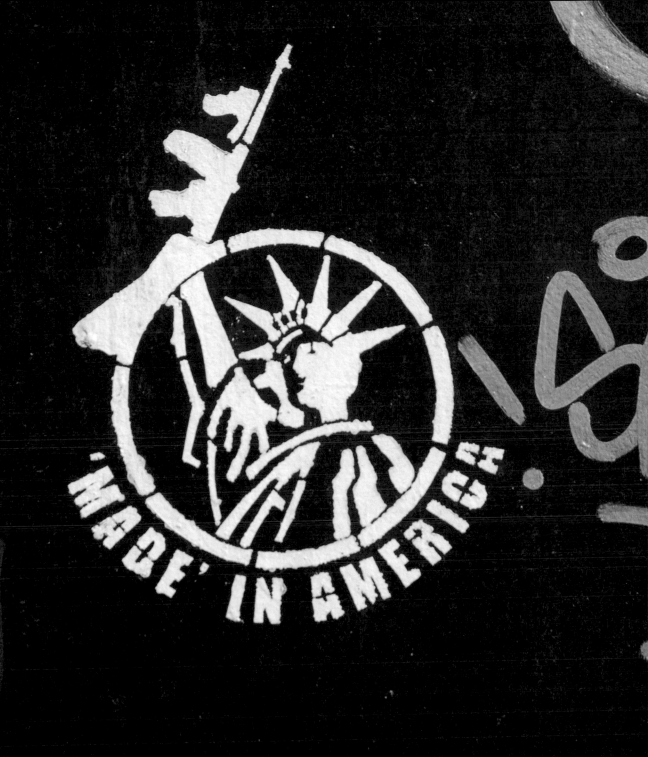

NEW YORK CITY / USA

STENCIL ON PAINTED METAL
ARTIST: UNKNOWN

APRIL 21, 2007

The Statue of Liberty no longer holds the flame of freedom but a rifle; using the iconography of a proud piece of branding. The fact that the gun is outside the main message suggests that the US presents one marketing face, but in practice uses military power – as in Iraq – to pursue its ends. Tangentially, the piece also suggests that the US government is no longer true to its founders' intentions or to the Constitution.

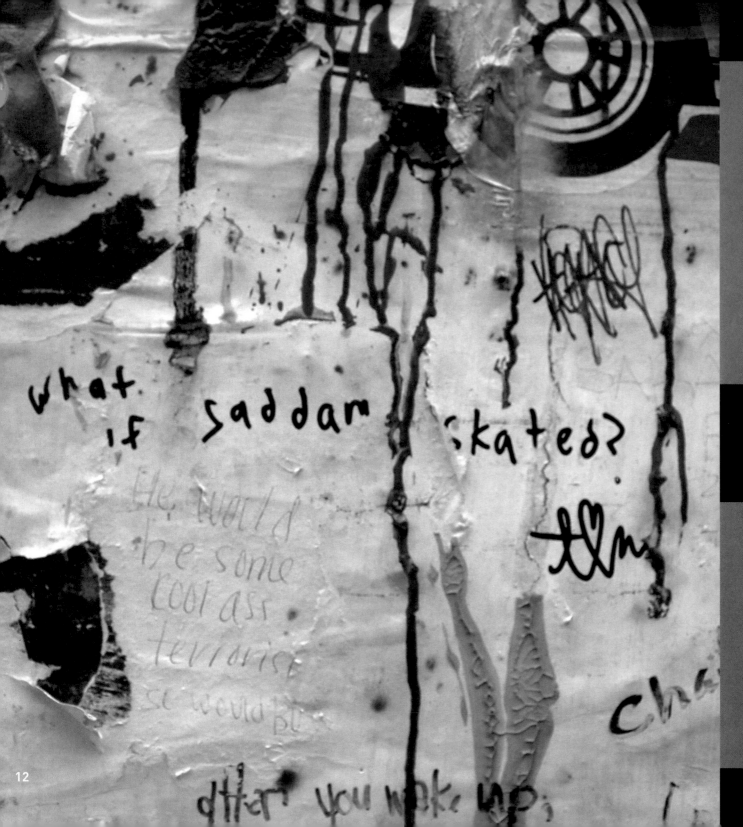

NEW YORK CITY / USA

STICKER ON PEDESTRIAN CROSSING
ARTIST: UNKNOWN

APRIL 21, 2007

Strange how someone has taken the trouble to get on a ladder to stick this on the most innocuous piece of NYC street furniture. But this achieves the effect of a double-take: it's an almost unnoticeable, bland, slightly celebratory message (typical of a lot of run-of-the-mill marketing) on something well made but mundane. Its message only hits you when you're already half-way across to the other sidewalk.

NEW YORK CITY / USA

MARKER PEN ON PASTE-UPS
ARTIST: UNKNOWN

APRIL 18, 2007

A very NYC, surreal comment which, in sending Saddam up, has the strange effect of questioning the whole War. Someone answers in pencil underneath: 'He would be some cool ass terrorist', and that in turn is answered: 'So would Bush'. So, it's all dudes playing games then.

NEW YORK CITY / USA

STENCIL ON BROWN PAPER PASTE-UP
ARTIST: UNKNOWN

APRIL 19, 2007

The artist has made brilliant use of the site – the banding strips in red and white evoke the stars and stripes and frame some amazing symbolism. The figure with his hand outstretched looks like his flesh has been flayed and gestures 'Enough'. The neat soldier images are hideously toy-like in their coffins – and they are both black and white. The ancient Egyptian symbol of a key in a bound hand was part of their Ceremony of the Dead. And down below the ghostly figure suggestive of an Iraqi mother, with the words 'Loss' for a neck, evokes with her headdress the shape of the coffins above. Brilliant; we wish we knew who the artist was.

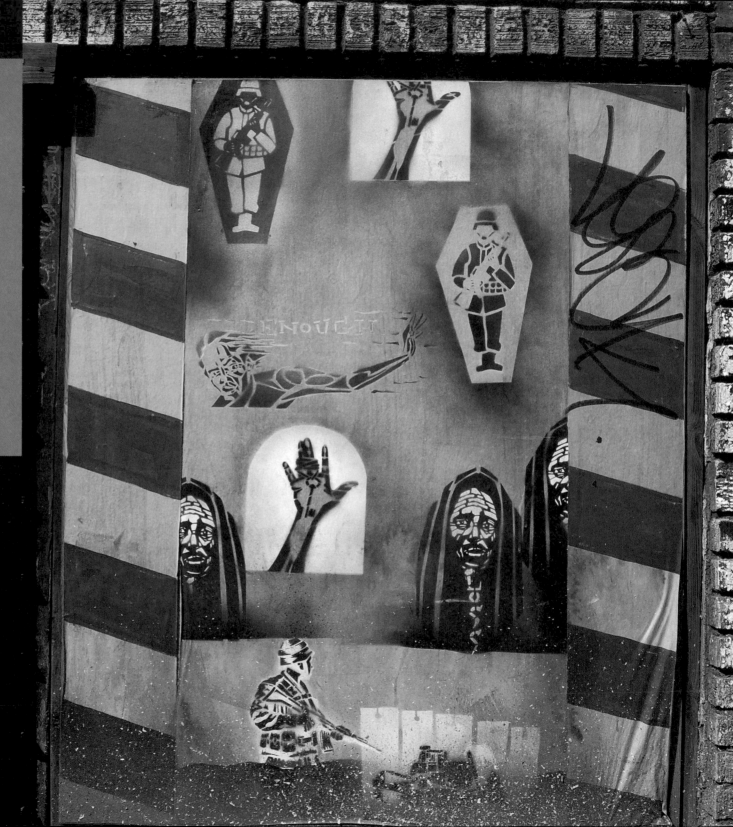

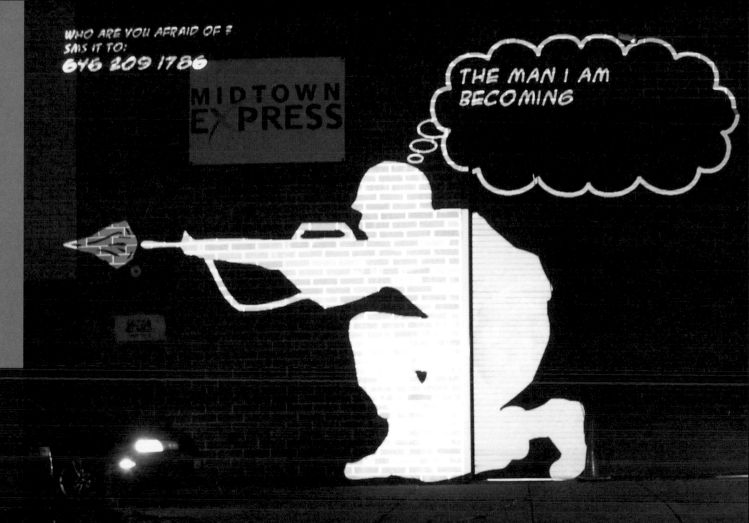

NEW YORK CITY / USA

PROJECTION AND TEXT MESSAGE
COLLABORATION
ARTIST: PAUL NOTZOLD

OCT 7, 2006

Paul Notzold has taken interactivity
to new heights with this projection
piece, named 'Fear Fighter'. He asked
passers-by to fill in the thought bubbles
via text message, with their responses
projected into place. The results were
smart and startling, showing sympathy
for the plight of US soldiers asked to
perform an impossible and compromised
mission by their political masters;
very few messages bought the Bush
administration line on the war.

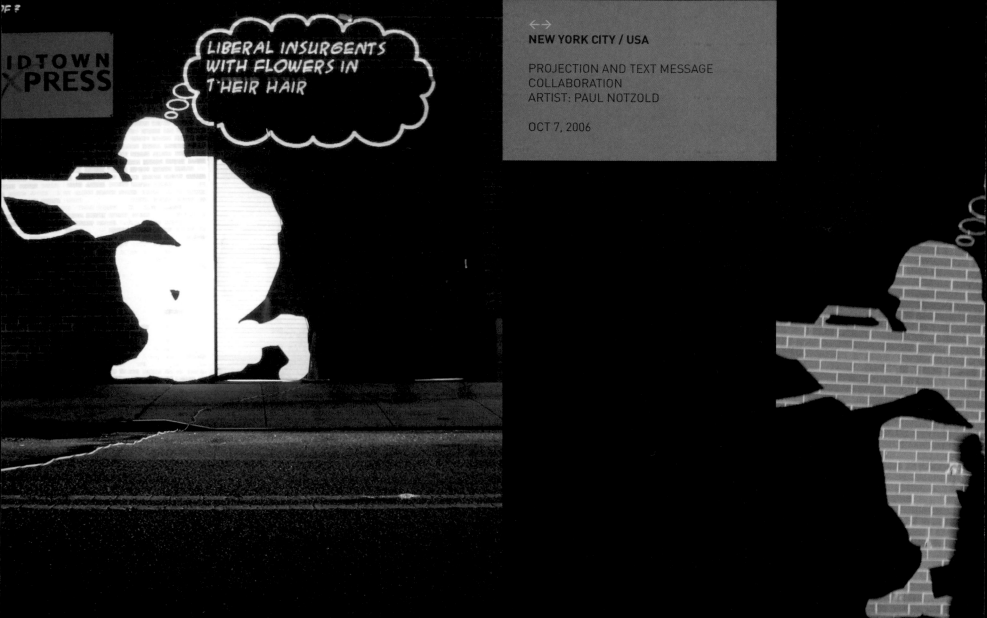

NEW YORK CITY / USA

PROJECTION AND TEXT MESSAGE
COLLABORATION
ARTIST: PAUL NOTZOLD

OCT 7, 2006

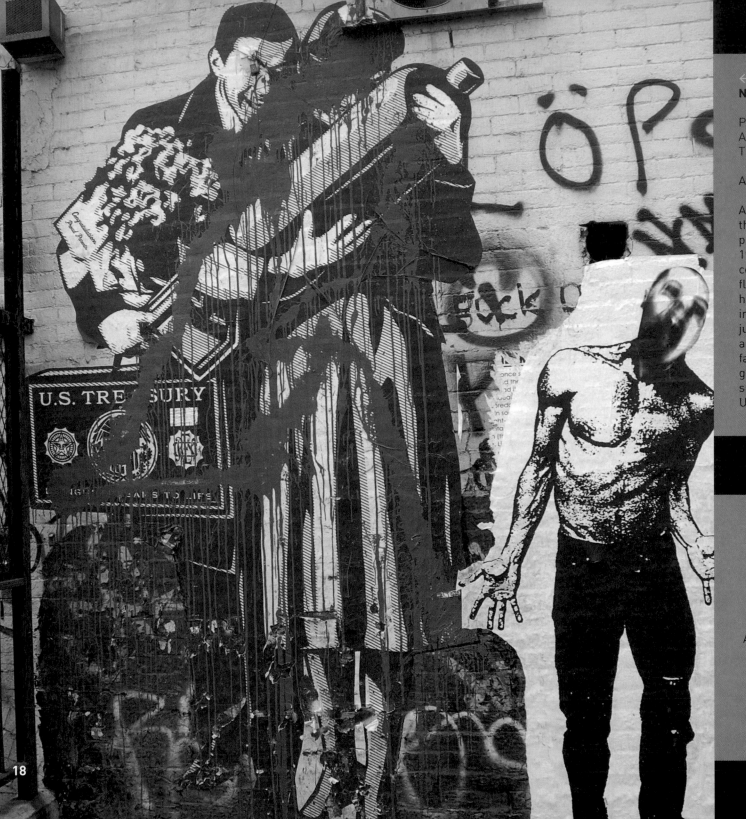

NEW YORK CITY / USA

PASTE-UP ON BRICK
ARTISTS: SHEPARD FAIREY (defaced by
THE SPLASHER) and UNKNOWN

APRIL 19, 2007

An instance of two artists working in
the same space to good effect. Fairey
produces a (now part-obscured) classic
1950s image of the standard US married
couple – he, grinning, brings home the
flowers and the work briefcase to fund
his family, she cradles a missile lovingly
in her arms. The stripped-down guy
just screams, seemingly in agony, with
a tortured 'why?' gesture, his obscured
face adding to the effect. The former is a
great comment on Bush's focus on war
spending at the expense of spending on
US families.

NEW YORK CITY / USA

PASTE-UP ON GRAFFITI BUILDING
ARTIST: UNKNOWN

APRIL 19, 2007

Arguably the most iconic US image – that
statue – is used brilliantly to make the
point that the War on Terror has cost US
citizens the very thing which defines the
US: the freedoms enshrined in the Bill
of Rights and the Constitution.

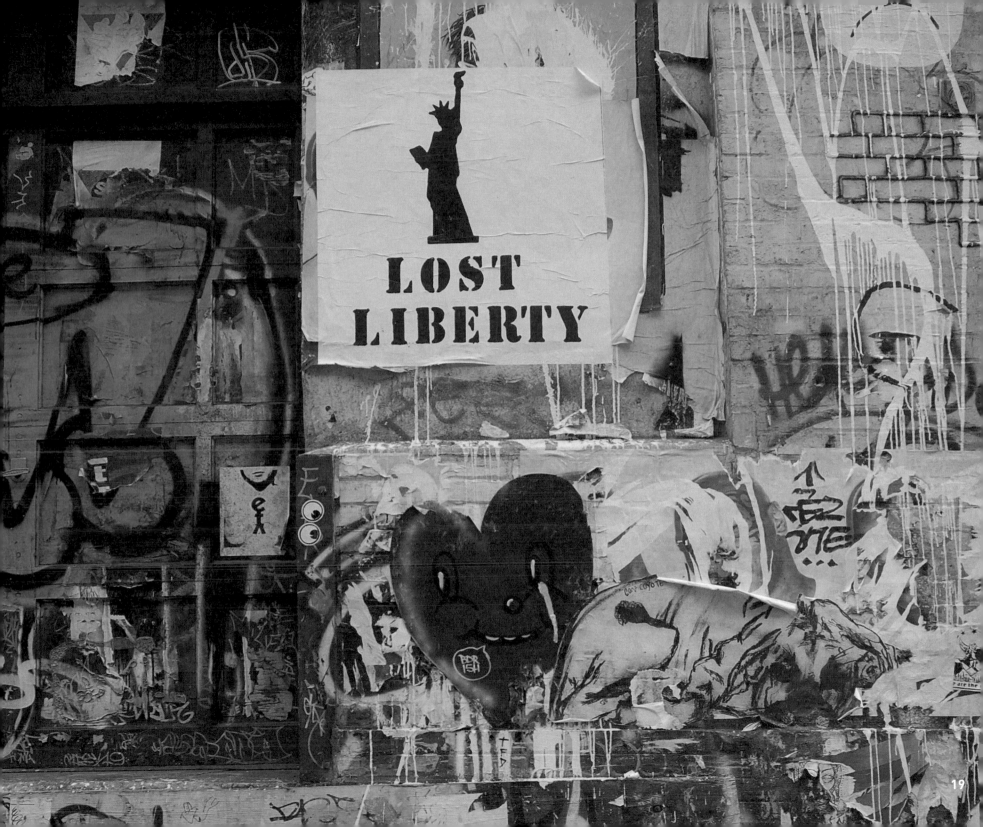

LOST
LIBERTY

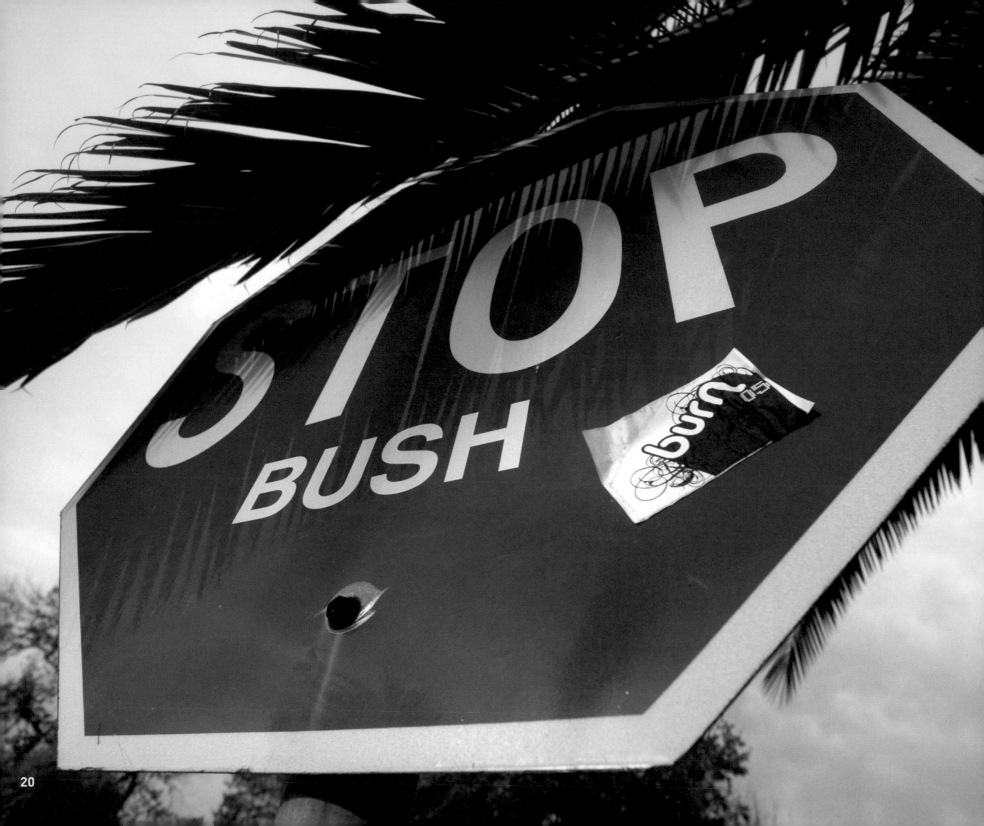

VINYL LETTERS ON ROAD SIGN
ARTIST: BURN

DEC 10, 2005

The typography on the BUSH bit of this is so well executed and neatly placed that it absolutely looks like the original sign. Usurping one of the signifiers of normality – municipal and road signage – works brilliantly as a way to make people think. There is an ironic contrast here between the political message and the sybaritic LA palm tree, shading Pacific sun.

→
LOS ANGELES / USA

STICKER ON METAL
ARTIST: NONSENSE

SEPT 5, 2004

A take on the popular Urban Outfitters t-shirt bearing the ironic slogan 'Jesus is my homeboy', this sticker simultaneously demonstrates the strength of public dislike for George W while highlighting his messianic delusions.

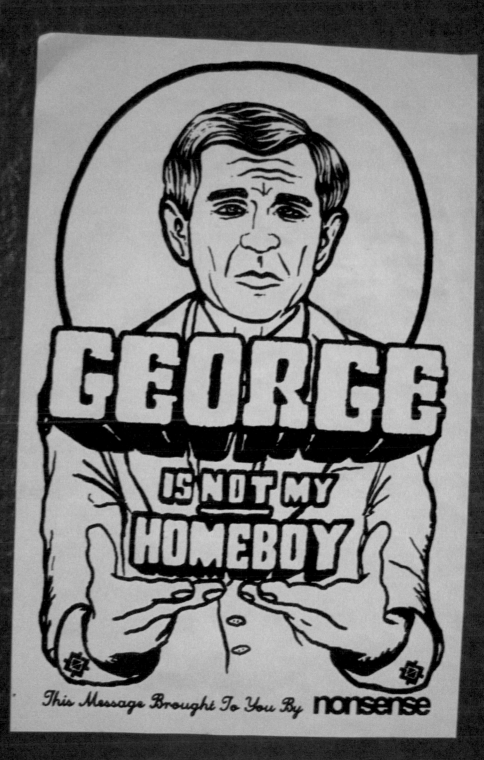

GEORGE IS NOT MY HOMEBOY

This Message Brought To You By nonsense

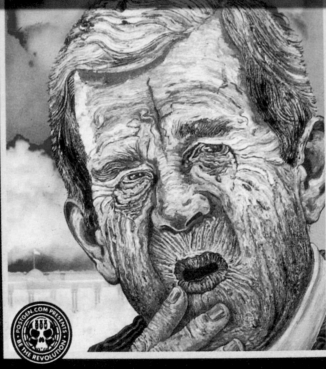

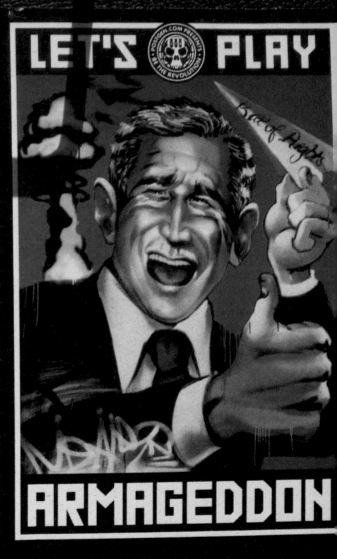

...OR WAS IT HUG BABIES AND DROP BOMBS?

OBEY

...UG BOMBS AND DROP BABIES?

ED TO USE OUR GLOBAL SUPREMACY TO PROTECT OUR CHILDREN
ED TO USE OUR CHILDREN TO PROTECT OUR GLOBAL SUPREMACY

READ MY APOCALIPS

POSTGEN.COM PRESENTS · BE THE REVOLUTION

LET'S PLAY

POSTGEN.COM PRESENTS · BE THE REVOLUTION

ARMAGEDDON

22

LOS ANGELES / USA

POSTERS ON TRASH CAN
ARTIST: ROBBIE CONAL

SEPT 5, 2004

Conal loves playing with the all-American corporate image of Bush, showing him as the out-of-control big kid, who just loves bombs, violence and gambling with all that power. It's a big joke, but a genuine comment on the extent to which the Bush administration was out of control for a while. The famous Bush senior comment "Read my lips: no new taxes" is shown as being adopted by his son to more vicious effect.

→

LOS ANGELES / USA

STENCIL ON CONCRETE WITH STICKY
TAPE AND PAPER
ARTIST: UNKNOWN

MAR 8, 2003

A hilarious comment on Dick Cheney having no idea – presumably – of how to conduct foreign policy (as witnessed by the execution of the War on Terror) – and on Dick himself, with his real business and political ambitions having been kept under cover. The phrase became popular under the corrupt Nixon; interestingly it was Nixon who gave Cheney his first executive job. 'Fuck Bush' gets straight to the point.

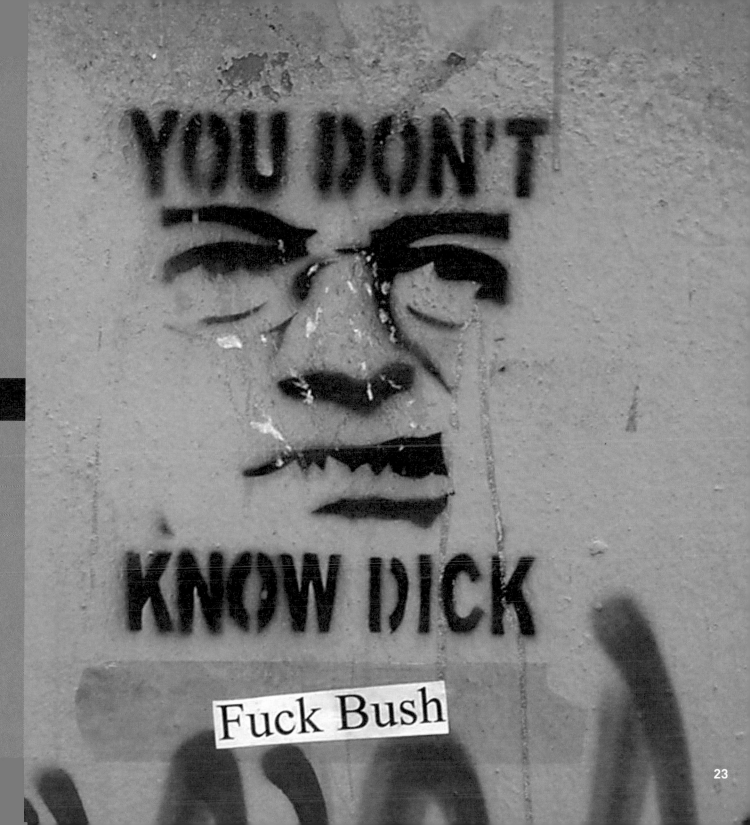

SECRETARY

OF OFFENSE

PREEMPTIVE MORALIZING WARFARE (when the whole rest of the world is against us) GROOVY, BABY

←
SAN FRANCISCO / USA

PASTE-UP ON BRICK
ARTIST: ROBBIE CONAL

NOV 14, 2002

Another comment on an administration of kids being out of control and playing with war. Here it is Rumsfeld as Austin Powers's alter-ego, Dr. Evil and Cheney as his Mini Me. The little finger gesture (as in a surprised 'Who me?') is a pointer to the faux-naiveté of the then Secretary of Defense. Only the power relationship seems odd: Cheney had rather more influence under Bush than Rumsfeld.

→
SAN FRANCISCO / USA

STICKER ON STREET SIGN
ARTIST: UNKNOWN

SEPT 25, 2005

Bush's clean-cut, boring, corporate nice guy image makes him easy to send up. This is rare comment: it is the Americans who elected this utterly normal looking madman so hey, what can you expect?

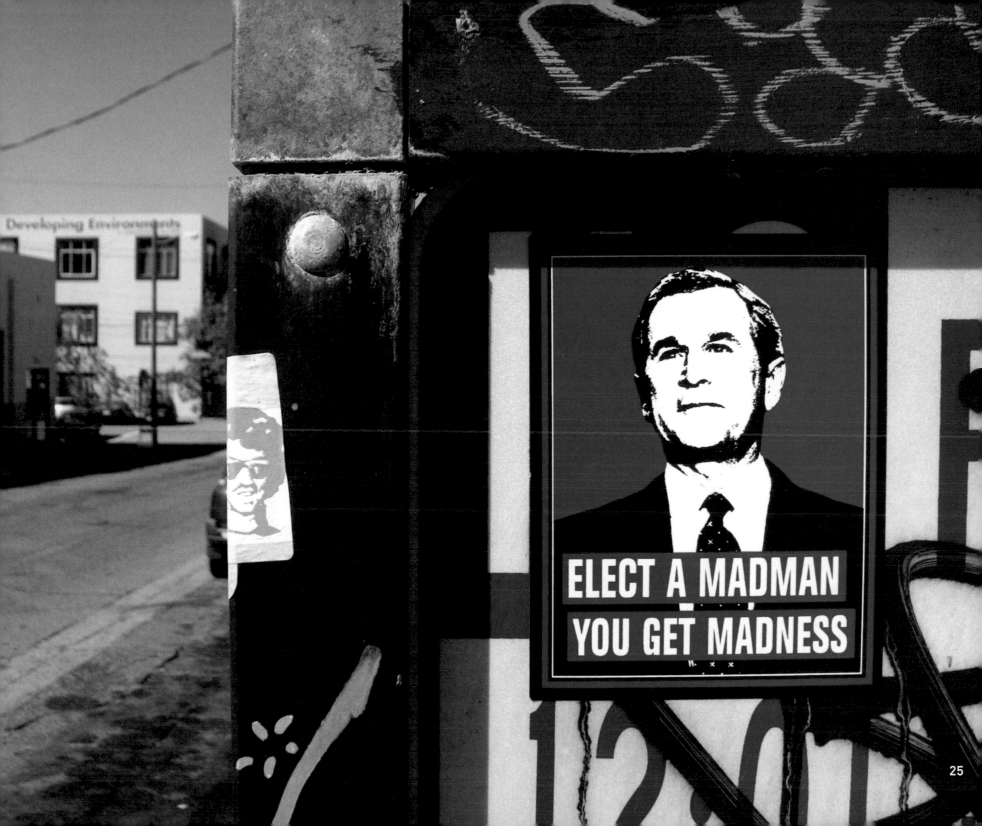

ELECT A MADMAN
YOU GET MADNESS

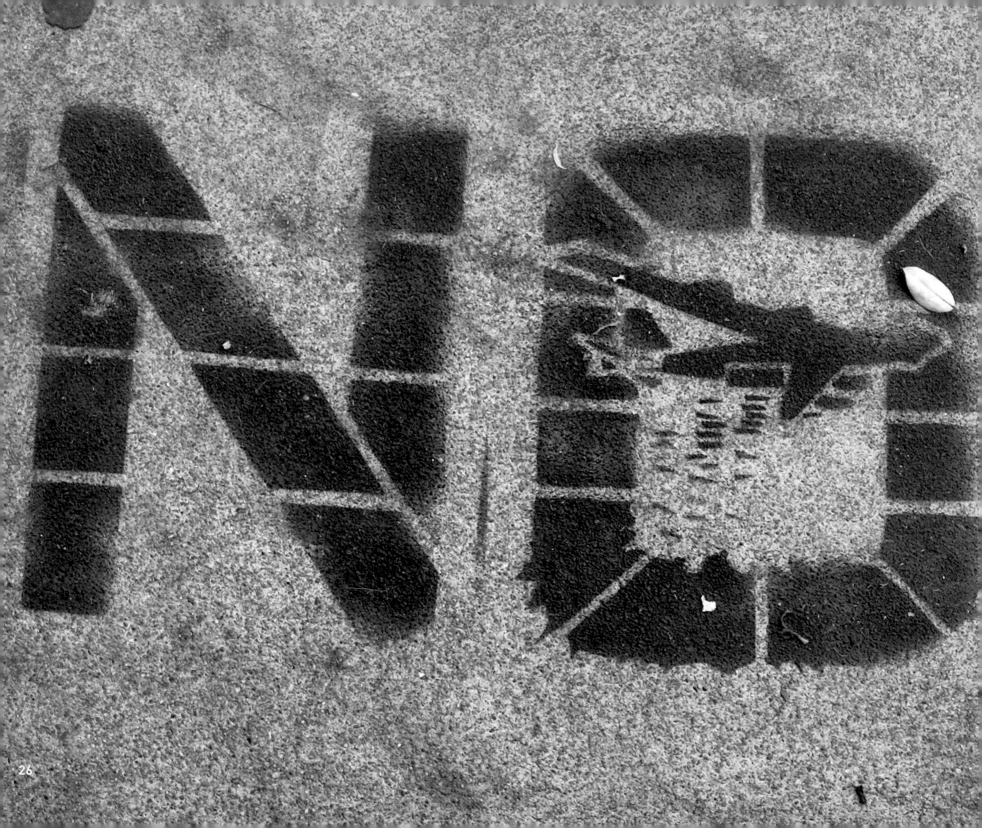

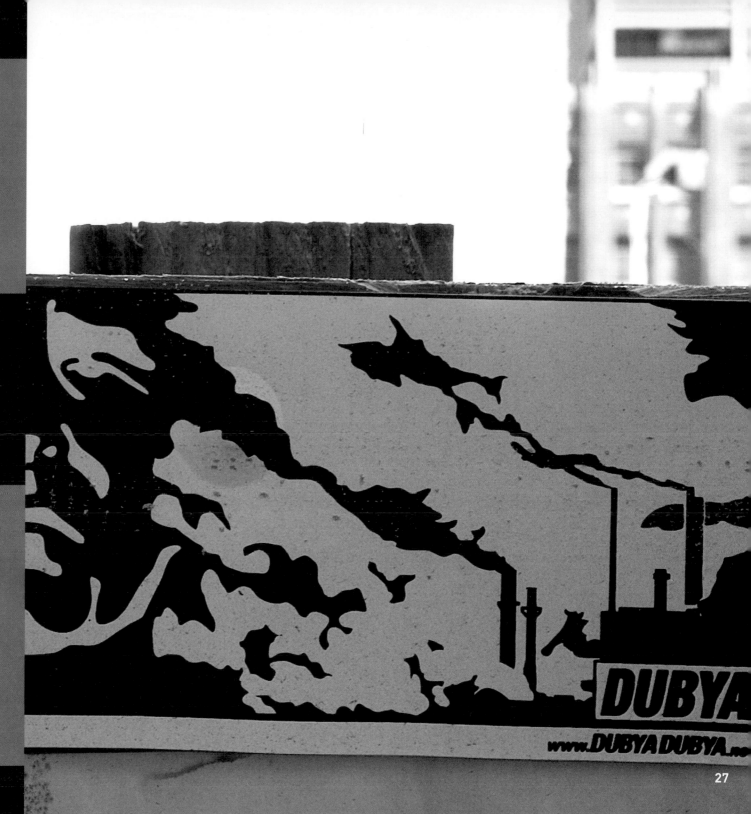

SAN FRANCISCO / USA

STENCIL ON SIDEWALK
ARTIST: UNKNOWN

NOV 16, 2002

The message is unusually direct. The plane is a B-52 dropping munitions – even though the bomber feels like a throwback to Vietnam in the 1960s, the B-52s are still active in the war on Iraq.

SAN FRANCISCO / USA

STICKER ON FENCE
ARTIST: UNKNOWN

MAY 18, 2002

Bush is presented as an omnipotent, oppressive dictator as the smoke from polluting heavy industry creates the pattern of his face in the sky. The primary message is clearly environmental, but the sense of the overbearing administration is very much a comment on the mood created by the War on Iraq.

DUBYA

www.DUBYADUBYA...

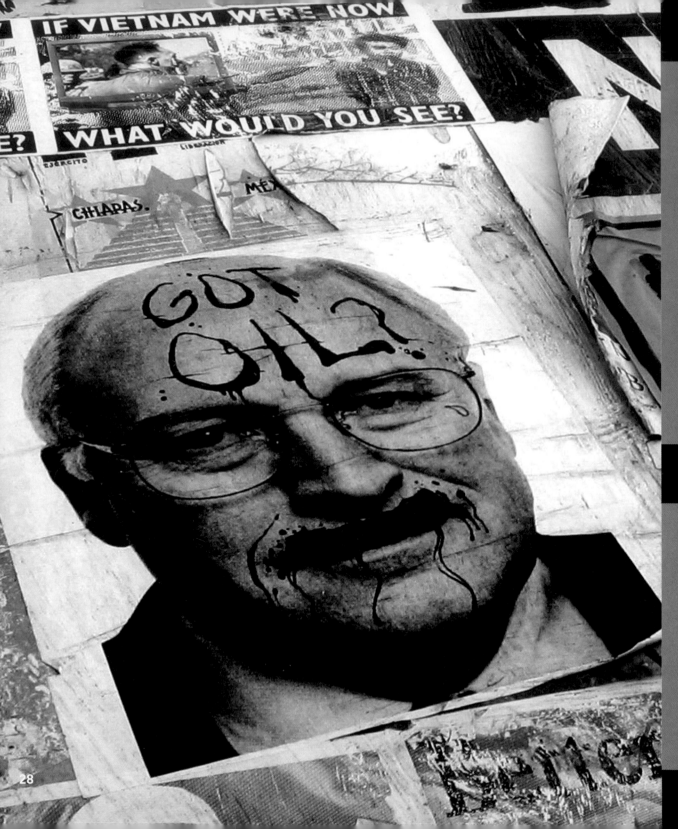

IF VIETNAM WERE NOW

WHAT WOULD YOU SEE?

EJÉRCITO LIBERACION

CHIAPAS. MÉX

GOT OIL?

PASTE-UP ON WALL
ARTIST: UNKNOWN

DEC 18, 2005

The 'Got Milk' slogan had various celebrities with a moustache of milk on their top lips. Here the slogan is subverted with Cheney and his oil obsessions. The poster above uses Eddie Adams's Pulitzer Prize-winning photo of General Nguyen Ngoc Loan executing a Viet Cong prisoner during the Vietnam War to comment on the self-censorship of the coverage of the War on Terror being undertaken by the US TV networks. A TV screen frames the image to show only the General; the prisoner – captured at the moment of death – is, of course, out of the picture.

PASTE-UP ON WALL
ARTIST: UNKNOWN

DEC 18, 2005

A brilliant use of the *Where's Waldo* (*Where's Wally*) cartoons. It suggests that the hunt for Osama is just one big kids' game. Other figures, nothing to do with the War, make an appearance: Charles Manson, Howard Marks and Timothy McVeigh.

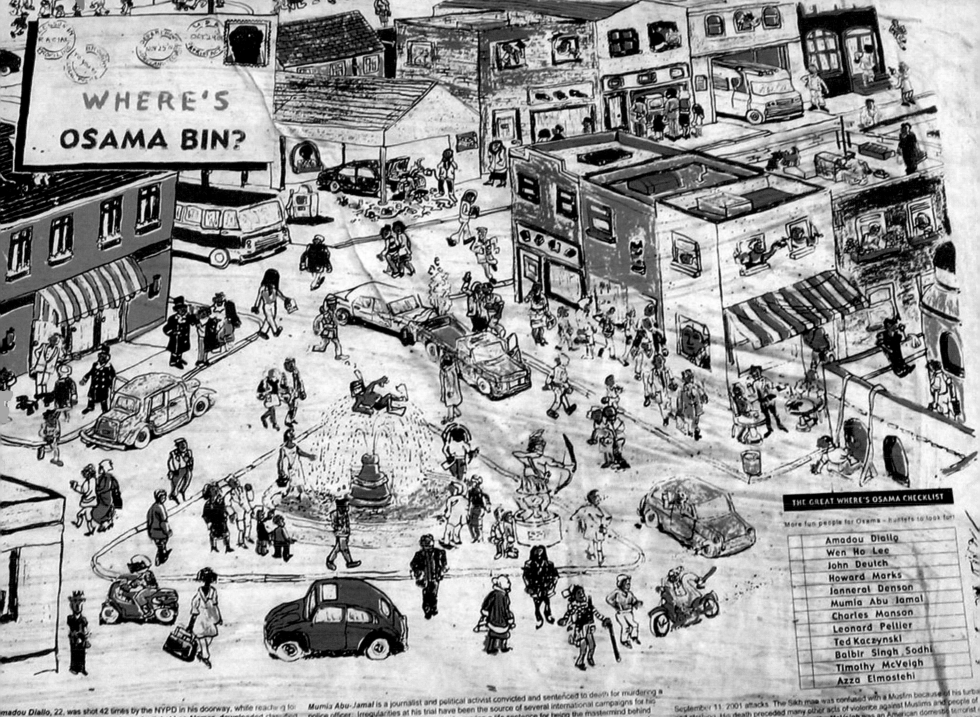

WHERE'S OSAMA BIN?

Amadou Diallo, 22, was shot 42 times by the NYPD in his doorway, while reaching for ... of no crime: *Wen Ho Lee*, a nuclear scientist at Los Alamos, downloaded classified ... onto his home computer. He was held in solitary confinement for over 1 year and nts of mishandling classified information, and threatened with life in prison. *John ...* ... wn as CIA director after downloading the highest level of restricted, classified ... home computer. No charges were filed against him. *Howard Marks*, aka Mr. Nice ... had 43 aliases, 89 phone lines, and owned 25 companies to launder money for his ... dealing. His business associates included the IRA, the CIA, the Mafia, and MI.16 nts. Agents handcuffed to a hospital bed for 2 days, forced to take laxatives and ... movements before releasing her as innocent. 8 days later, following bleeding required an emergency Caesarean section to deliver her 3 lb. 4 oz. premat...

Mumia Abu-Jamal is a journalist and political activist convicted and sentenced to death for murdering a police officer. Irregularities at his trial have been the source of several international campaigns for his release and/or a retrial. *Charles Manson* is serving a life sentence for being the mastermind behind several mass murders that were committed by members of his cult-like group of followers. *Leonard Peltier* is serving a life sentence for the deaths of FBI agents during a 1975 shootout on Pine Ridge Indian Reservation. Many people and institutions, including Amnesty International, Archbishop Desmond Tutu, and the Robert F. Kennedy Memorial Center for Human Rights, consider him a political prisoner for his work with the American Indian Movement (AIM). Evidence used to acquit other members of AIM of murder at the Pine Ridge shootout was ruled not admissable by the judge presiding over Mr. Peltier's ... Ex-Berkeley math professor *Ted Kaczynski*, also known as the Unabomber, attempted to fight of technology by mounting a 18-year mail bombing campaign, killing 3 people and injuring ... ir Singh Sodhi was a Phoenix, Arizona gas station owner, murdered in the aftermath of the

September 11, 2001 attacks. The Sikh man was confused with a Muslim because of his turban ... and clothing. His death preceded many other acts of violence against Muslims and people of ... Easter descent throughout the USA. *Timothy McVeigh* was an American domestic terrorist ... and executed for his part in the April 19, 1995 Oklahoma City bombing. Hundreds were injured ... men, women and children died when a truck loaded with improvised explosives was detonat... the Alfred P. Murrah Federal Building. *Azza Elmostehi* came to Manhattan to work 3 1/2 ... after working for Poggenpohl Inc. for 16-1/2 years overseas. After the Sept. 11 terrorist atta... saleswoman began taunting Elmostehi, an operations manager. Elmostehi was repeatedly ... names including "Mrs. Osama Bin Laden" and "Mrs. Taliban." When Elmostehi com... Poggenpohl bosses, she was fired from her job.

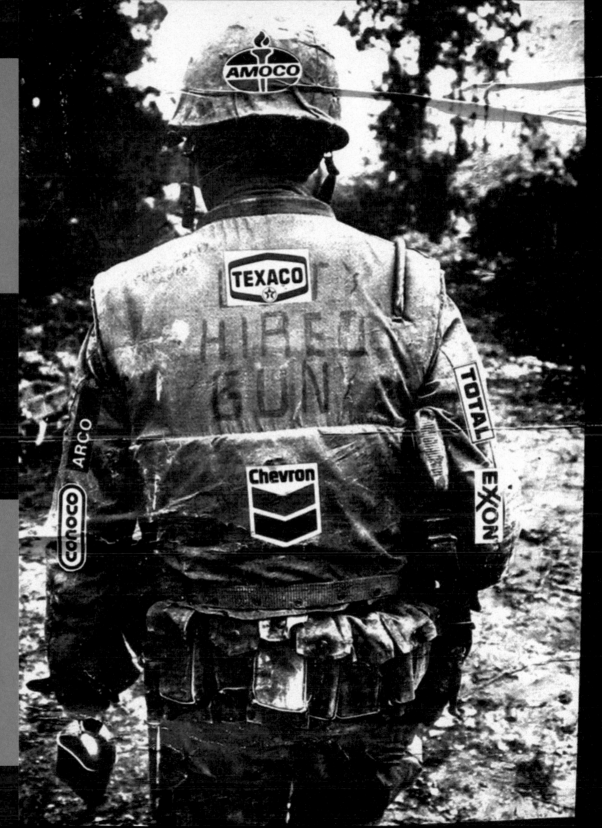

←

SAN FRANCISCO / USA

GOLD STENCIL PIECE
ARTIST: UNKNOWN

NOV 8, 2006

A hilarious Osama bin Laden; the childish treatment makes one think of all the bogeymen of children's literature – he has been so demonized that in effect he has become a figure of fiction.

→

SAN FRANCISCO / USA

POSTER PASTE-UP ON WALL
ARTIST: NICHOLAS LAMPERT

MAY 29, 2007

A US soldier portrayed as a mercenary ('Hired Gun') in the employ of major US oil companies (although Total is in fact French, with its HQ in Paris – an unintended comment by the artist we suspect). The image echoes anti-Vietnam War photos from the 1960s.

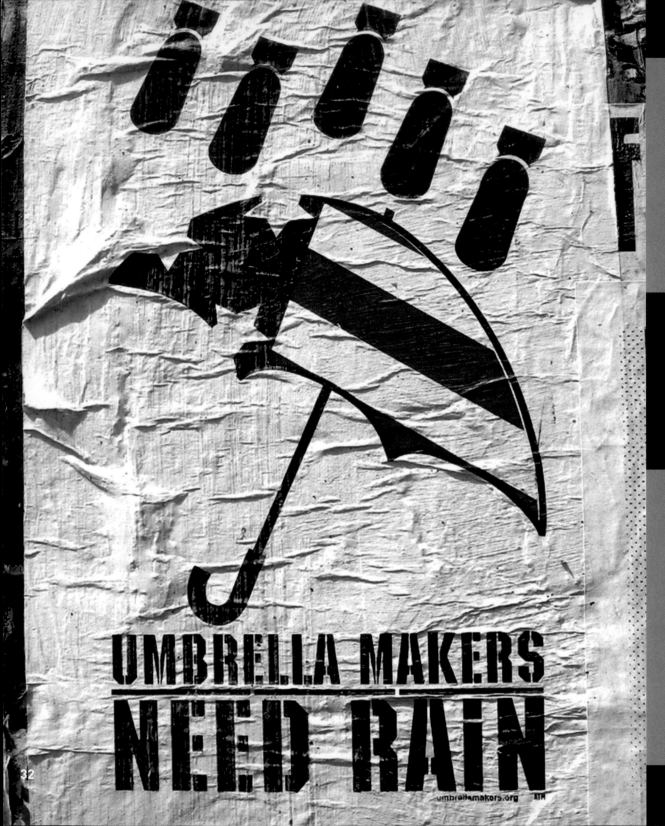

umbrellamakers.org ATM

SAN FRANCISCO / USA

POSTER PASTE-UP ON WALL
ARTIST: UNKNOWN

MAY 29, 2006

The image is strong, even if the analogy of the Stars and Stripes umbrella doesn't quite work. The suggestion seems to be that the US needs to create wars to keep those weapon contracts coming.

SAN FRANCISCO / USA

BILLBOARD ALTERATION
ARTIST: UNKNOWN

NOV 17, 2006

A great piece of culture-jamming, appropriating the language of a billboard. It's all wishful thinking: 'Coulda', given the amount of protection around the President, is unlikely, and one would have quite a lot to lose, but the effect is an amusing way of demonstrating opposition to Bush. The whole billboard was quickly pasted over by an ad council campaign.

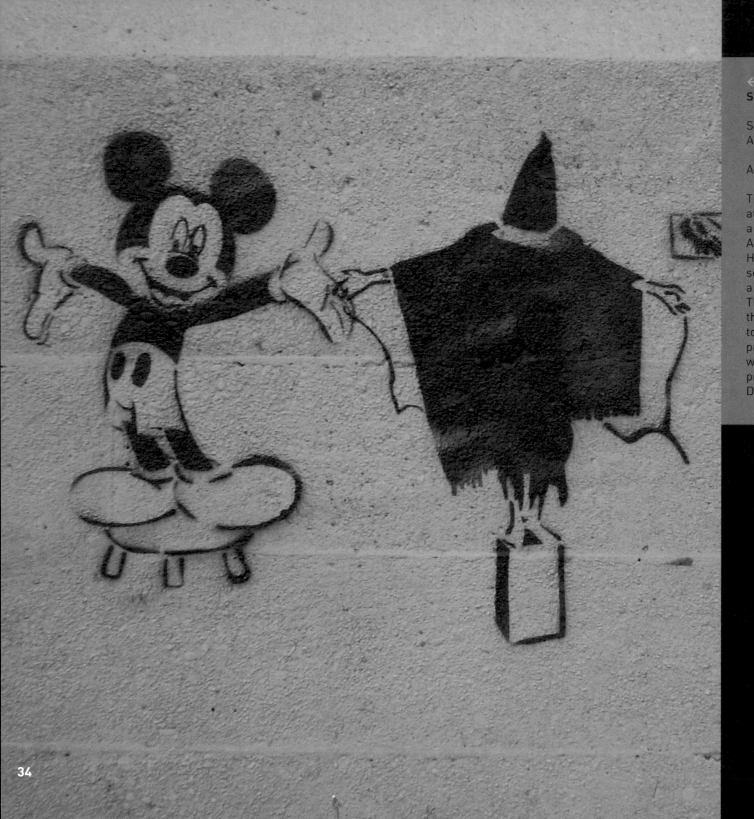

←

SEATTLE / USA

STENCIL ON CONCRETE
ARTIST: UNKNOWN

AUG 9, 2006

The horrific image of electro-torture, at Abu Ghraib prison in Baghdad, was a public relations disaster for the US Army in 2006. It quickly became iconic. Here it is sent up further, with Mickey seemingly delighted at the 'show' which a tiny section of the US forces 'put on'. The effect is disturbing, using one of the classic figures of US childhood to highlight illegal torture. It works precisely because it is utterly at odds with the public image, and declared principles, associated with the land of Disney.

war is peace

PASTE-UP ON WOOD
ARTIST: UNKNOWN

JULY 30, 2006

A deliberately obscure message on a poster with a cutsey folk aesthetic – all that hand-painted scrollwork and sepia tones. The effect is one warning us against political humbug: present something in a pretty enough way, and you can say the most ridiculous things and be believed.

CHICAGO / USA

STENCIL ON PRIMED PLASTER
ARTIST: SOLVE

OCT 23, 2006

Unusual for being a portrait not of
Bush, or Cheney or bin Laden, but of
Khalid Sheik-Mohammed (aka KSM),
mastermind of the terrorist atrocities
of 9/11 and planner of the Richard Reid
shoe-bomb attempt to blow up a 747. The
demonic look is pretty unsettling. Solve
has stamped his name all over KSM's
face in a gesture of disdain. KSM was
held at Guantanamo Bay and remains
in US custody following his claims, or
confessions, of responsibility, in
March 2007.

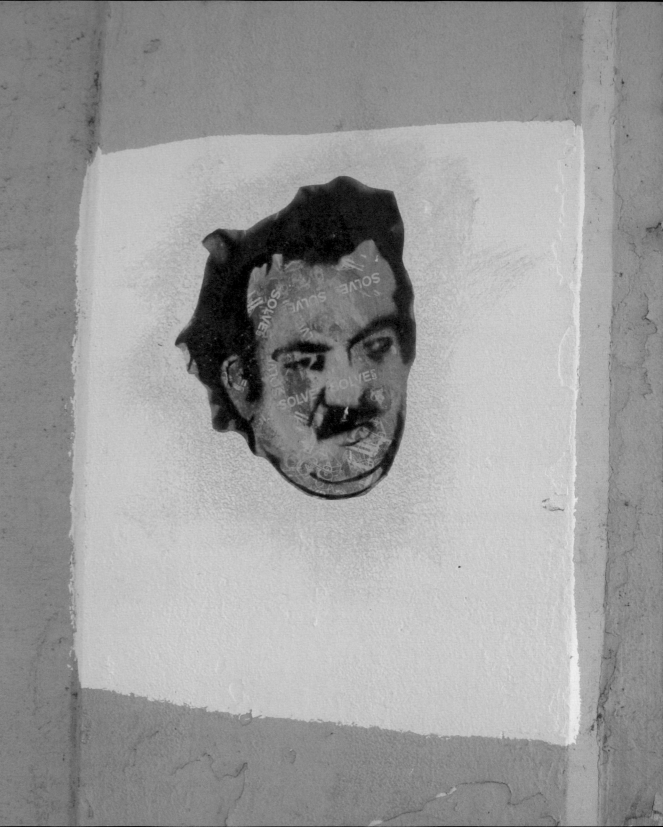

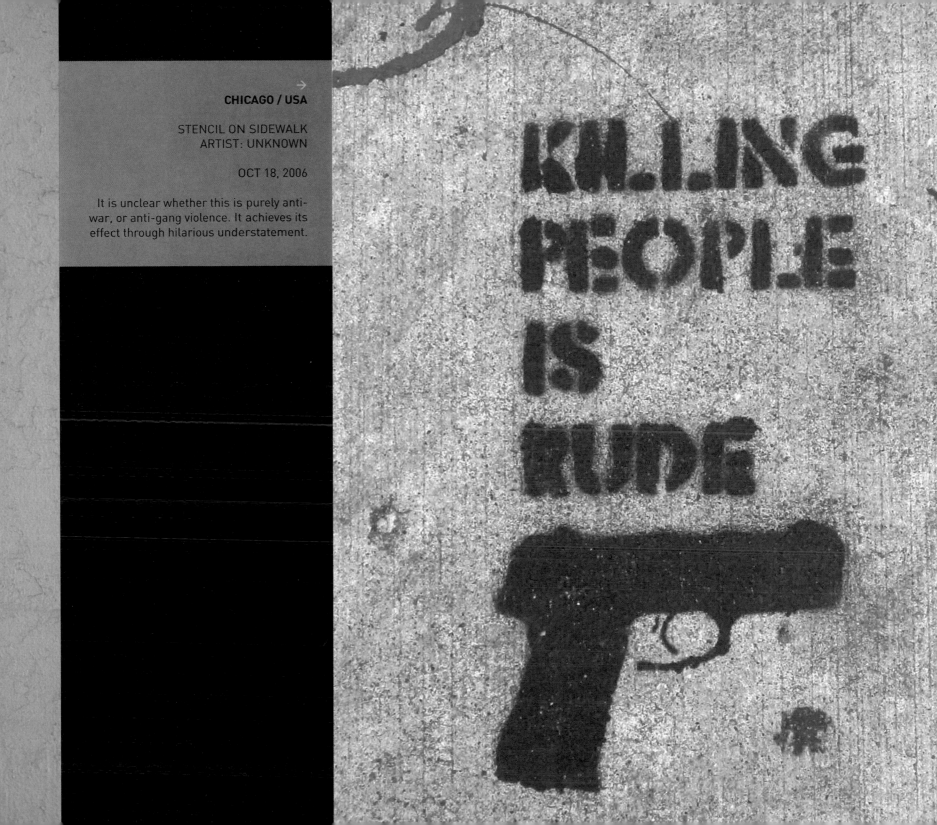

CHICAGO / USA

STENCIL ON SIDEWALK
ARTIST: UNKNOWN

OCT 18, 2006

It is unclear whether this is purely anti-war, or anti-gang violence. It achieves its effect through hilarious understatement.

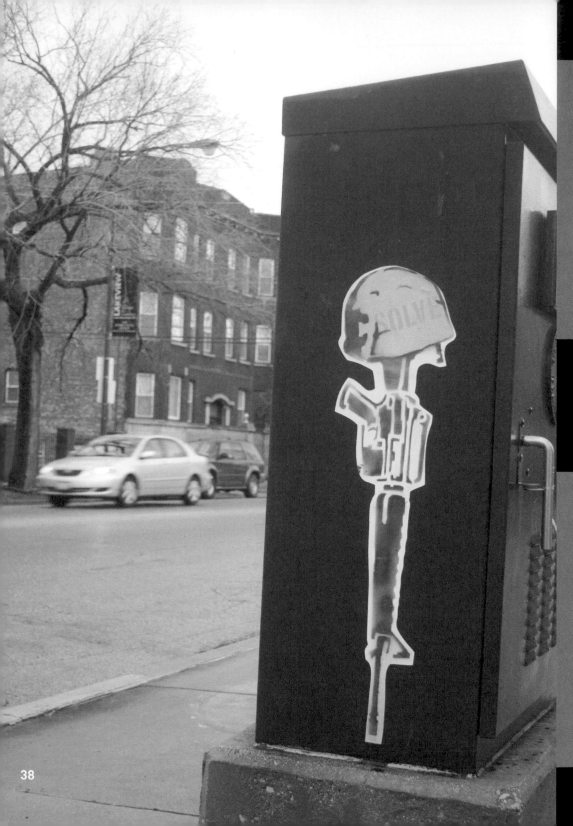

CHICAGO / USA

PASTE-UP ON STEEL
ARTIST: SOLVE

JAN 4, 2007

Sticking artworks on bits of utility or council property has the effect of shifting our sense of normality. Here Solve gives a sense that US streets are now militarized thanks to the War, with this image of a semi-automatic rifle, as if carelessly left by a soldier on patrol: a bit like Baghdad transported to Chicago.

PHILADELPHIA / USA

POSTER ON STEEL CONTAINER
ARTIST: UNKNOWN

OCT 4, 2006

The image is really clever, using the iconography of one of the main reasons for war (oil), to show how the end result of the war is to cause a conflagration of terror, rather than its defeat. The positioning of the sticker – under the other '!Caution' label, adds to the eloquence of the piece. Brilliant and succinct.

CAUTIO
DO NOT PLAY
IN, OR AROU
THIS CONTA

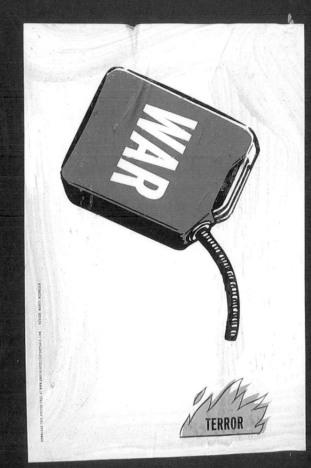

39

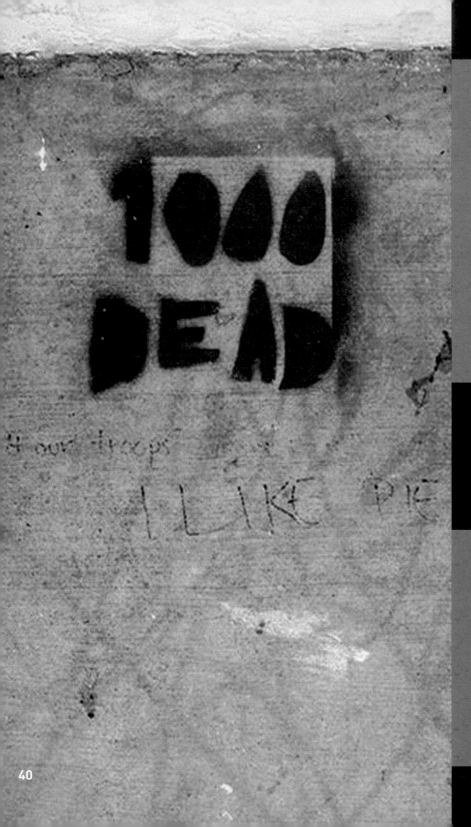

MIAMI / USA

SPRAY PAINT ON CONCRETE
ARTIST: UNKNOWN

SEPT 28, 2005

The spray-painted '1000 DEAD' appeared
on the first-floor stairwell of the
Chemistry and Physics building at Florida
International University. Commemorating
the death toll amongst US soldiers in
Iraq, the plan was to paint a similar '2000
DEAD' on the second-floor stairwell,
when that milestone was reached.
The reminder has resonance given the
relative lack of emphasis given to US
forces' casualties by the Administration.

ATLANTA / USA

SPRAY PAINT ON STUCCO WALL
ARTIST: UNKNOWN

MARCH 11, 2006

An unusual linking of race relations in
the US with the Iraq War issue. The figure
of Martin Luther King and the use of the
heart symbol is all very 1960s Summer of
Love. An echo of Vietnam perhaps?

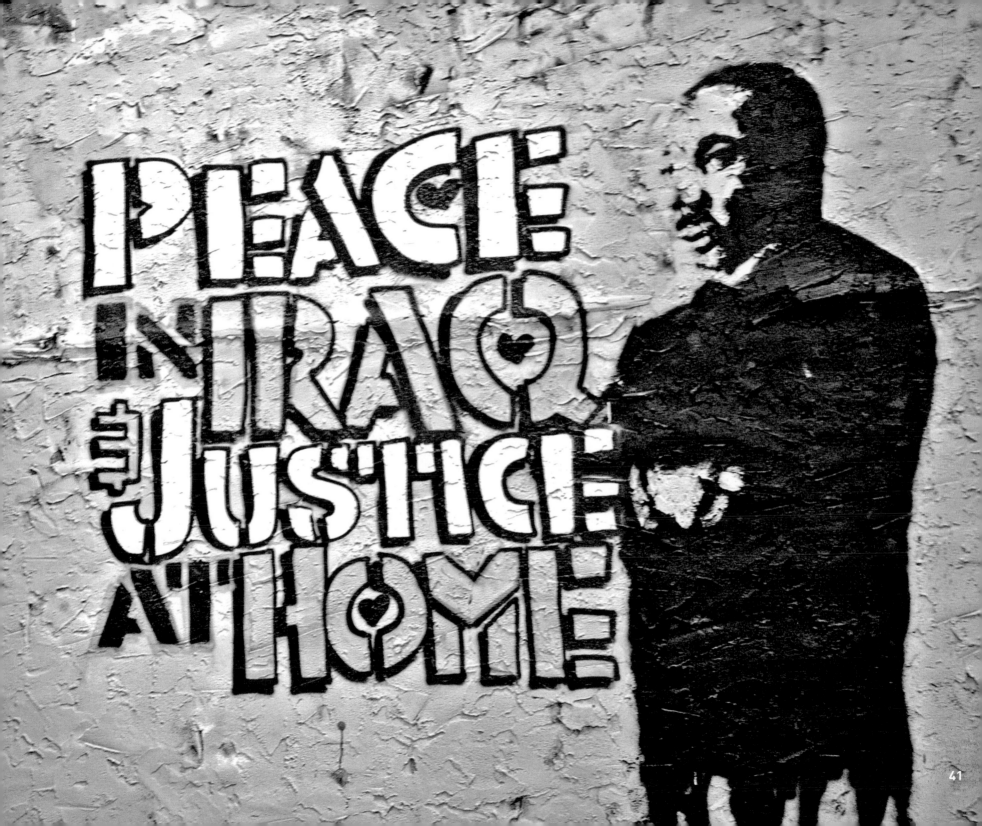

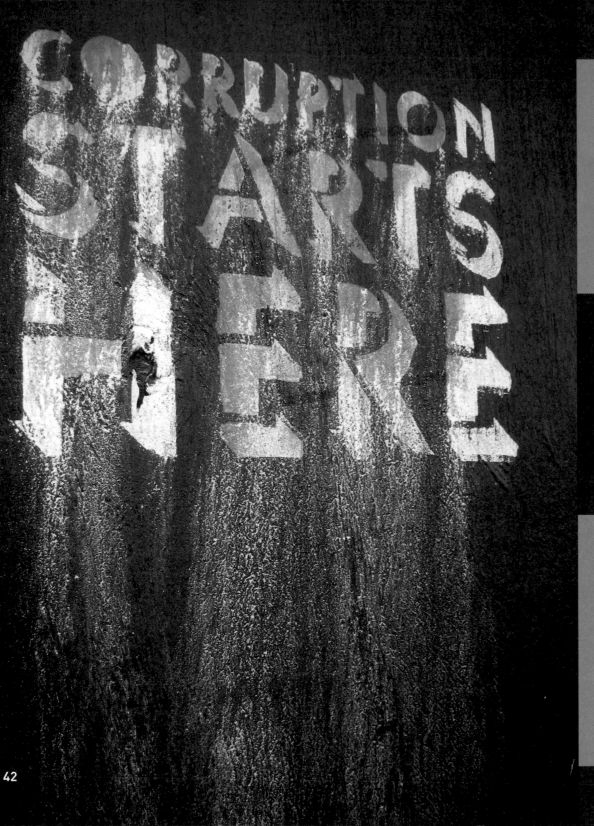

WASHINGTON, DC / USA

STENCIL ON PAINTED CONCRETE
ARTIST: UNKNOWN

FEB 10, 2007

The Bush administration has been
bedevilled by accusations of corruption.
This stencil blames the whole
Washington machinery of government
and politics

→

WASHINGTON, DC / USA

STENCILLED STICKER ON STREET LAMP
ARTIST: UNKNOWN

MAY 23, 2005

Complicity in disinformation by
mainstream media was a frequent
accusation once the US was at war in
Iraq. The motif, as in this case, usually
shows a TV frame only showing a
selective part of the image.

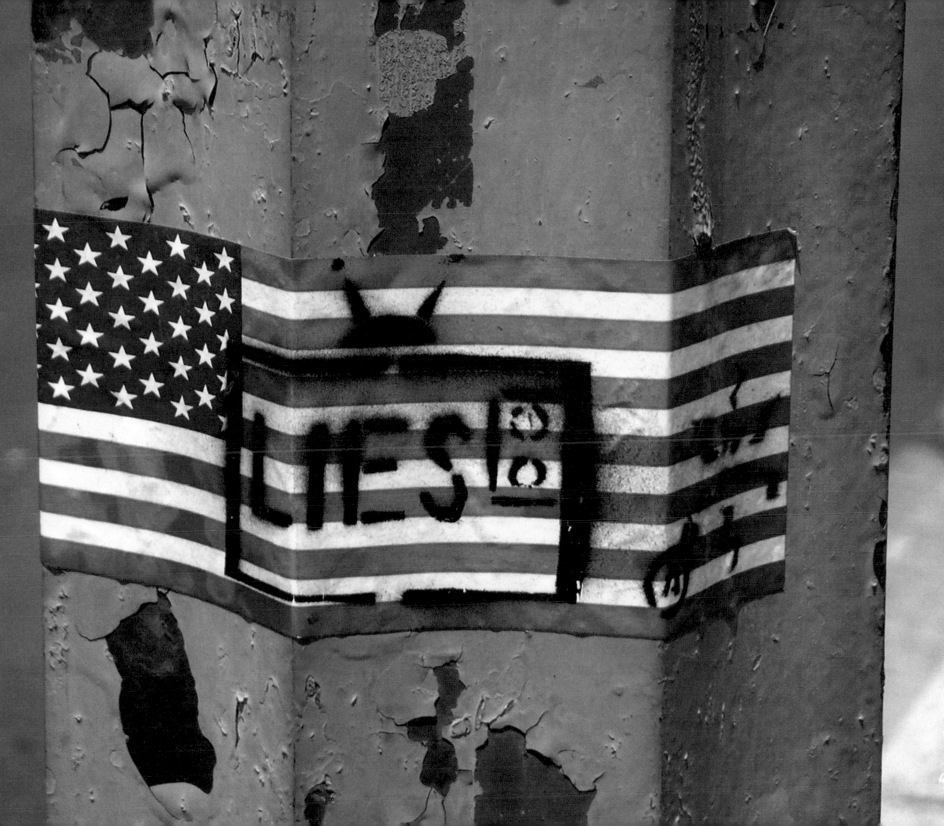

WASHINGTON, DC / USA

STENCIL PASTE-UP
ARTIST: UNKNOWN

MARCH 17, 2006

The usual police poster is subverted by a
taunting Osama, showing him in control
of events, with, by implication, the Bush
administration being all at sea.

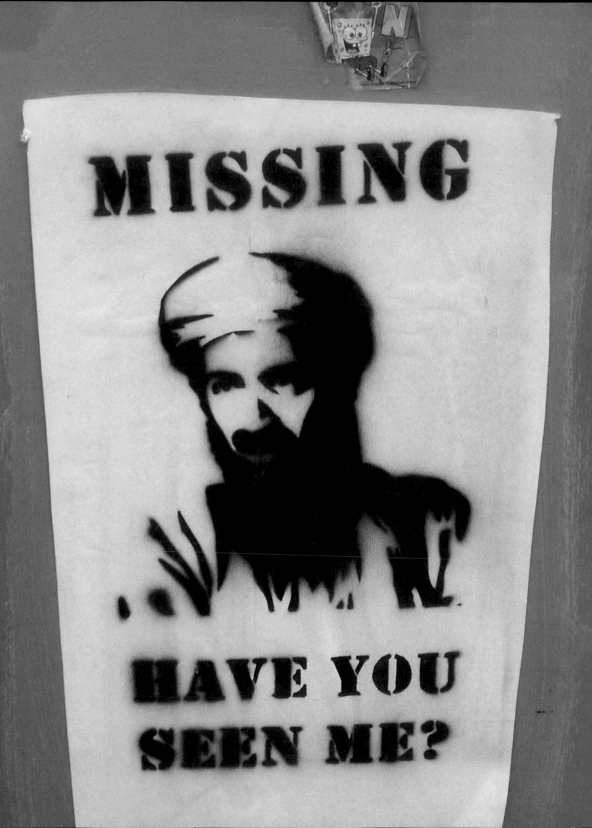

MISSING

HAVE YOU
SEEN ME?

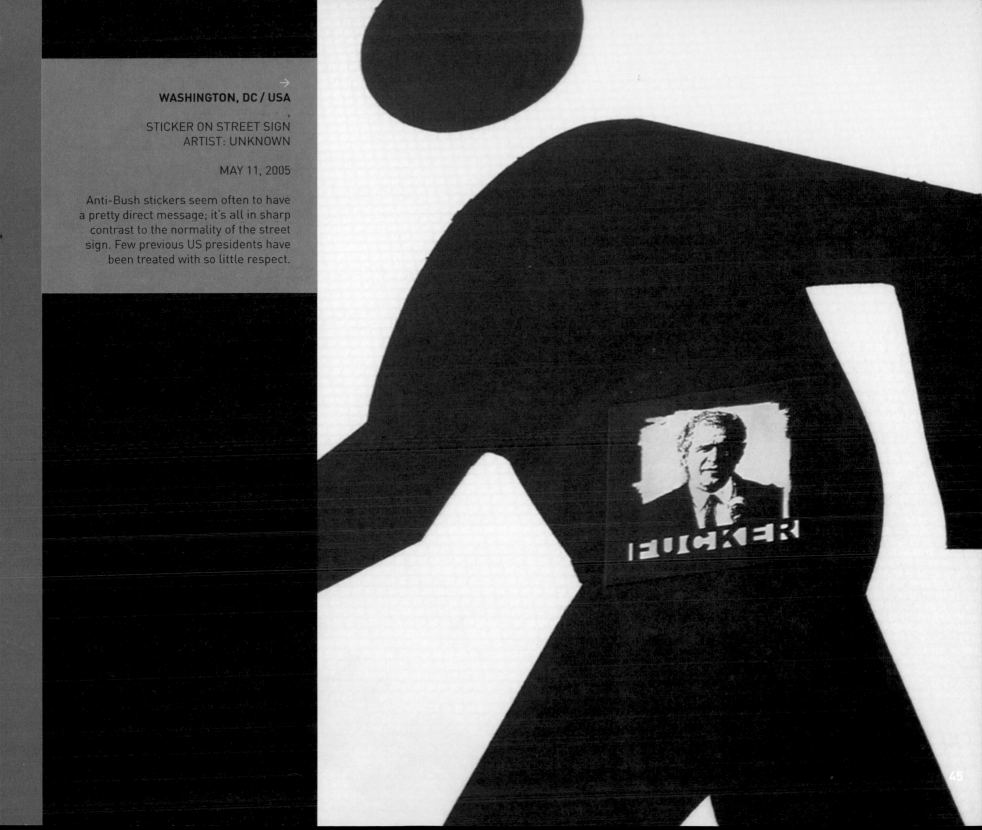

STICKER ON STREET SIGN
ARTIST: UNKNOWN

MAY 11, 2005

Anti-Bush stickers seem often to have
a pretty direct message; it's all in sharp
contrast to the normality of the street
sign. Few previous US presidents have
been treated with so little respect.

FUCKER

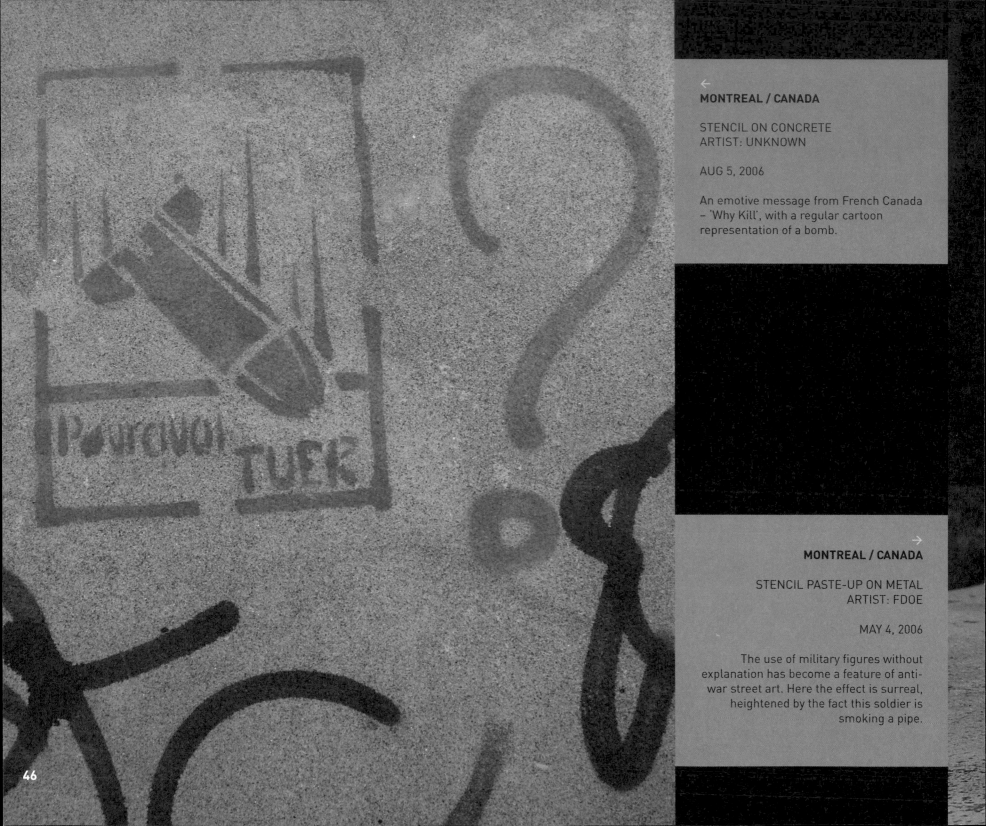

←

MONTREAL / CANADA

STENCIL ON CONCRETE
ARTIST: UNKNOWN

AUG 5, 2006

An emotive message from French Canada – 'Why Kill', with a regular cartoon representation of a bomb.

→

MONTREAL / CANADA

STENCIL PASTE-UP ON METAL
ARTIST: FDOE

MAY 4, 2006

The use of military figures without explanation has become a feature of anti-war street art. Here the effect is surreal, heightened by the fact this soldier is smoking a pipe.

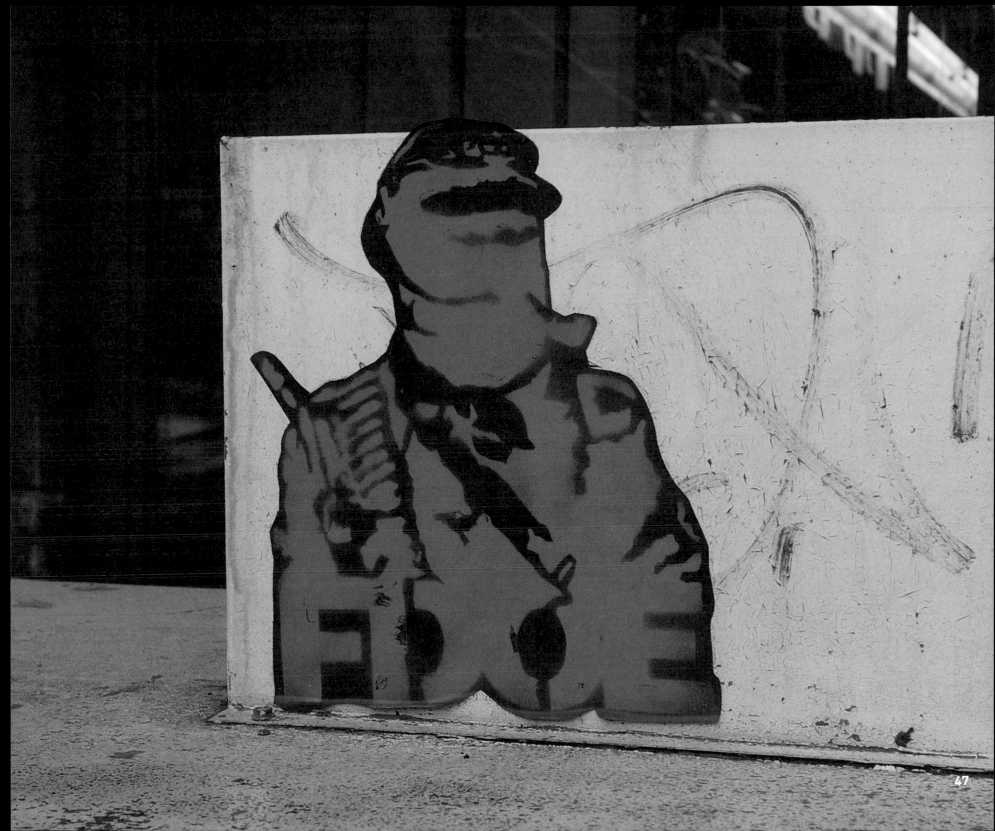

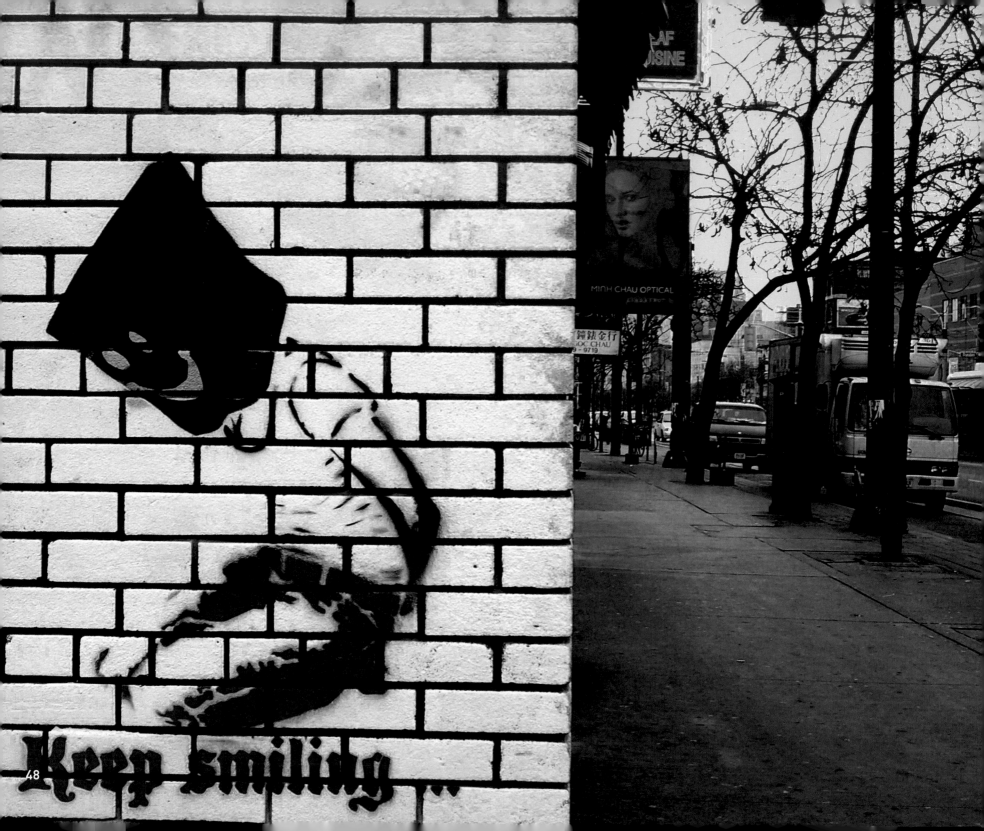

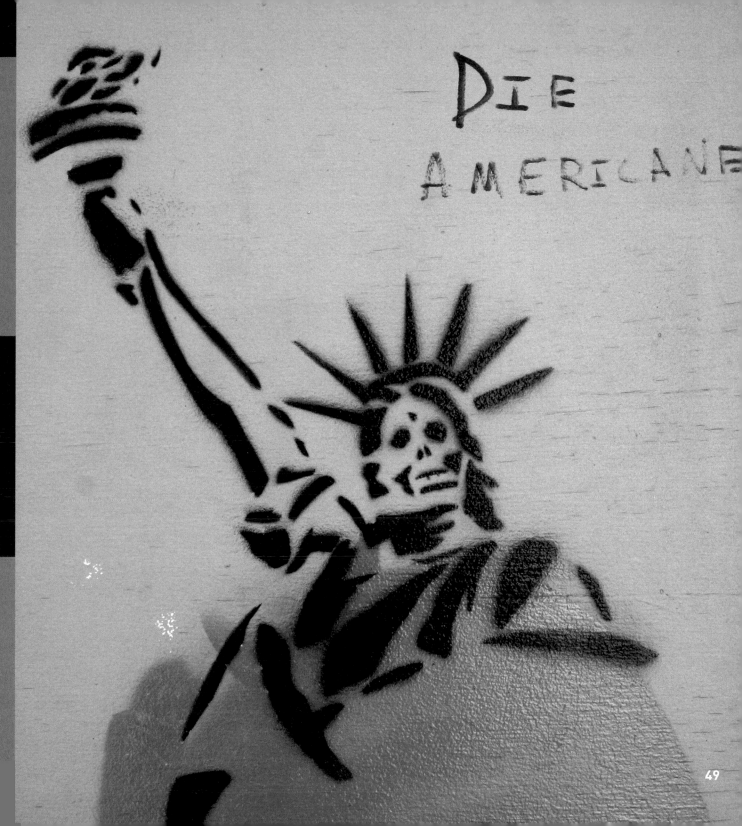

TORONTO / CANADA
CHINATOWN

RED AND BLACK STENCIL ON PAINTED BRICK
ARTIST: UNKNOWN

NOV 23, 2006

The reference is to the captives held without trial in Guantanamo Bay. The posture of arms tied behind the back, with a paper bag over the head, became another disturbing iconic image from the War.

MONTREAL / CANADA

STENCIL AND PEN ON PAINTED METAL
ARTIST: UNKNOWN

AUG 5, 2006

The Statue of Liberty is a frequently subverted image. Here she is represented as Death Triumphant.

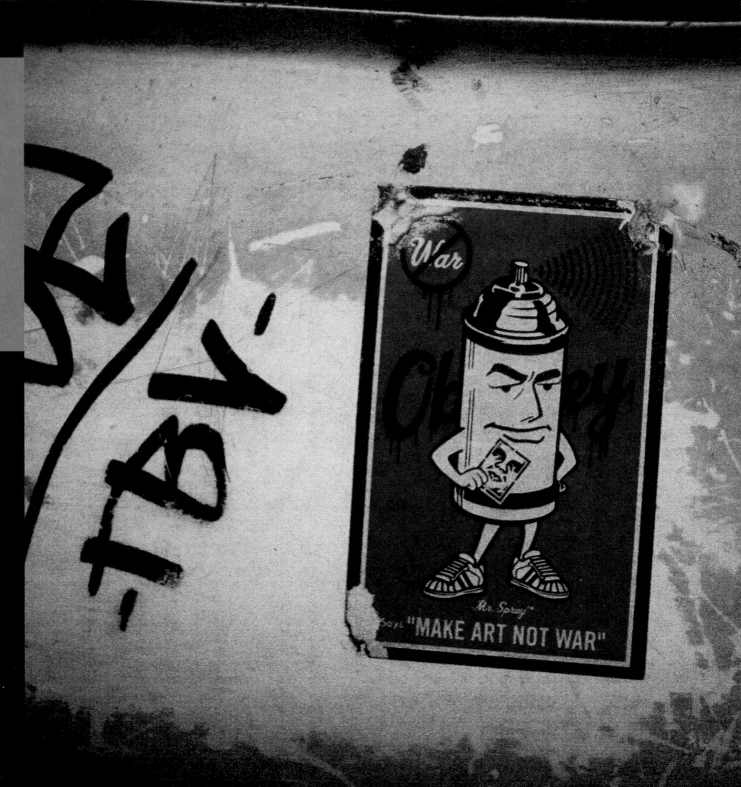

VANCOUVER / CANADA

STICKER ON METAL
ARTIST: SHEPARD FAIREY

FEB 1, 2007

Shepard Fairey in playful mood, creating
a cute spray can holding one of his 'Obey'
stickers, which appeared just as the
Neo-Cons looked like they were going to
achieve power in the US. There is an irony
in that graffiti is considered illegal, whilst
the law sanctions the massive destruction
of war. The whole thing is a very 21st-
Century twist on the 1960s hippy slogan

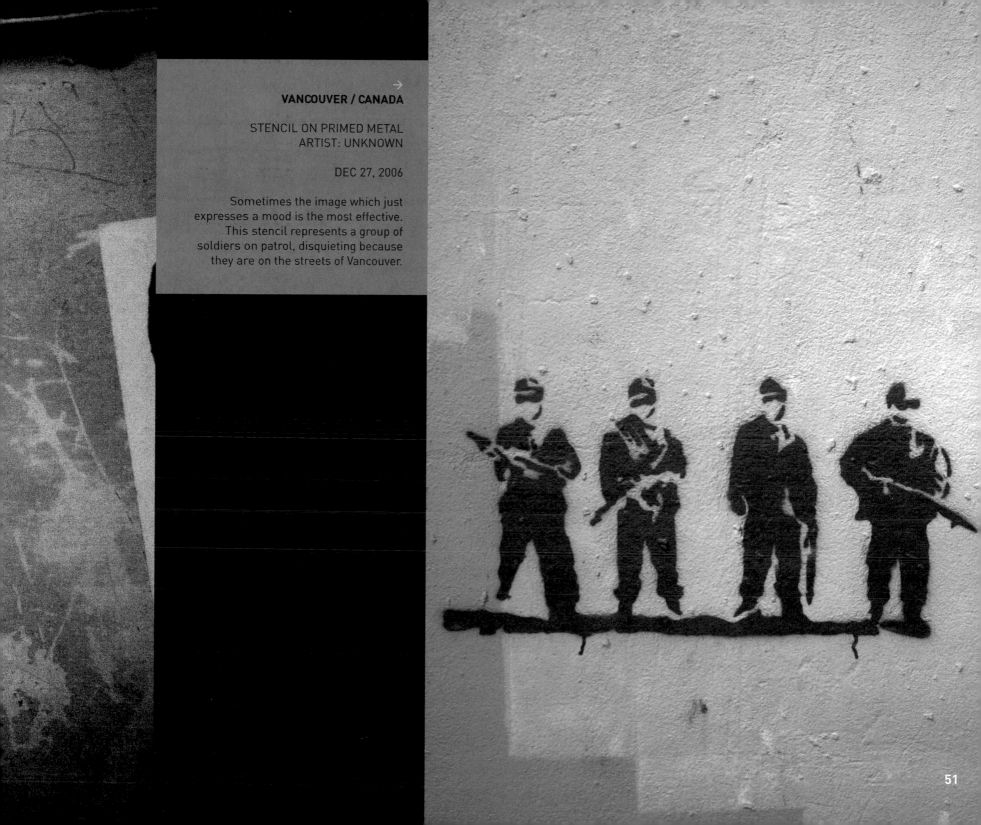

VANCOUVER / CANADA

STENCIL ON PRIMED METAL
ARTIST: UNKNOWN

DEC 27, 2006

Sometimes the image which just
expresses a mood is the most effective.
This stencil represents a group of
soldiers on patrol, disquieting because
they are on the streets of Vancouver.

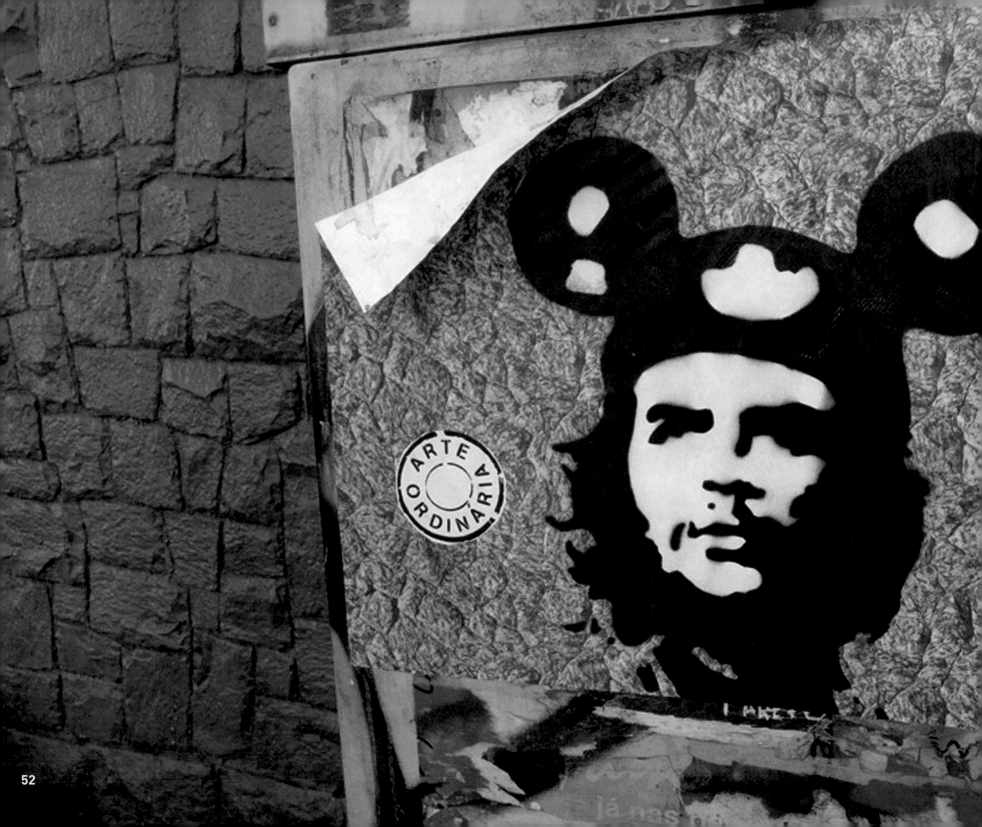

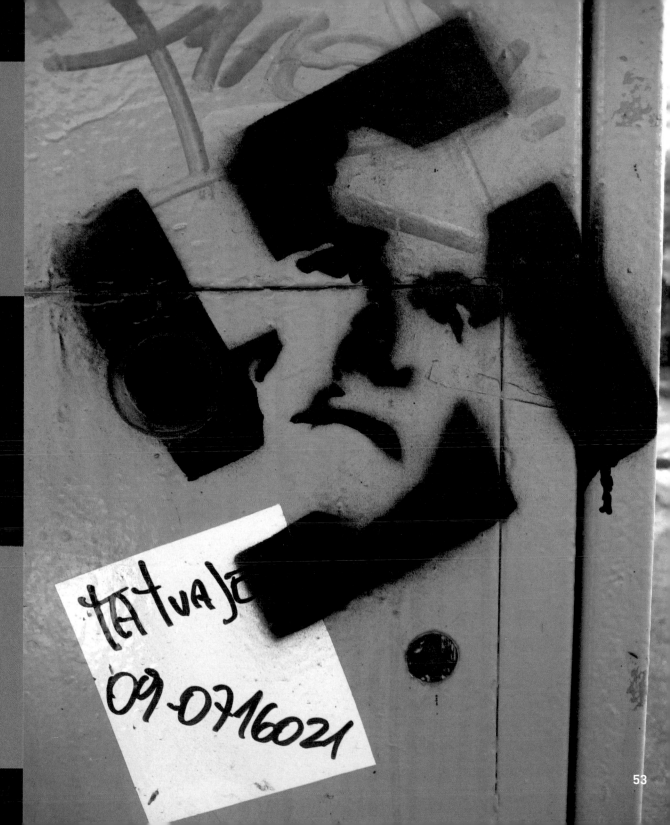

SÃO PAULO / BRAZIL

PASTE-UP ON METAL
ARTIST: ARTE ORDINARIA

JAN 11, 2006

In Latin America, anti-Americanism and opposition to the War on Terror often fuses; here all-pervasive US influence is shown by even the great Che being given the Mickey Mouse treatment.

SANTIAGO / CHILE

STENCIL ON ELECTRICITY BOX
ARTIST: UNKNOWN

APRIL 26, 2007

Bush is represented intertwined with a swastika; again the comment is on how right-wing the Neo-Con establishment is, rather than on the War in particular.

53

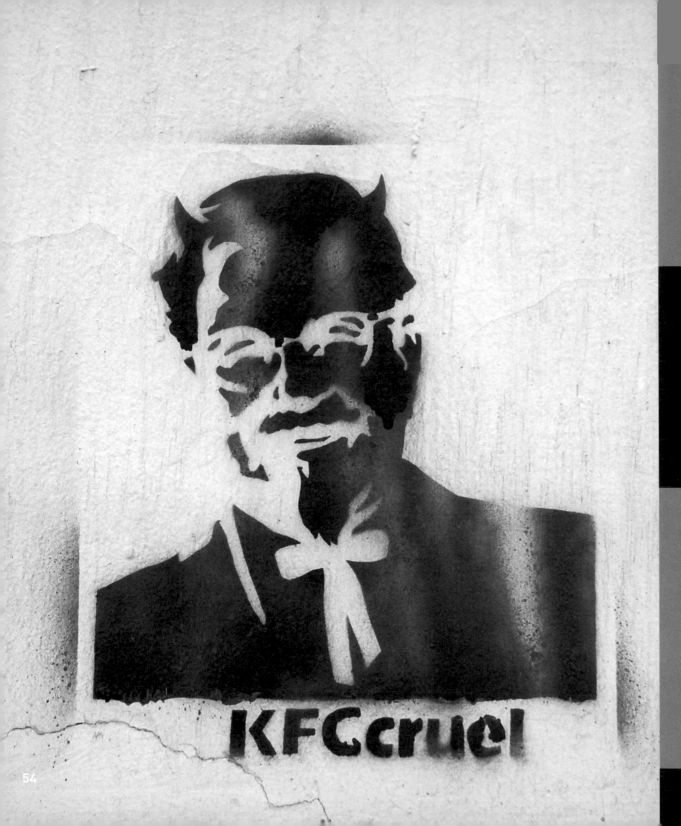

KFCcruel

VALPARAISO / CHILE

STENCIL ON CONCRETE
ARTIST: UNKNOWN

NOV 7, 2006

A Colonel Sanders look-alike, turned into an Uncle Sam figure with devil horns, represents US foreign policy in general.

→

BUENOS AIRES / ARGENTINA

STENCIL ON CONCRETE
ARTIST: CAM BSAS

APRIL 7, 2007

A brilliantly eloquent piece from the land which exported beef to the world. The perspective is long – since 1989 – and the comment on the Bush family is a witty and cutting comment on their foreign policy adventures. Cut and stencilled with precision, this one is satisfying on a whole lot of levels.

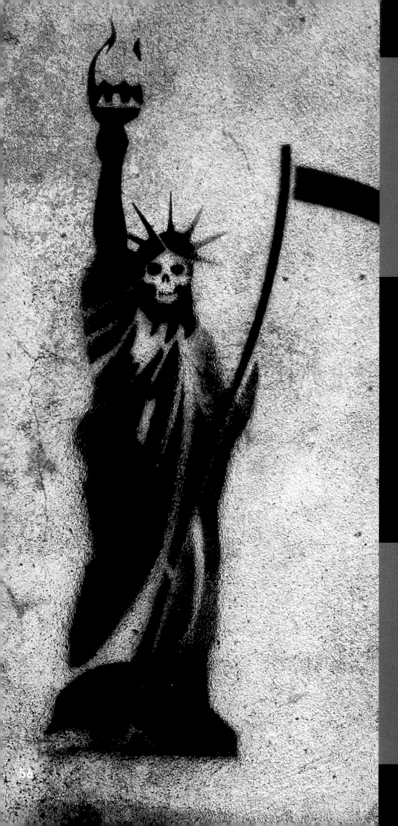

← **BUENOS AIRES / ARGENTINA**

STENCIL ON CONCRETE
ARTIST: CAM BSAS

OCT 19, 2006

Cam BsAs created this work to mark Bush's visit to Buenos Aires: a really sinister rendition of the Statue of Liberty as the Grim Reaper.

→

BUENOS AIRES / ARGENTINA

STENCIL ON CONCRETE
ARTIST: CAM BSAS

APRIL 7, 2007

A great take on the US National Basketball Association logo, the artist calls this one 'National Killing Association'.

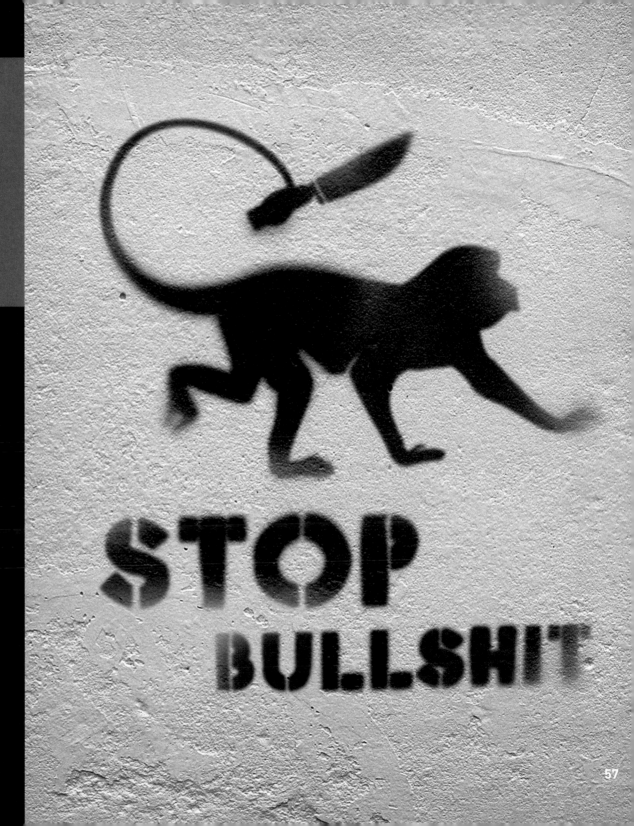

BUENOS AIRES / ARGENTINA

STENCIL ON CONCRETE
ARTIST: CAM BSAS

APRIL 7, 2007

Cam BsAs seems to love anything to do with Argentinian beef as a way to comment on the Bush administration. Here a monkey (with a profile that has echoes of Bush's) improbably wields a steak knife in its tail.

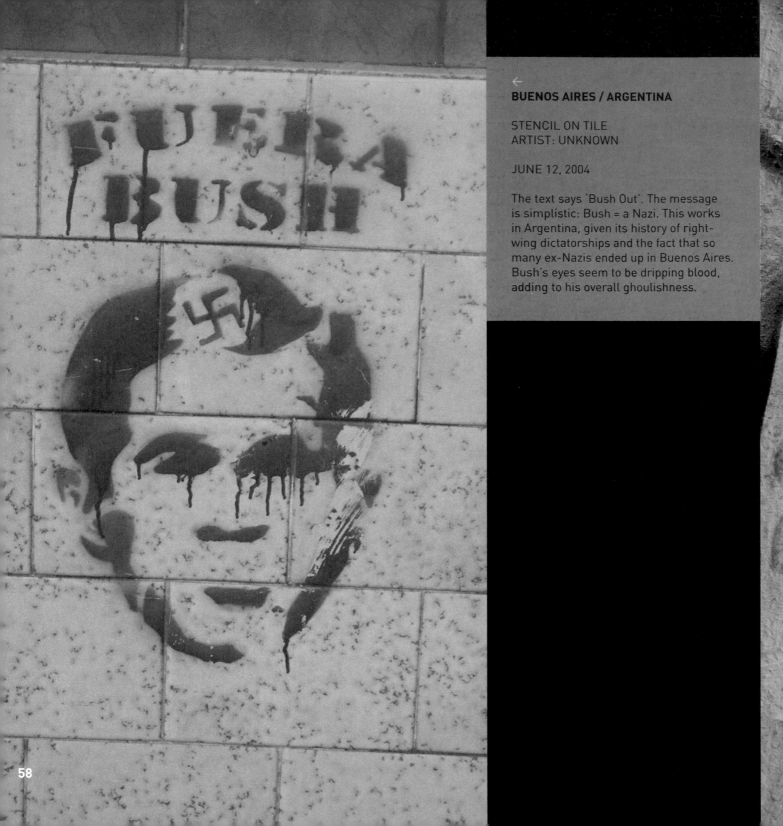

BUENOS AIRES / ARGENTINA

STENCIL ON TILE
ARTIST: UNKNOWN

JUNE 12, 2004

The text says 'Bush Out'. The message is simplistic: Bush = a Nazi. This works in Argentina, given its history of right-wing dictatorships and the fact that so many ex-Nazis ended up in Buenos Aires. Bush's eyes seem to be dripping blood, adding to his overall ghoulishness.

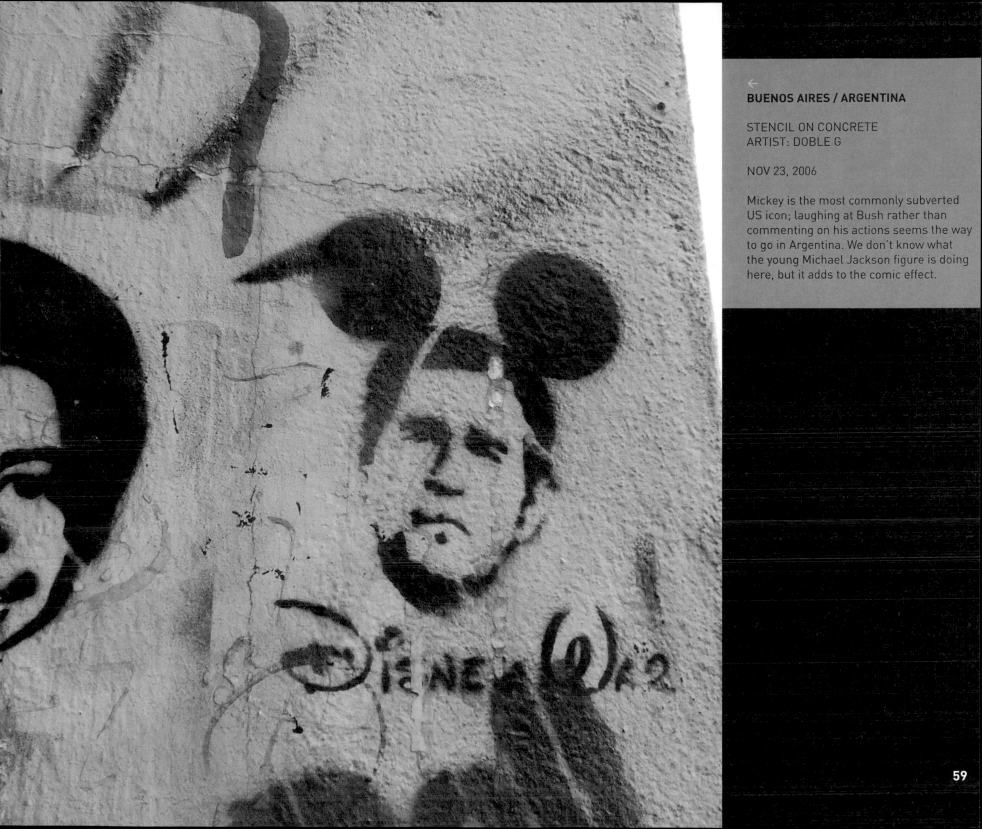

BUENOS AIRES / ARGENTINA

STENCIL ON CONCRETE
ARTIST: DOBLE G

NOV 23, 2006

Mickey is the most commonly subverted US icon; laughing at Bush rather than commenting on his actions seems the way to go in Argentina. We don't know what the young Michael Jackson figure is doing here, but it adds to the comic effect.

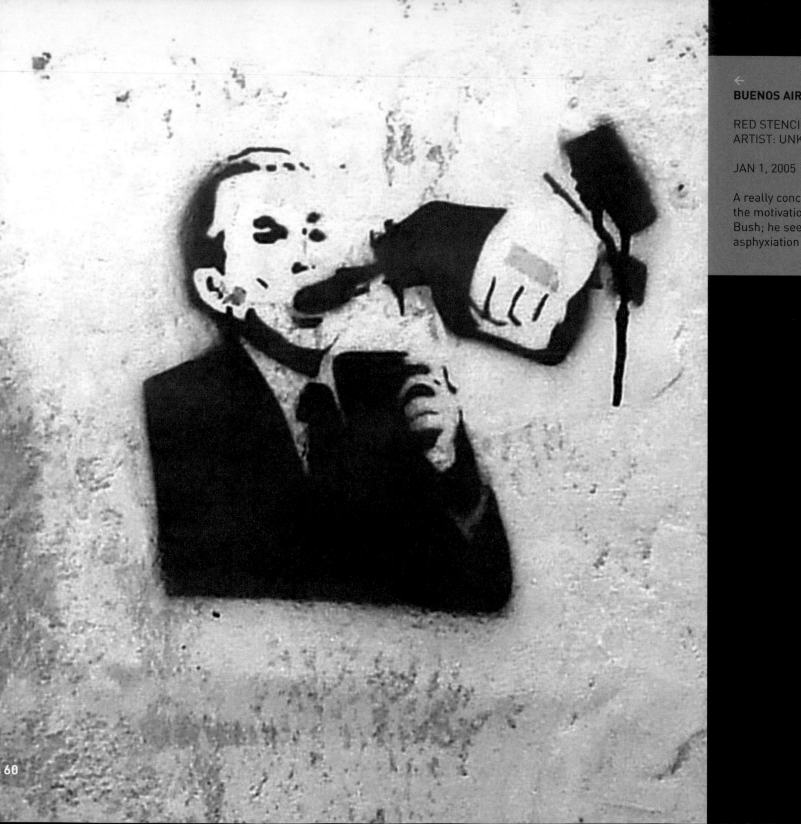

BUENOS AIRES / ARGENTINA

RED STENCIL ON RENDERED WALL
ARTIST: UNKNOWN

JAN 1, 2005

A really concise, visceral comment on the motivation for the War; the figure is Bush; he seems to be willing his own asphyxiation with oil.

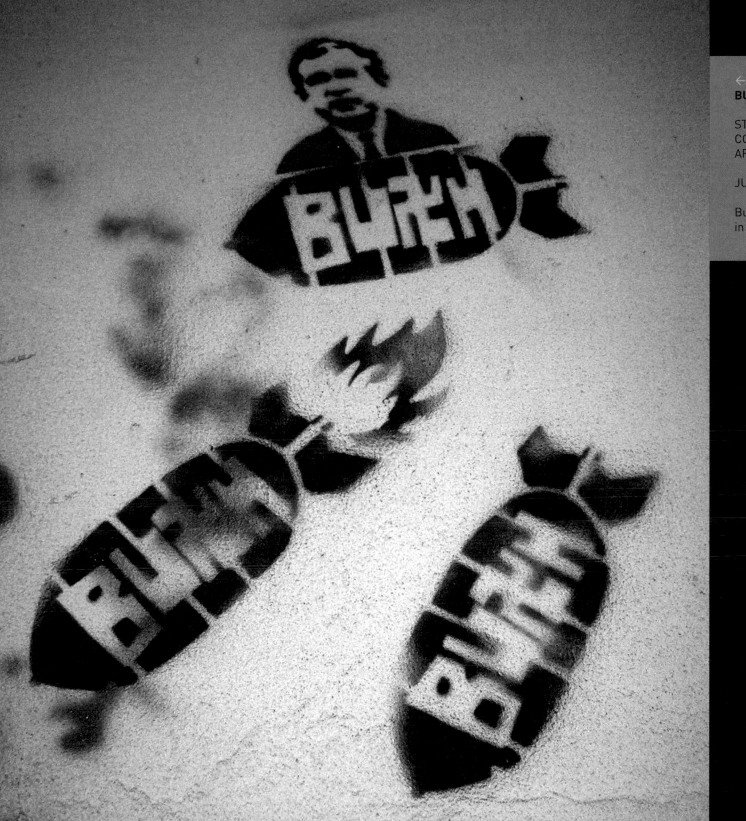

BUENOS AIRES / ARGENTINA

STENCIL AND SPRAY PAINT ON PAINTED
CONCRETE
ARTIST: UNKNOWN

JUNE 15, 2004

Bush, war and Nazism neatly wrapped
in a single image.

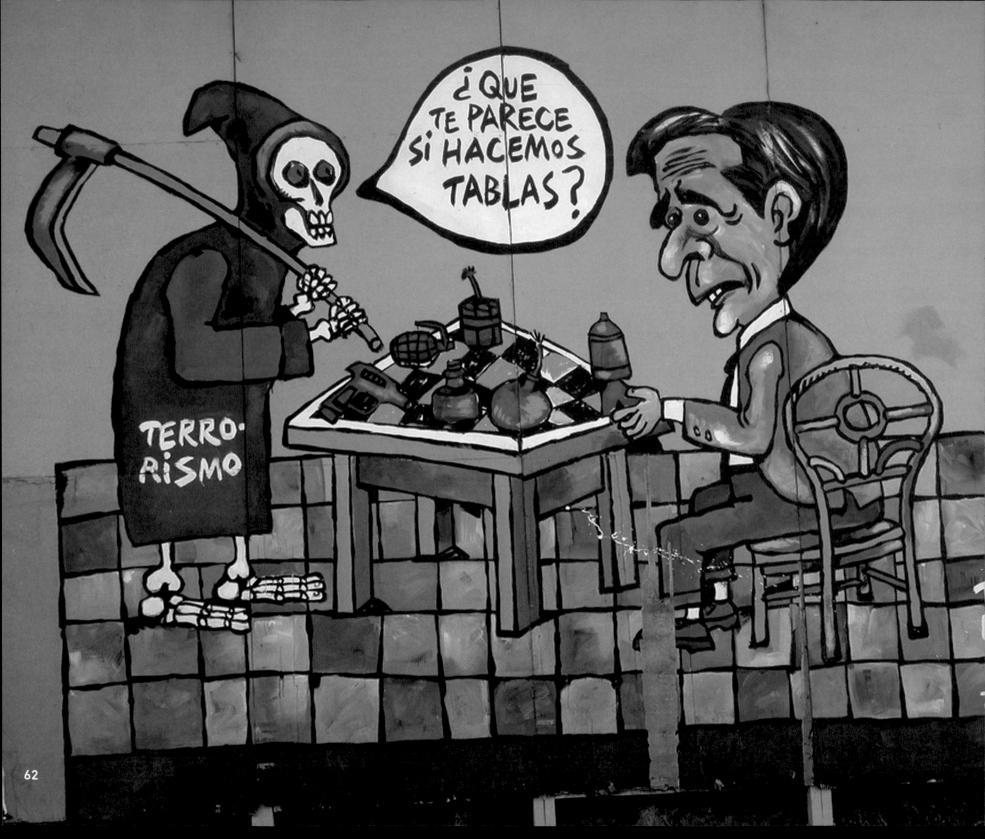

HAVANA / CUBA

PAINT ON WOOD PANELS
ARTISTS: TOMY, ADANO AND JOSEPH

NOV 30, 2006

LEFT: The figure of Bush to the right asks Terrorism, represented by the Grim Reaper, whether he wants to play. A comment on the Neo-Cons' relish for a long-planned war

RIGHT: To the left an Uncle Sam figure blocks Cuba's chimney and the smoke comes out of his ear: this is standard comment on the trade blockage on Cuba the US still maintains. The image on the far right is a perceptive comment on the War – Bush as Uncle Sam being voted in, with the Dove of Peace totally alarmed. The use of a childish/cartoon iconography is typical of Cuba.

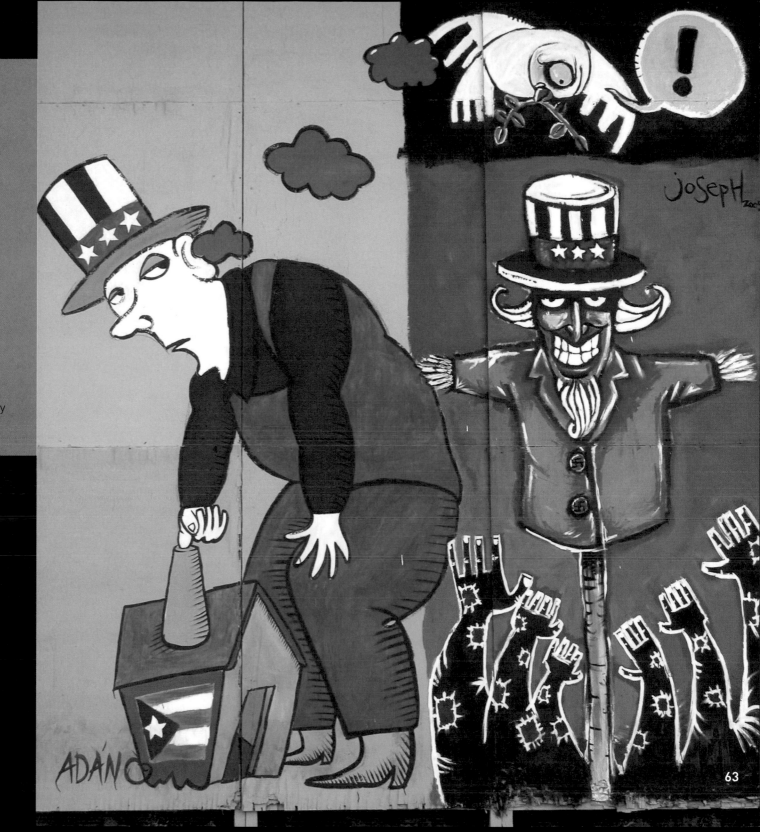

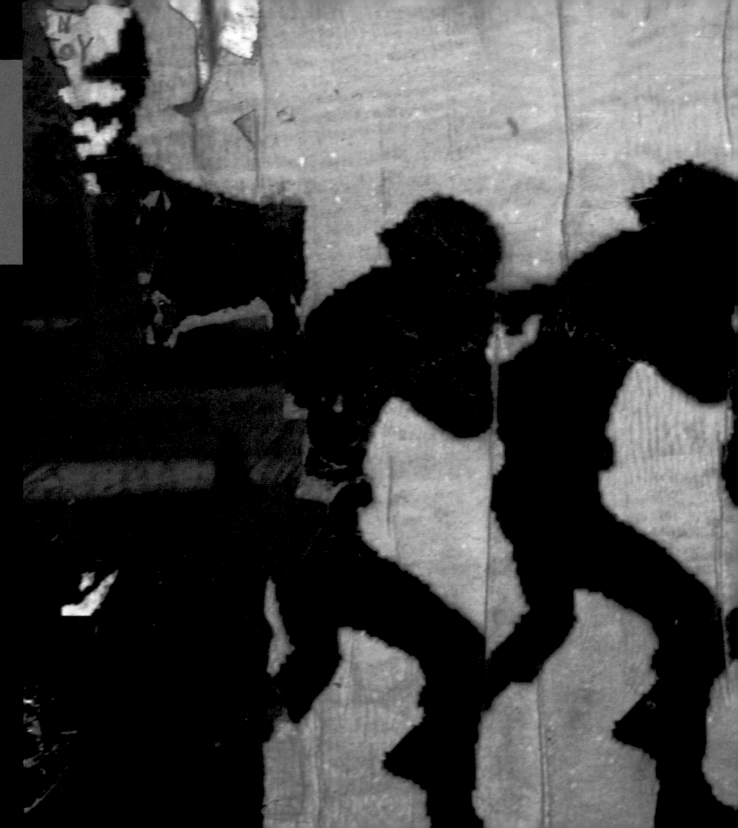

MEXICO CITY / MEXICO

STICKER ON GLASS
ARTIST: UNKNOWN

APRIL 5, 2007

The image, recalling that of slaves
on forced march, represents the
endlessness of war.

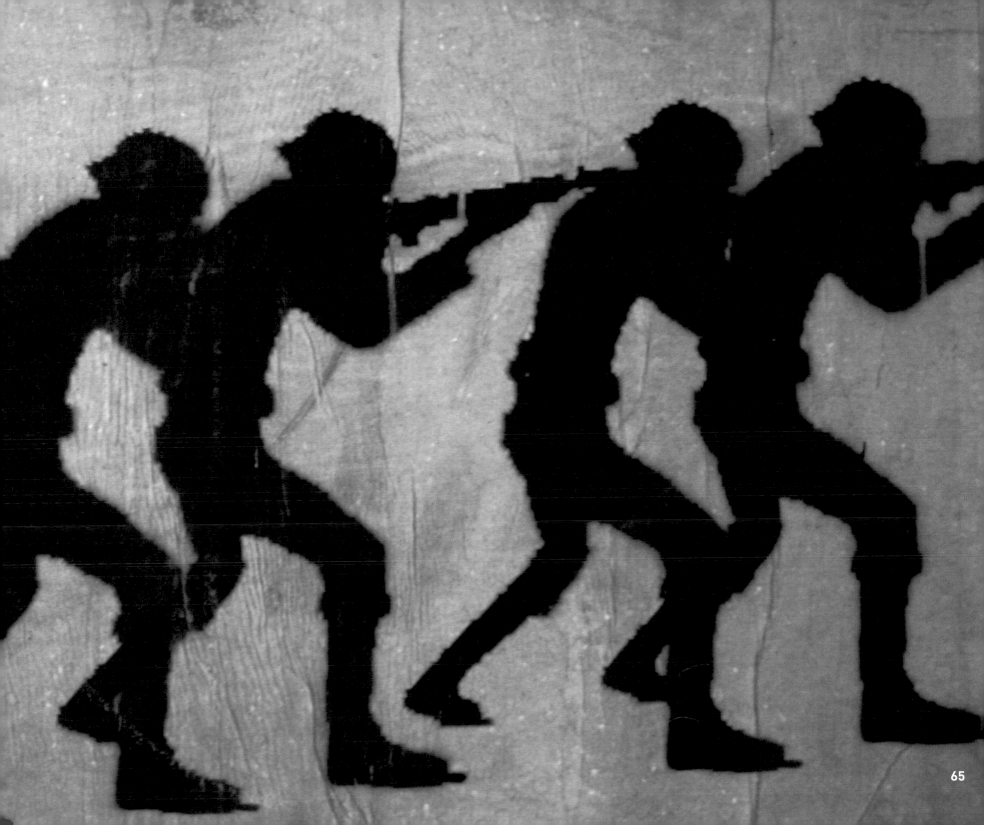

EUROPE

LONDON / BRIGHTON / NEWCASTLE / IPSWICH / CORK / GLASGOW / BERLIN /
MUNICH / SALZBURG / PRAGUE / PARIS / MARSEILLE / LISBON / BARCELONA
/ MADRID / VENICE / ROME / THESSALONIKI / STOCKHOLM / AMSTERDAM /
HELSINKI / OSLO / MOSCOW

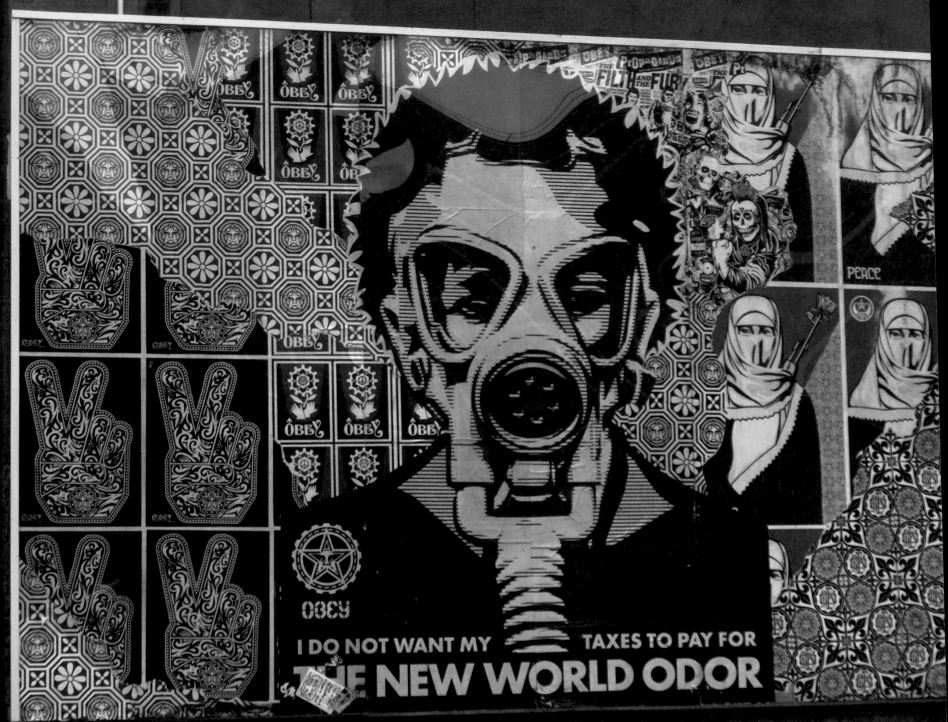

OBEY

I DO NOT WANT MY TAXES TO PAY FOR
THE NEW WORLD ODOR

PEACE

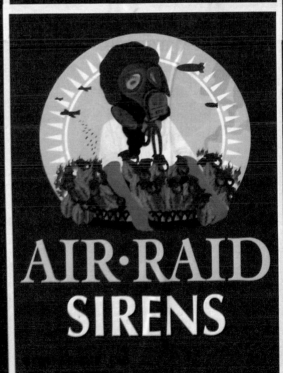

LONDON / ENGLAND

POSTER
ARTIST: SHEPARD FAIREY

MAY 17, 2007

Fairey has developed a completely
original iconography around the
juxtaposition of pretty decorative
designs and fascistic themes. Fairey
layers Islamic motifs behind an image
of the West strapped into a gas mask.
The New World Odor, however, is the
world created by the Neo-Cons and
their supporters. Amongst this all is the
classic Fairey stamp of OBEY. Brilliant.

LONDON / ENGLAND

POSTER PASTE-UP
ARTIST: UNKNOWN

MARCH 18, 2007

Probably inspired by Fairey. Here, Sun
Maid Rasins packets are subverted from
their sweet, sunny, happy design into an
image of the horrors to come in the Neo-
Con New World Order. The 'Best Before
End Of / The / World' message completes
a brilliant image.

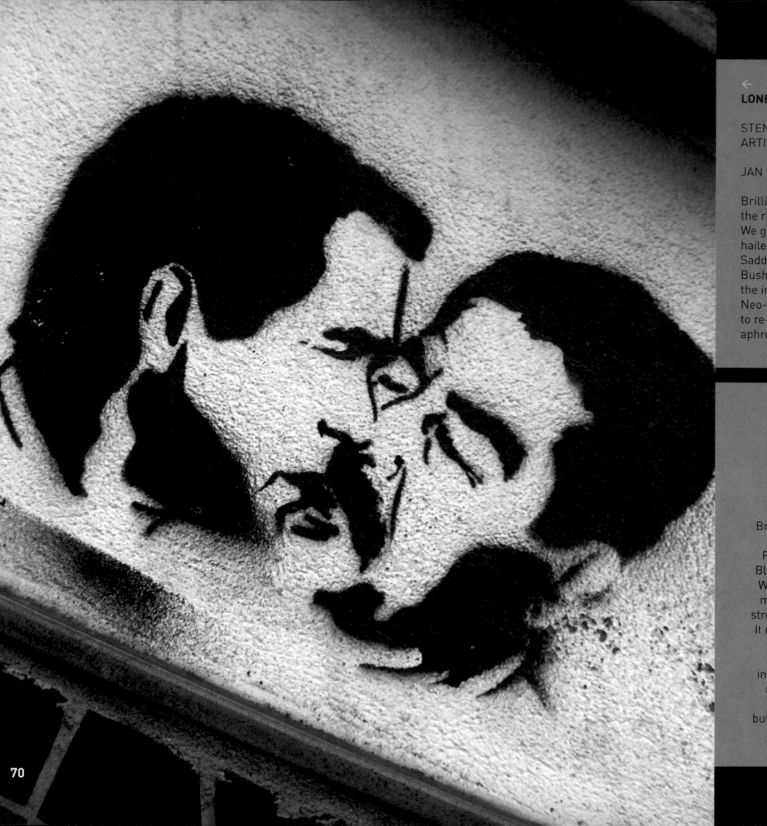

←

LONDON / ENGLAND

STENCIL ON CONCRETE
ARTIST: UNKNOWN

JAN 13, 2006

Brilliant and designed to really offend the right-wing Bush lobby in the States. We get lots of takes on this: the US had hailed and supported Saddam for years; Saddam loved the idea of tweaking Bush's tail; but overriding both these is the ironic comment it makes about the Neo-Cons' desire for a war with Saddam to re-order the Middle East. It's all pretty aphrodisiacal.

→

LONDON / ENGLAND

PROTEST PLACARD
ARTIST: BANKSY

MAY 23, 2006

Brian Haw's anti-war protest of scruffy banners opposite the Houses of Parliament in London hugely irritated Blair and his supine MPs who voted for War. Haw seemed to speak for the one million plus who demonstrated on the streets of London against action in Iraq. It made Haw hard to dislodge, but after three years the House of Commons finally passed a law. The protest, including this funny Banksy piece, was recreated in the Tate Gallery by Mark Wallinger. A pyrrhic victory for Haw, but another democratic right had fallen victim to the Bush/Blair war.

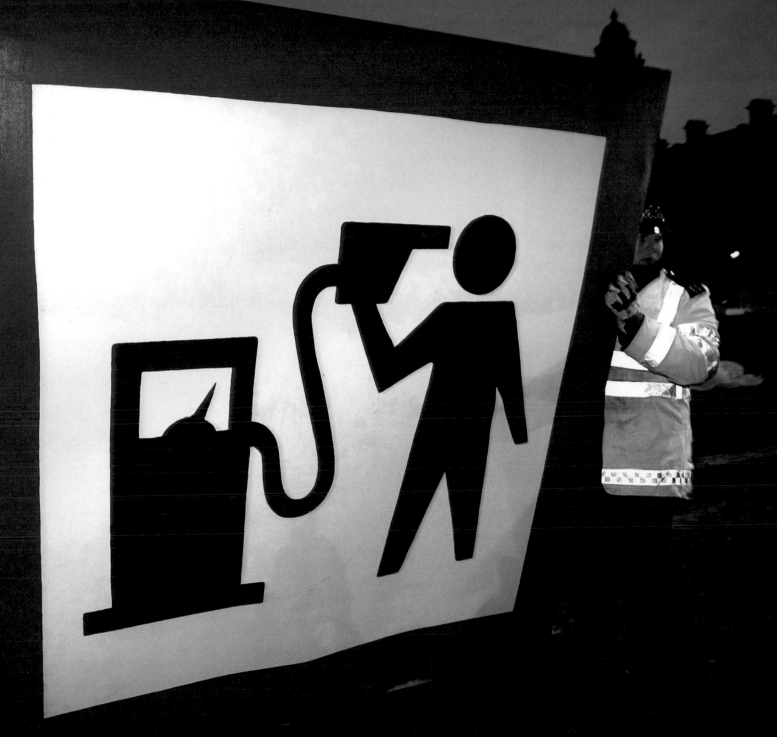

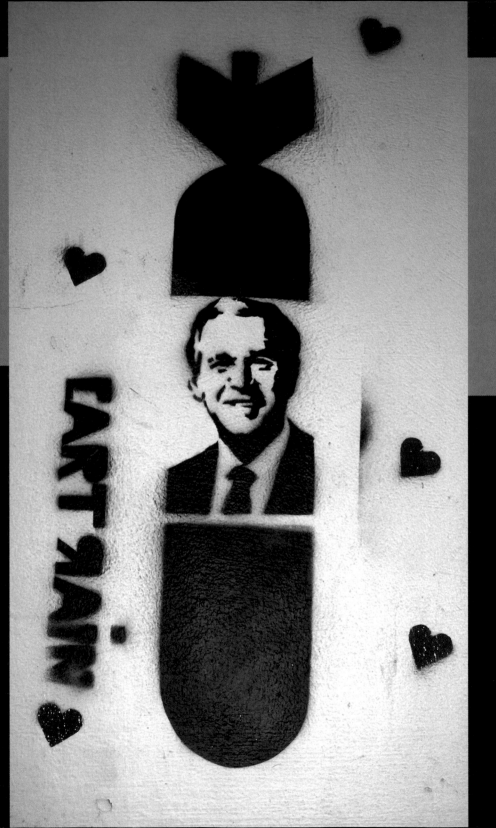

LONDON / ENGLAND

STENCIL ON BRICK
ARTIST: CARTRAIN

OCT 28, 2006

A favourite rendition of George Bush, maxing the contrast between the supposedly bland corporate suit and slightly idiotic smile and a bomb about to rain indiscriminately on some hapless souls. The depiction of the munition owes more to cartoon imagery than the shape of guided bombs today. The Valentines hearts heighten the sarcastic tone of the piece.

LONDON / ENGLAND

STICKER ON PEDESTRIAN CROSSING
ARTIST: SPACE HIJACKERS

OCT 9, 2006

A classic, slighty surreal, and hilarious, subversion of street furniture. From being the golden boy heralding in a new era, Blair's government lost almost all credibility over the way it went to war. The insistence that Saddam had weapons of mass destruction showed amazing contempt for the British electorate. Here, we are given the illusion of choice, but are forced to press 'yes' and agree with the government if we want to proceed.

STENCIL ON CAR
ARTIST: BANKSY

NOV 12, 2006

A tangential Banksy piece reflecting the general mood of oppression around the War. Is it the Grim Reaper, and are we imagining it or is this what Blair's skull might look like?

PHOTOCOLLAGE IN SHOP WINDOW
ARTIST: PETER KENNARD

DEC 18, 2006

Blair's faux sincerity is sent up big-time in this iconic piece. Even the use of a mobile phone camera parodies his attempts to be in touch with yoof culture. The montage appeared in the Oxford Street window at Santas Ghetto, an annual shop/exhibition organized by street artists including Banksy. Peter Kennard has been producing highly politicized artworks since the 70s; he used to design placards for CND.

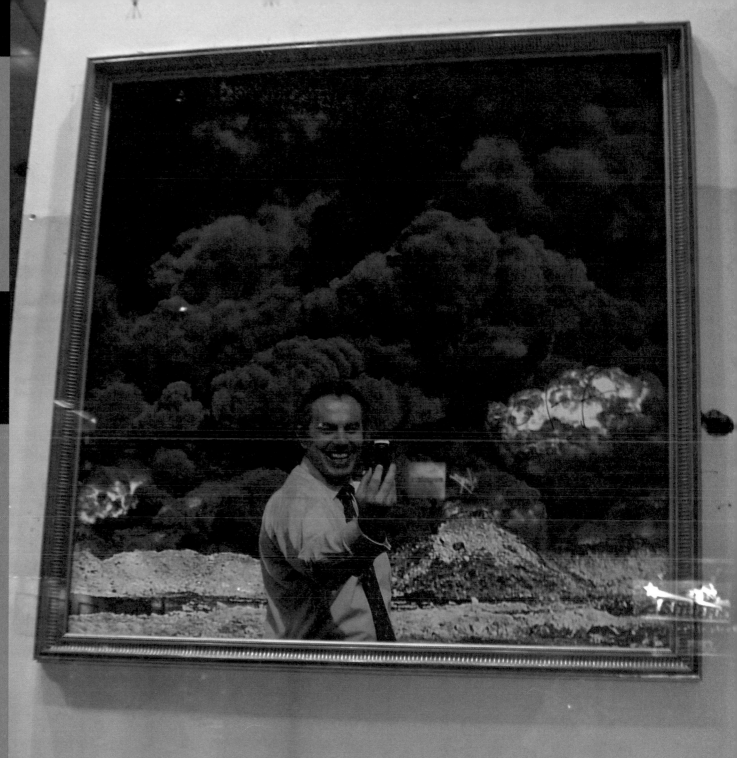

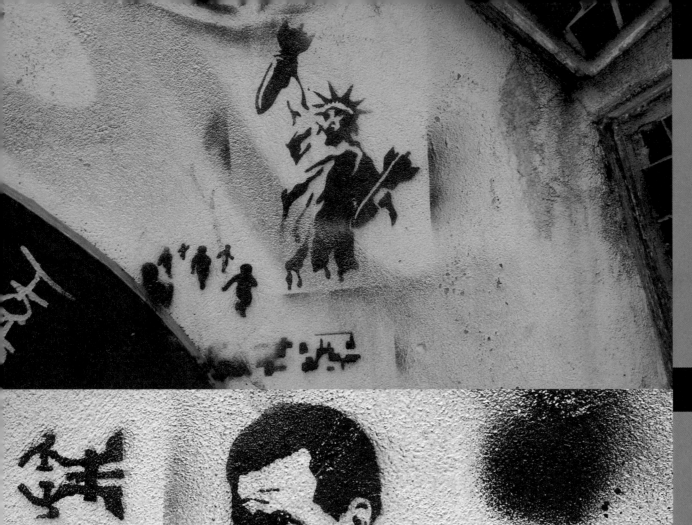

LONDON / ENGLAND

STENCIL ON CONCRETE
ARTIST: UNKNOWN

JAN 13, 2006

The Statue of Liberty is here turning on, and about to bomb, its own citizens. The running figures echo those of office workers fleeing the Twin Towers on 9/11. The suggestion is that Bush has brought the War (and the loss of liberty) to the American people. This is clearly a European design – the word 'fascist' is the standard short-hand insult on the UK side of the Pond.

LONDON/ ENGLAND

SPRAY PAINT ON BUS LANE
ARTIST: UNKNOWN

MAY 29, 2005

The artist uses this bus lane as the perfect public canvas, getting his message across and making the transport authority look faintly ridiculous for leaving a nice fat space for the H on the right. There is a further twist of legitimacy to the graffito – London's mayor, Ken Livingstone, is one of the most anti-Bush politicians in the West. This motif has been copied on stop signs all over the world: Toronto, Vancouver, San Diego and Hong Kong to name a few.

BRIGHTON / ENGLAND

SPRAY PAINT ON STUCCO
ARTIST: UNKNOWN

APRIL 2, 2003

Donald Rumsfeld's time as US Defense Secretary was characterized by snappy, slightly understated phrases which through over-use turned into cliches. 'Regime Change' was one. Here it is conjoined with another cliche – 'Charity Begins at Home' – to suggest Blair should have been deposed. Its effectiveness lies in the irony of appropriating US language to a UK situation – something Blair was rather prone to

BRIGHTON / ENGLAND

TOP: STENCIL ON STUCCO
ARTIST: UNKNOWN
BOTTOM: SPRAY PAINT ON TERRAZO
ARTIST: UNKNOWN

APRIL 5, 2003 and NOV 27, 2005

Infantilization is a standard way of highlighting the idiocy of the War. This is contrasted with palpable anger on another wall in Brighton, a town with a strong counter-cultural and anti-Establishment streak.

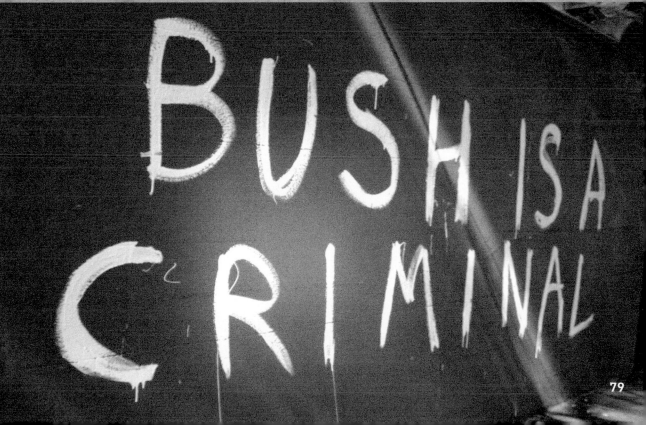

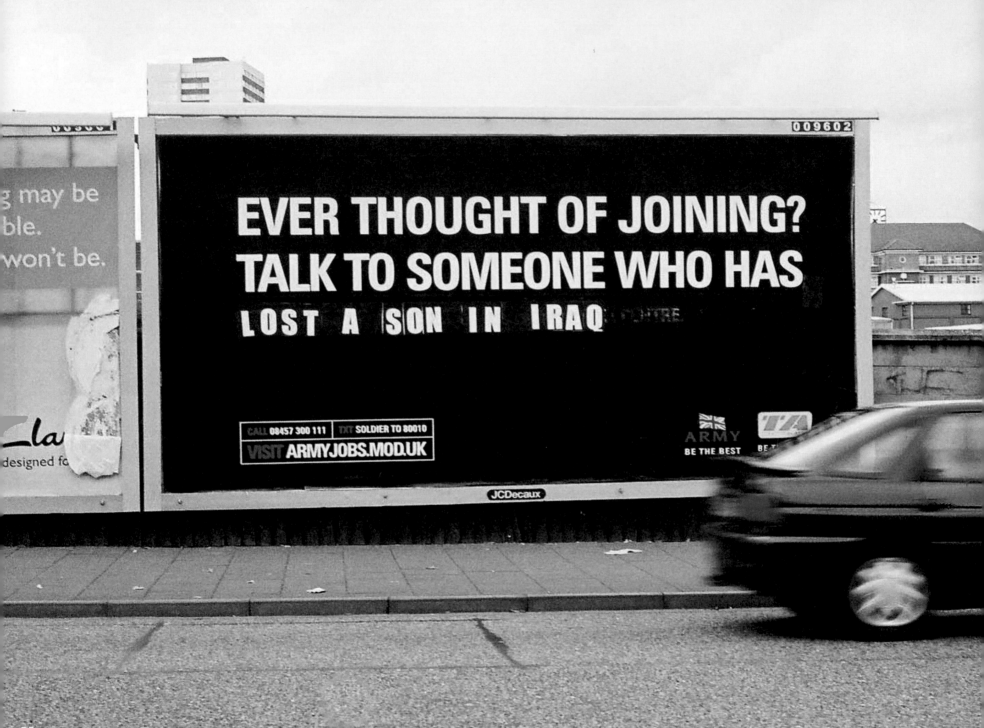

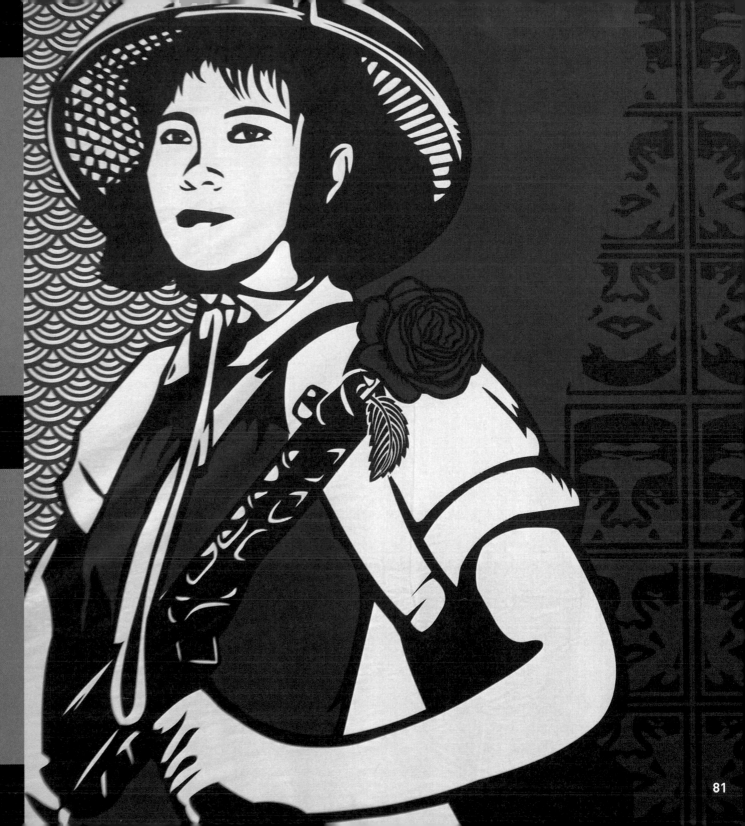

NEWCASTLE / ENGLAND

PASTE-UP ON BILLBOARD
ARTIST: UNKNOWN

OCT 9, 2006

The army is a major advertiser in the UK; the ads come out when recruitment, usually during wartime, goes down. In its campaigns, the army never wants anyone to think about the raw reality of killing or death; this one gives it to you straight. The fatuousness of the copy line 'ever thought of joining?' is used to brilliant advantage. The impact couldn't be more effective: using an Establishment method of influence and control – advertising – as a mechanism for street action.

→

NEWCASTLE / ENGLAND

QUAYSIDE BANNER
ARTIST: SHEPARD FAIREY

OCT 19, 2006

Shepard Fairey's work is more directly political than many others'. He captures perfectly the totalitarianism of the War on Terror. This imagery borrows heavily from posters from Mao's cultural revolution. The 'Obey' figure first appeared in the streets of Manhattan when the Neo-Cons got into power. It has grown from a 2" sticker to the massive banners seen here.

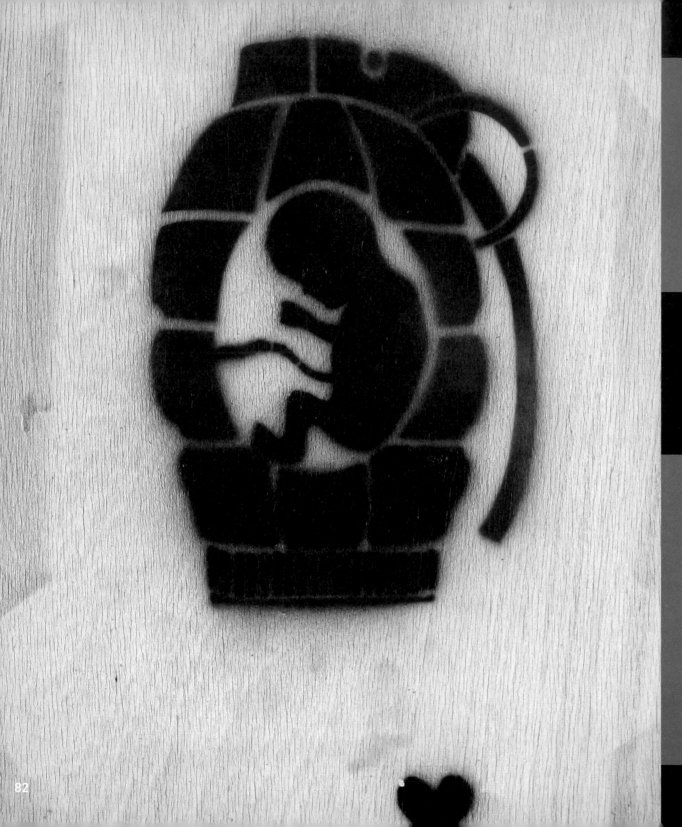

←

IPSWICH / ENGLAND

STENCIL ON WOOD PANEL
ARTIST: ASBO

APRIL 2, 2006

ASBO titled this piece 'Explosive Birth'.
The comment is both that the coming
generation will be one born in a state
of war and that current wars will beget
future wars.

→

CORK / IRELAND

STENCIL ON CONCRETE
ARTIST: UNKNOWN

JUNE 6, 2006

George Bush is portrayed in US Army
fatigues, committing suicide. The image
suggests that the War is ultimately
self-destructive, tantamount to suicide.
The message is a comment on moral
equivalence between the terrorists and
the Bush policy in Iraq. The link between
the two is linguistic – if Bush's policy
is a War on Terror then he is in effect
terrorizing himself.

WAR IS TERRORISM

83

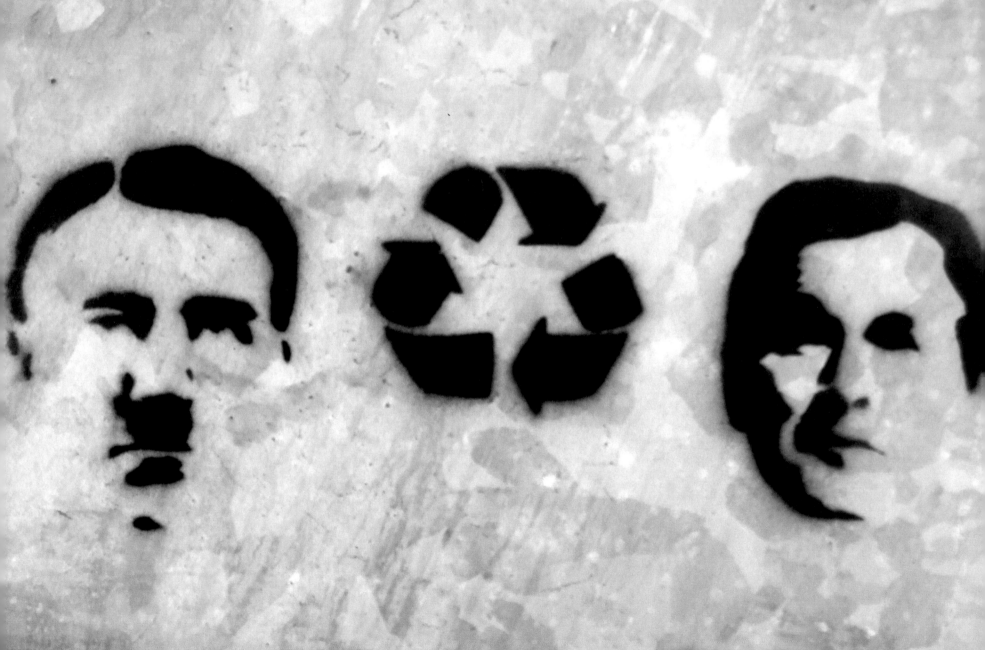

← **CORK / IRELAND**

STENCIL ON METAL
ARTIST: UNKNOWN

JUNE 8, 2006

A witty use of the now ubiquitous recycling symbol: Hitler recycled into Bush. The comment is a simple one about tyranny. In domestic politics Hitler, the National Socialist, and Bush, the Republican, couldn't be further apart. On foreign policy both used war as a way of advancing their interests. The suggestion of moral equivalence is designed to shock and amuse.

→ **GLASGOW / SCOTLAND**

STENCIL ON WOOD
ARTIST: UNKNOWN

JUNE 1, 2005

The vampiric sense of dripping blood perhaps suggests that Bush deserves a slaughterhouse end.

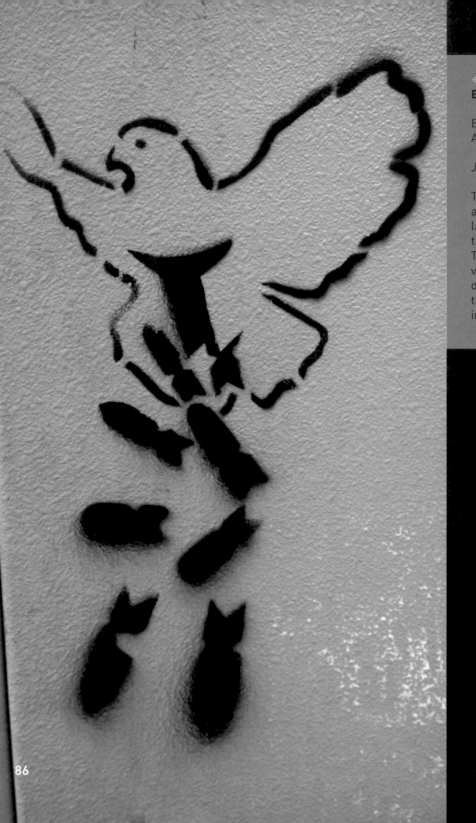

BERLIN / GERMANY

BLACK STENCIL ON PAINTED METAL
ARTIST: UNKNOWN

JAN 31, 2007

The dove of peace dropping bombs,
a comment on the West's pious PR
language over the Iraq War, when
the real intent is military domination.
There is a depressing sense of déjà
vu about this image – almost as if no
one can believe any longer in anything
that politicians say. The image is more
impactful for having no comment.

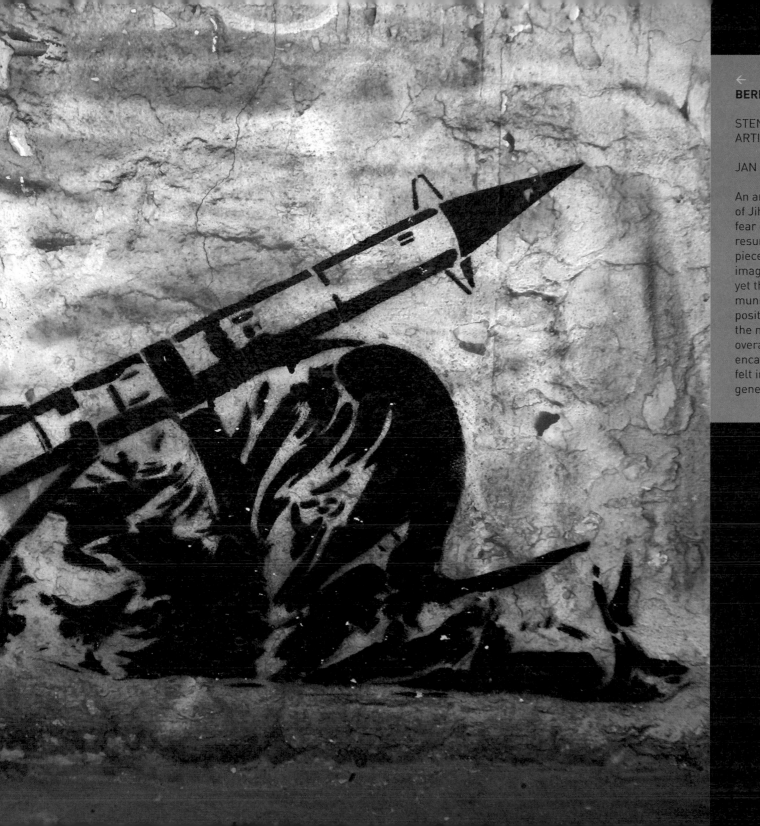

STENCIL ON SILVER-PRIMED STUCCO
ARTIST: DOLK

JAN 30, 2007

An amazing iconographic representation of Jihad by Dolk, encapsulating Western fear of the religious fervor underlying a resurgent Islamic world. Like all of Dolk's pieces there is a complex layering to the image. The figure is entirely traditional, yet the missile is a modern SAM-style munition: this is a real threat. If the position of the figure is facing East, then the missile is clearly facing the West. The overall impact is one which brilliantly encapsulates the intense, furious anger felt in the Middle East at Western policy in general, not just policy in Iraq.

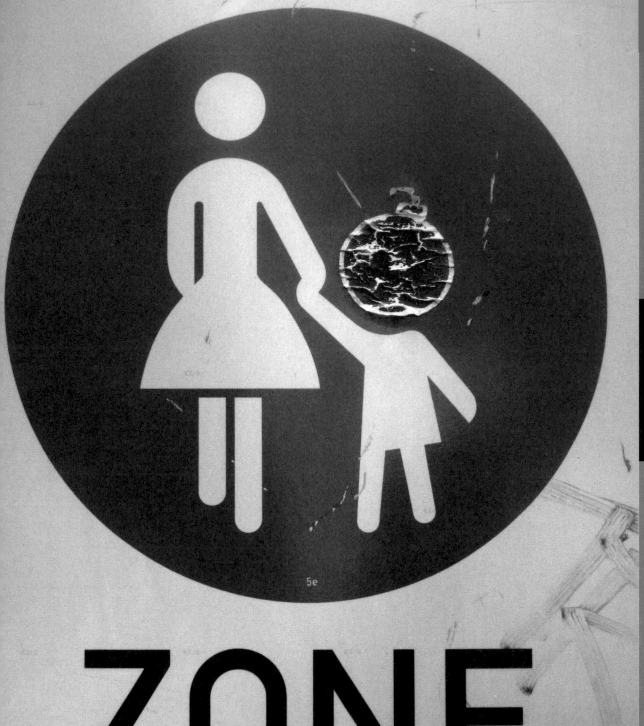

ZONE

88

←

MUNICH / GERMANY

STICKER ON ROAD SIGN
ARTIST: UNKNOWN

JULY 27, 2005

A classic use of street furniture. The
effect suggests that it is the next
generation who will reap the violence
instigated by the War on Terror. The bomb
is the standard kid's cartoon, smoking
fuse, retro type.

→

BERLIN / GERMANY
TACHELES
STENCIL ON SANDSTONE
ARTIST: UNKNOWN

JAN 28, 2007

The imagery of the Holocaust – which in
Germany is particularly shocking – used
to highlight the suffering caused by the
War. The image asks the question, why
does the West spend so many billions
of dollars on conducting wars, when
millions around the world are dying of
hunger? The linking of these issues is
relatively rare.

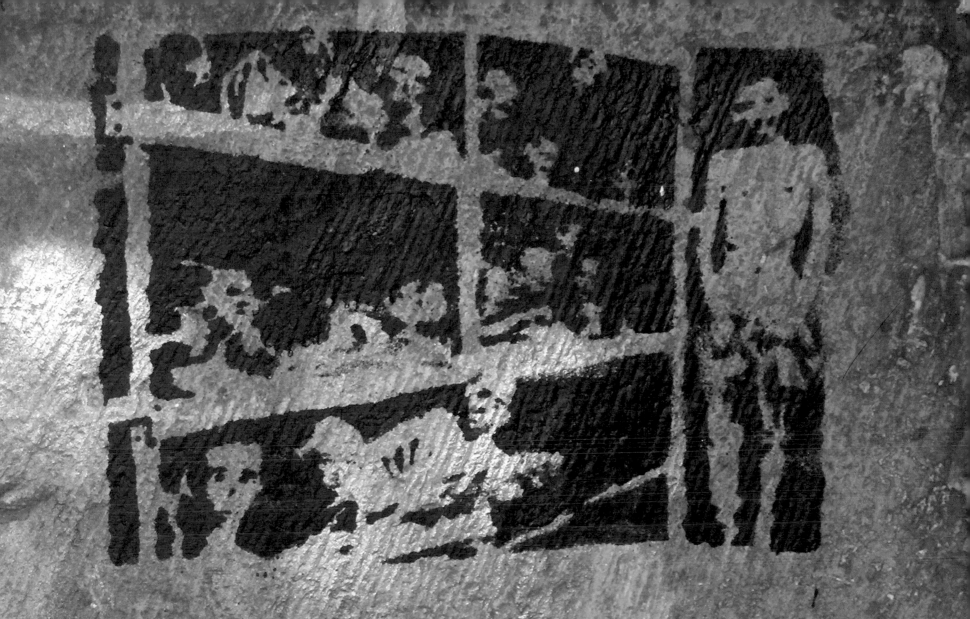

FOOD NOT
BOMBS

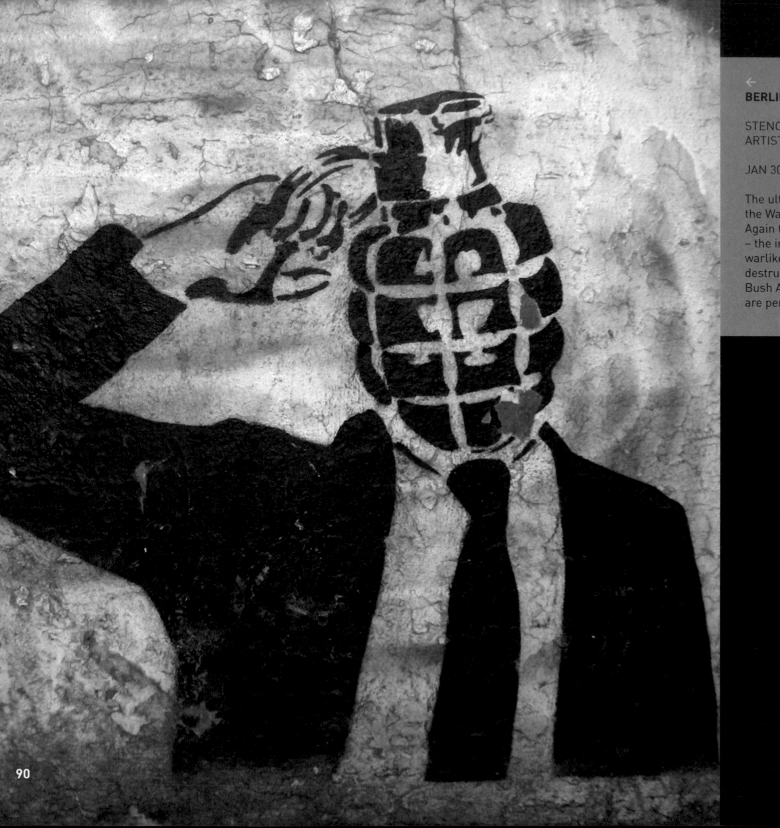

BERLIN / GERMANY

STENCIL ON SILVER-PRIMED BRICK
ARTIST: DOLK

JAN 30, 2007

The ultimately self-destructive effect of the War is brilliantly captured by Dolk. Again there are several meanings to this – the image is a play on warhead; think in warlike ways and you will reap your own destruction. Even if dressed in suits, the Bush Administration's war-like intentions are perfectly clear.

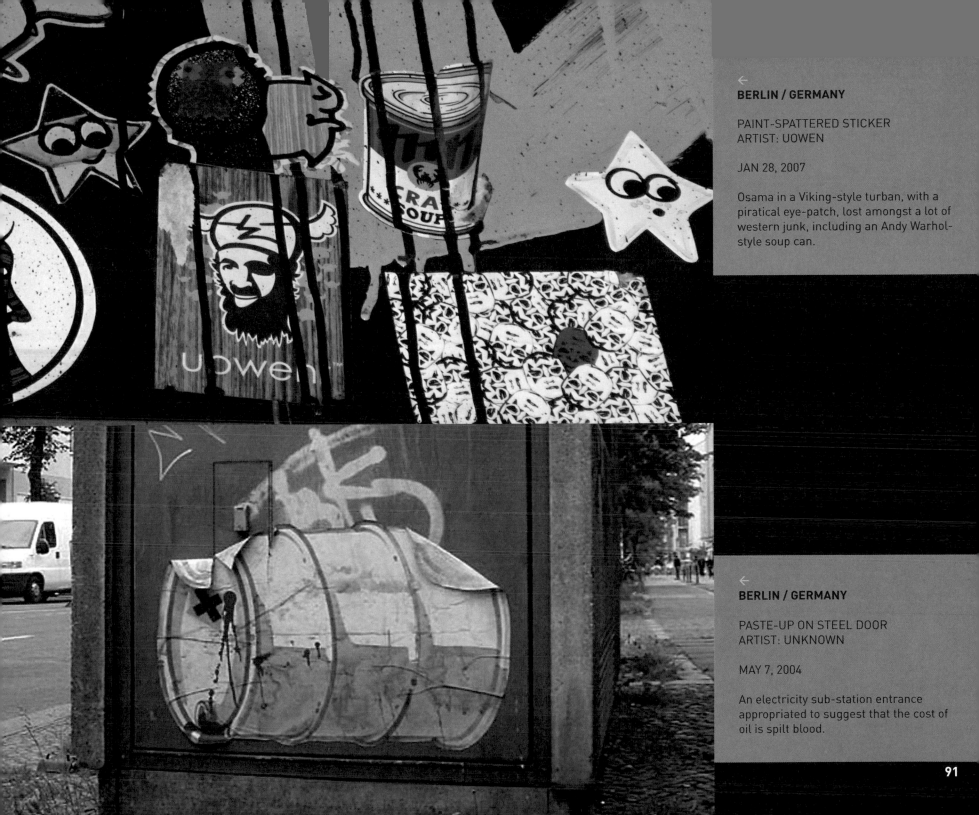

BERLIN / GERMANY

PAINT-SPATTERED STICKER
ARTIST: UOWEN

JAN 28, 2007

Osama in a Viking-style turban, with a
piratical eye-patch, lost amongst a lot of
western junk, including an Andy Warhol-
style soup can.

BERLIN / GERMANY

PASTE-UP ON STEEL DOOR
ARTIST: UNKNOWN

MAY 7, 2004

An electricity sub-station entrance
appropriated to suggest that the cost of
oil is spilt blood.

STENCIL ON CONCRETE
ARTIST: UNKNOWN

APRIL 15, 2005

The message is straightforward. There is a call to assassinate Bush, with a target specified for the bullet. Blair was more often named a liar than Bush, as in 'Bliar'.

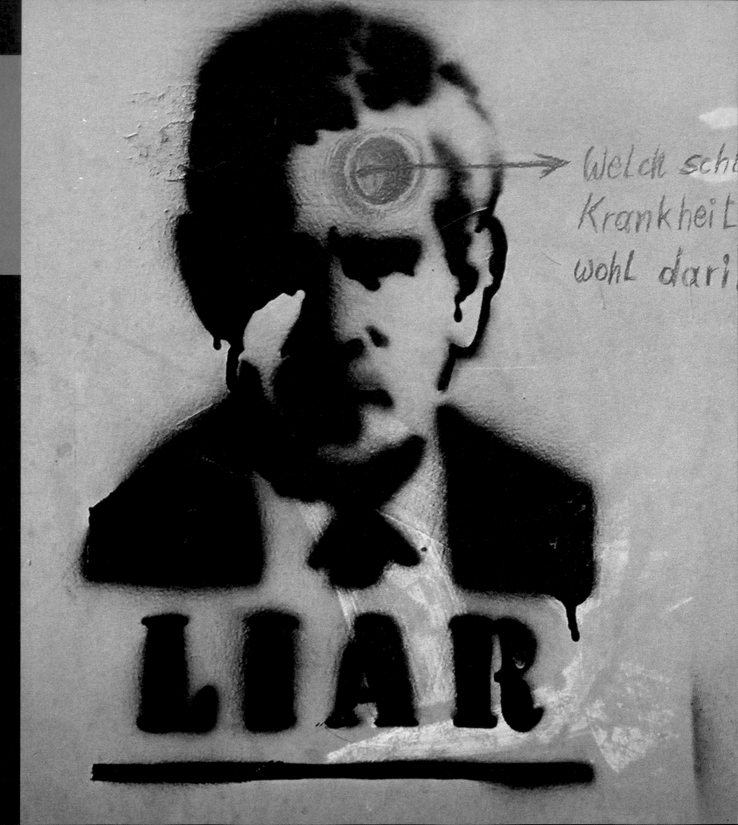

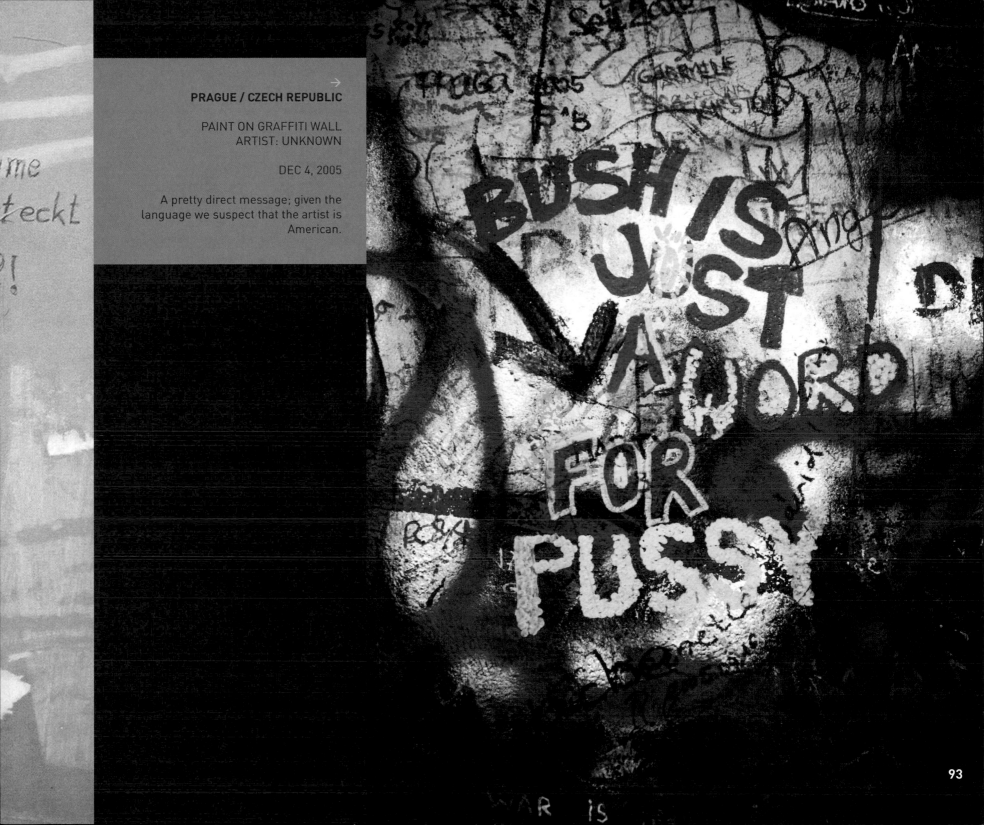

PRAGUE / CZECH REPUBLIC

PAINT ON GRAFFITI WALL
ARTIST: UNKNOWN

DEC 4, 2005

A pretty direct message; given the
language we suspect that the artist is
American.

93

TOUT LE MONDE
A UNE ARME
TO FIGHT
YOU WITH.

PARIS / FRANCE

STICKER ON STREET LAMP
ARTIST: UNKNOWN

MARCH 27, 2007

An unusual juxtaposition of French and
English. The message could be from an
anti-American extremist, suggesting that
there is an embedded fundamentalist
Muslim army willing to take the War to
the US in every Western city.

PARIS / FRANCE

STICKER ON GLASS
ARTIST: TRIP

MARCH 26, 2007

'On the walls I declare my opposition';
Trip is making the point that the only
recourse, given the democratic deficit
in both the UK and US, is to take to the
streets to say NO to the War. The French
government opposed the war, yet even in
Paris anger at US/UK actions was strong
enough to elicit this response.

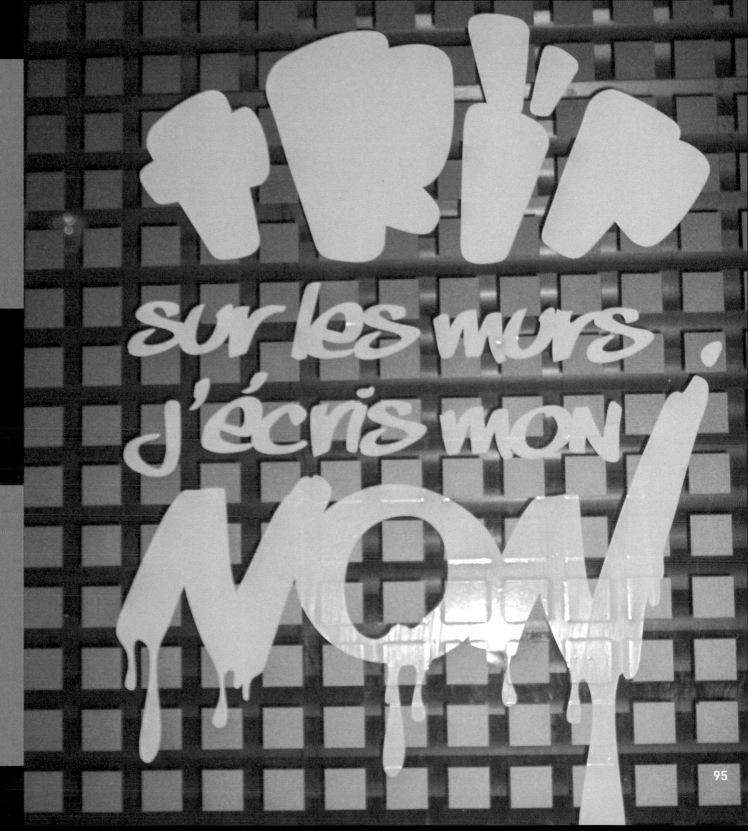

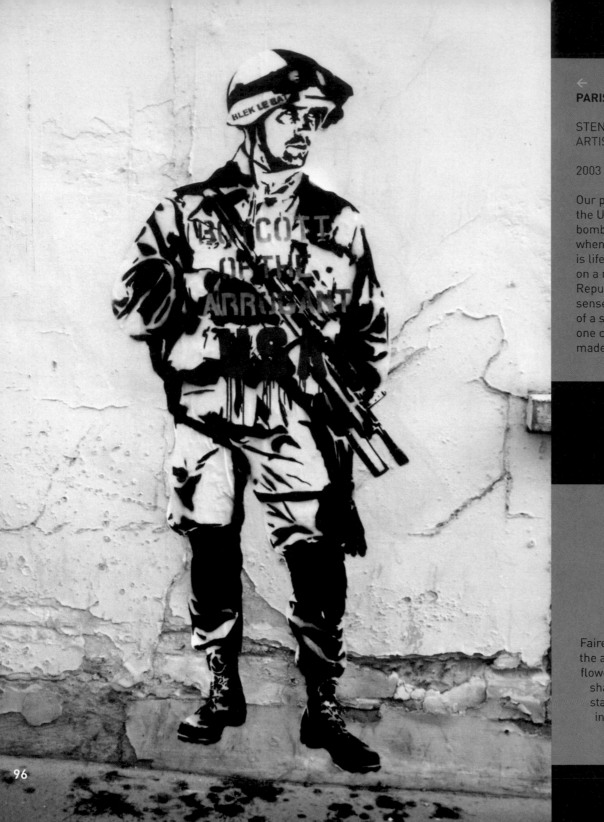

← PARIS / FRANCE

STENCIL ON RENDERED WALL
ARTIST: BLEK LE RAT

2003

Our photographer took this shot the day the US Government dropped the first bombs on Iraq; the paint was still wet when she came across it. The artwork is life-size, and is eerily tucked away on a narrow street near the Place de la Republique. Blek brilliantly achieves a sense of disquiet by the strange presence of a soldier on a side street of Paris. How one can boycott the US in practice isn't made clear.

→

PARIS / FRANCE

PASTE-UP ON WOOD PANELLING
ARTIST: SHEPARD FAIREY

OCT 12, 2006

An ambiguous piece, like much of Fairey's work. A female figure inspired by the art of Mao's cultural revolution wears flowers in her hair and asks for Peace. In sharp contrast, bottom right, is Fairey's standard OBEY moniker, a comment on increasingly oppressive government in the West.

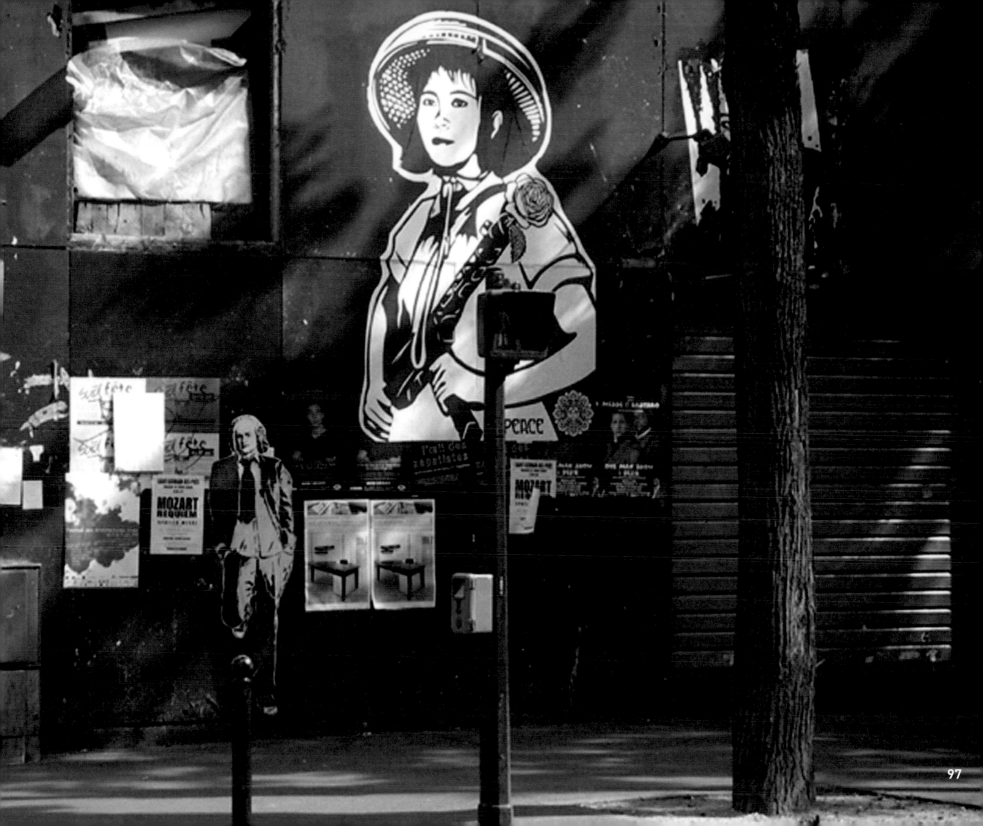

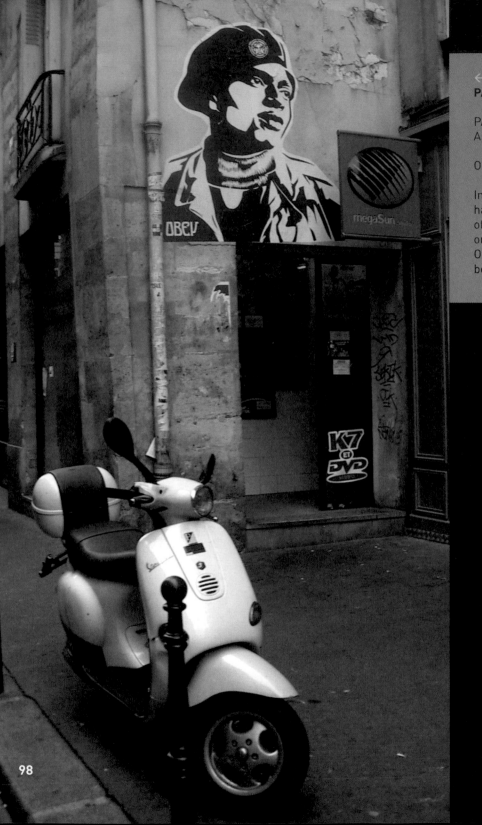

←

PARIS / FRANCE

PASTE-UP ON SANDSTONE
ARTIST: SHEPARD FAIREY

OCT 12, 2006

In the Marais district of Paris, this figure
has the aspect of a militia trooper – one
of those urban angels who will protect
one against crime. It includes Fairey's
OBEY signature and symbol (on the man's
beret).

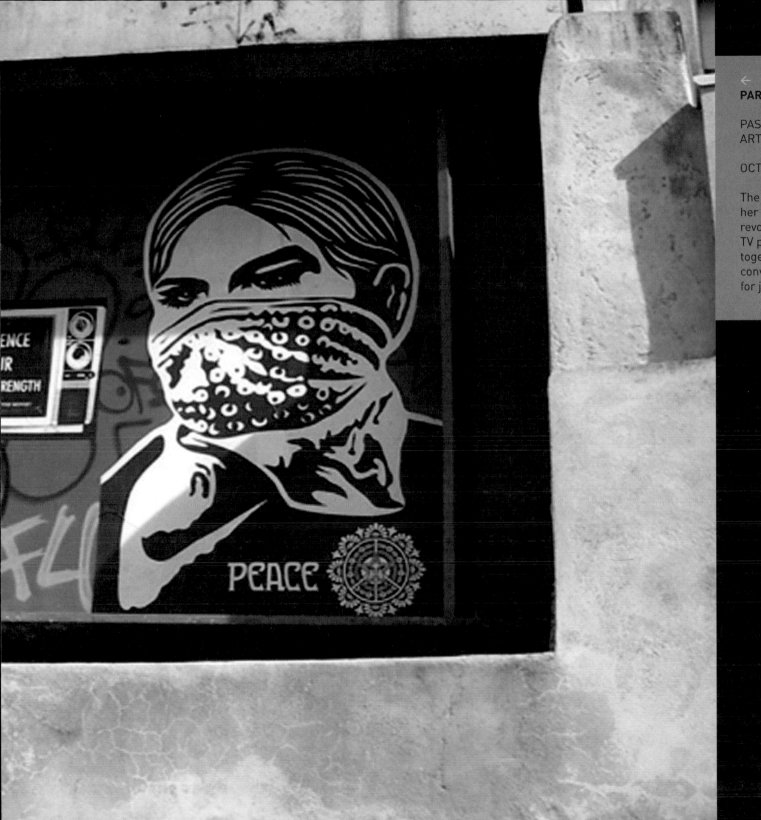

PASTE-UP ON METAL
ARTIST: SHEPARD FAIREY

OCT 12, 2006

The female figure wearing a scarf over her mouth seems to be threatening a revolution for peace. This piece and the TV paste-up next to it work really well together. They share the same mood, conveying the sense of a grass-roots fight for justice.

PEACE

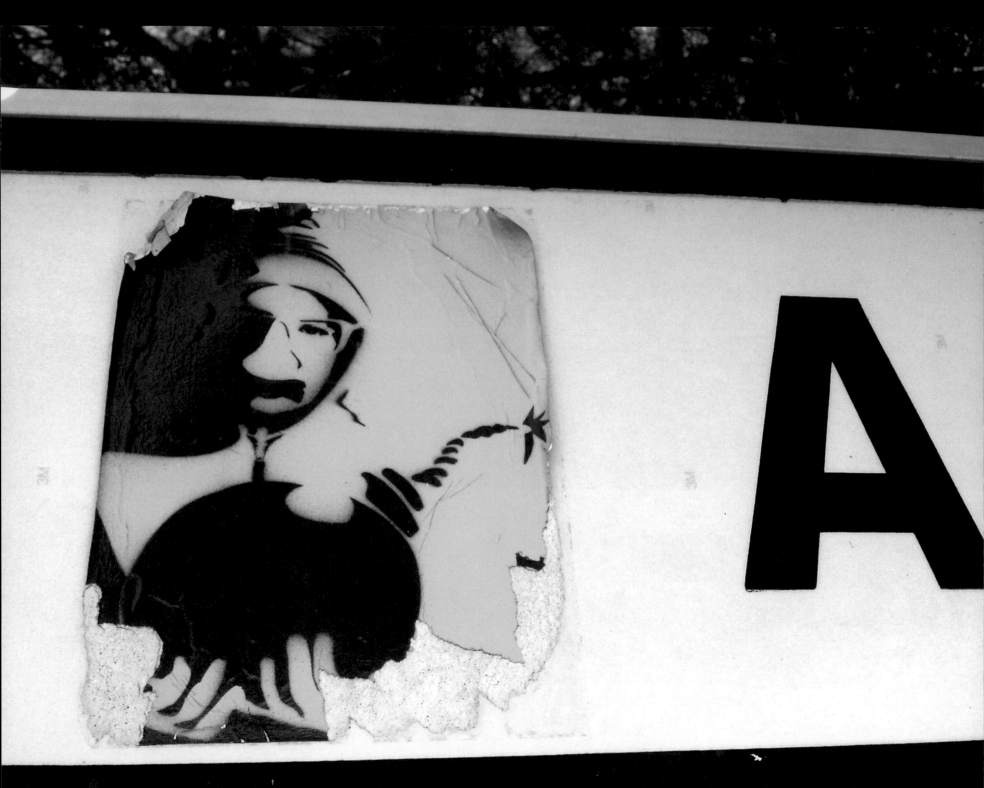

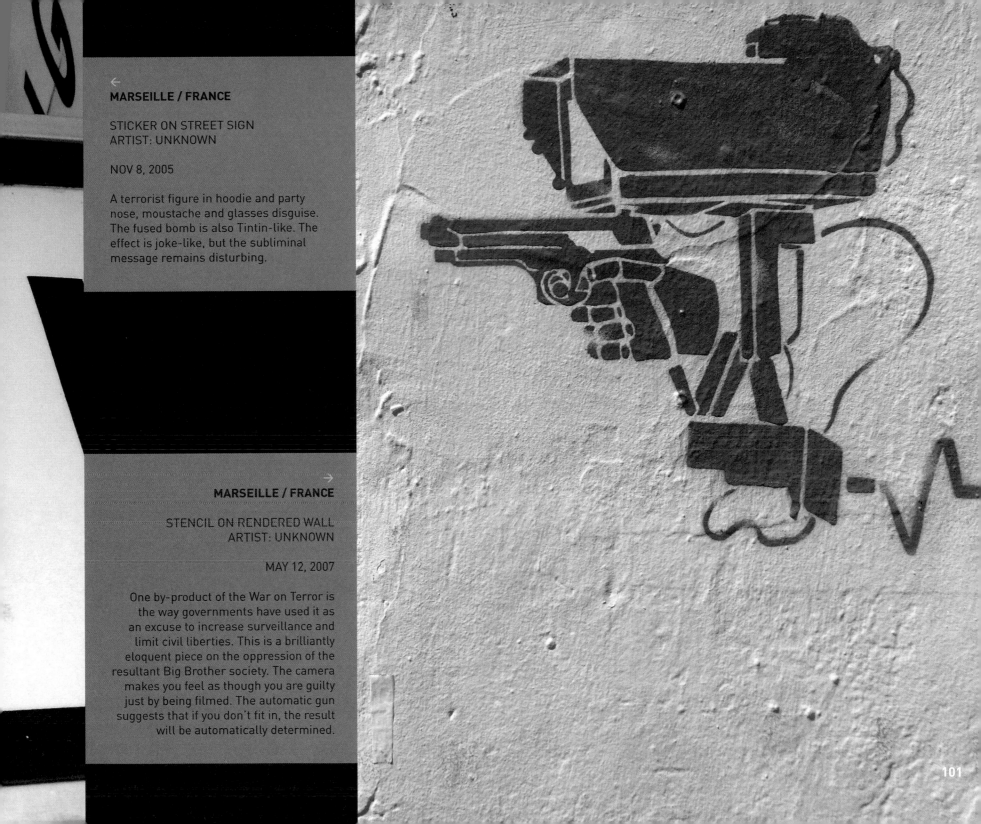

MARSEILLE / FRANCE

STICKER ON STREET SIGN
ARTIST: UNKNOWN

NOV 8, 2005

A terrorist figure in hoodie and party nose, moustache and glasses disguise. The fused bomb is also Tintin-like. The effect is joke-like, but the subliminal message remains disturbing.

MARSEILLE / FRANCE

STENCIL ON RENDERED WALL
ARTIST: UNKNOWN

MAY 12, 2007

One by-product of the War on Terror is the way governments have used it as an excuse to increase surveillance and limit civil liberties. This is a brilliantly eloquent piece on the oppression of the resultant Big Brother society. The camera makes you feel as though you are guilty just by being filmed. The automatic gun suggests that if you don't fit in, the result will be automatically determined.

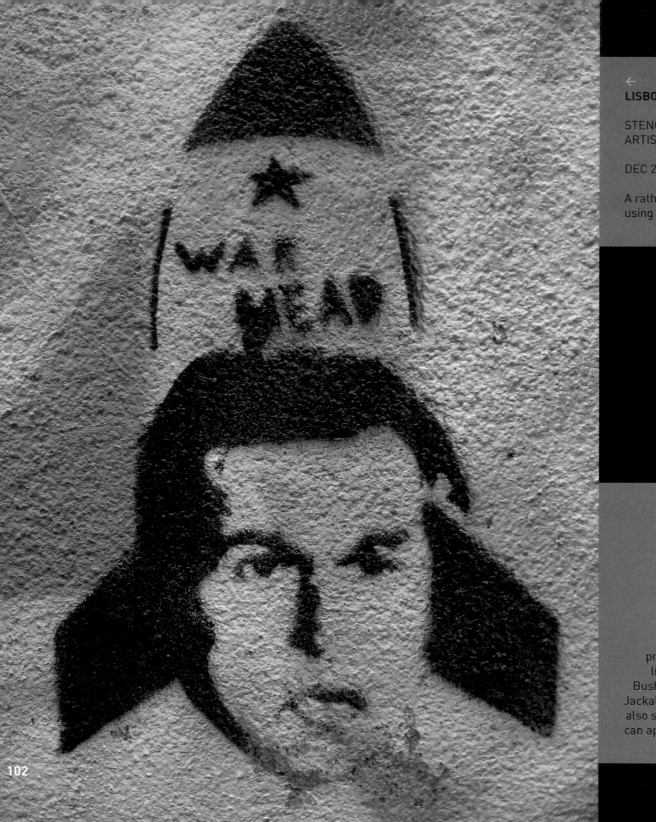

LISBON / PORTUGAL

STENCIL ON CONCRETE
ARTIST: UNKNOWN

DEC 26, 2006

A rather funny, war-obsessed Bush, using the regular 'War Head' pun.

LISBON / PORTUGAL

PASTE-UP ON DOORWAY
ARTIST: UNKNOWN

APRIL 10, 2007

Multiple Bush heads beginning with the regular corporate guy Bush and progressing to Bush with blood on his lips, Bush with a cowboy moustache, Bush as Hitler and Bush with Carlos the Jackal glasses. The effect is amusing, but also suggests the ubiquity of US power: it can appear under many guises anywhere.

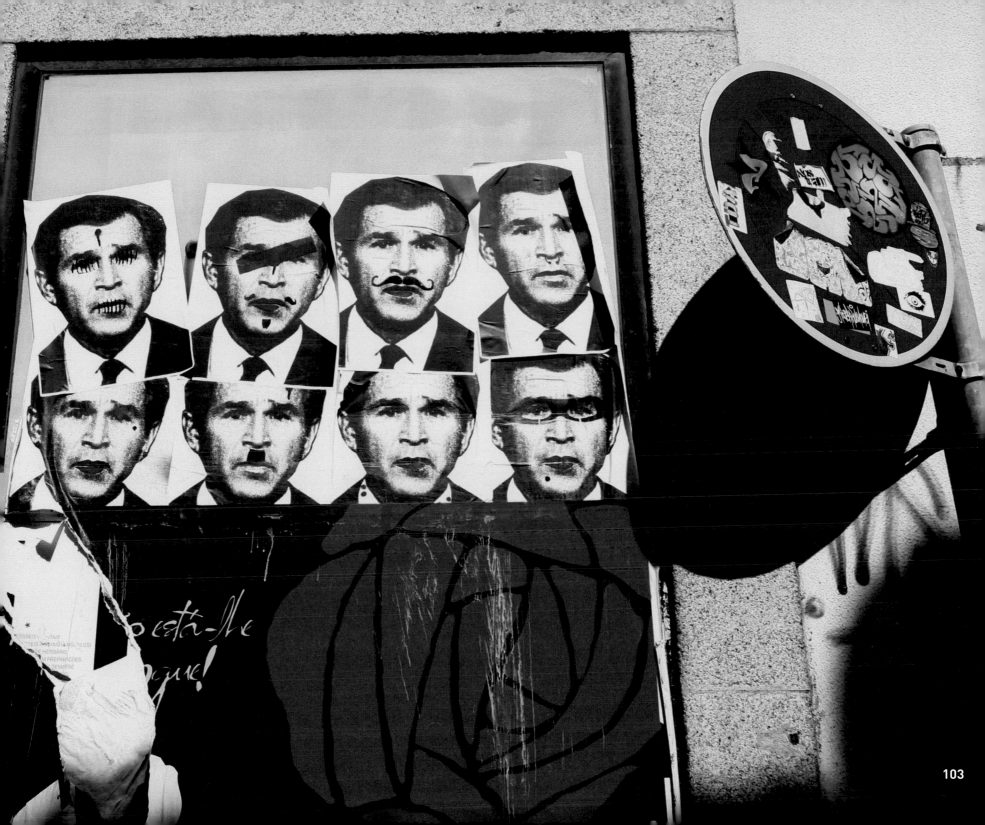

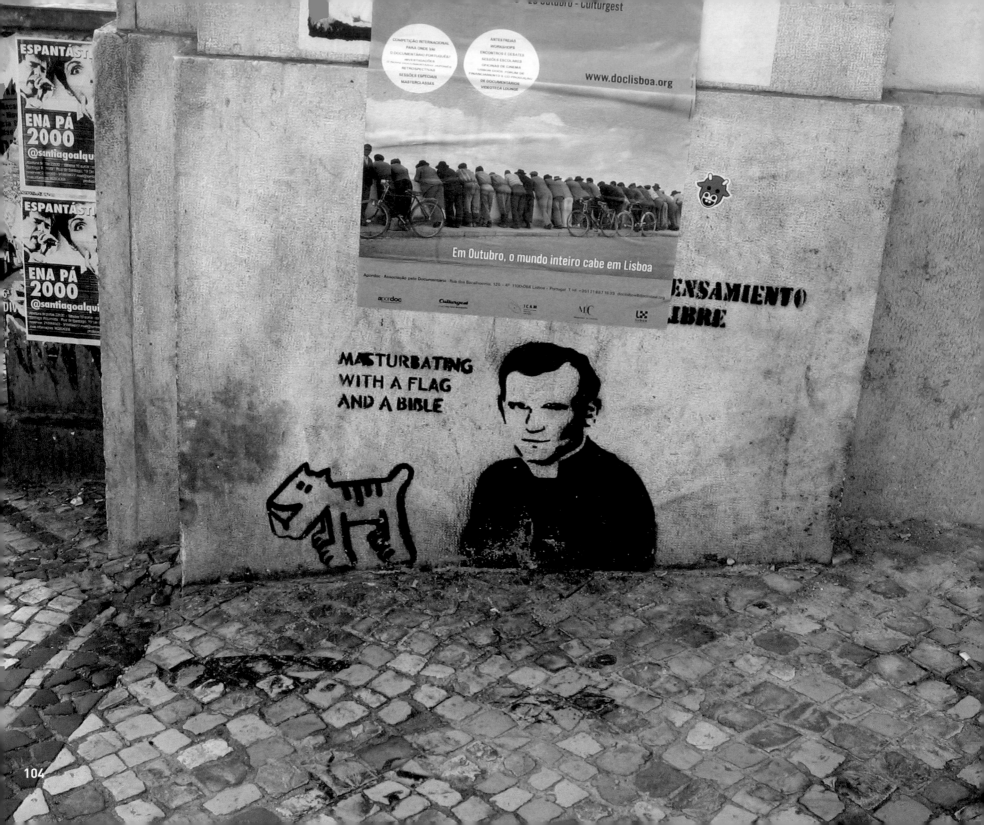

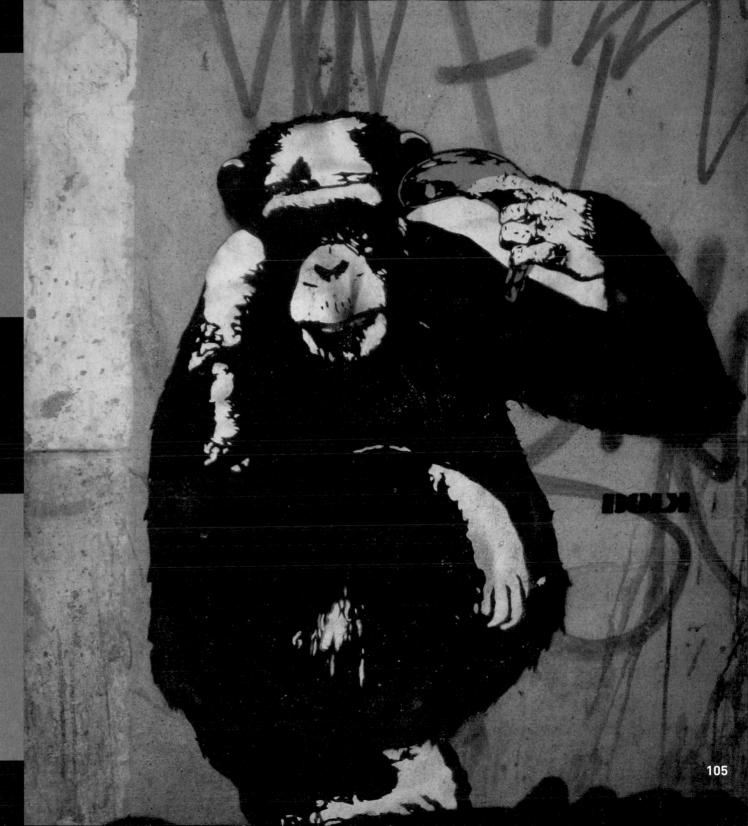

LISBON / PORTUGAL

STENCIL ON CONCRETE
ARTIST: UNKNOWN

OCT 2, 2006

Bush is dressed as a priest with a dog
collar. The simplistic tenets of Bush's
war as a great wank by the religious and
political Right is sent up. The idea of a
padre having a wank is still shocking
enough to illicit a reaction and the
suggestion of hypocrisy.

LISBON / PORTUGAL

STENCIL ON CONCRETE
ARTIST: DOLK

DEC 27, 2006

Dolk on brilliant form. The War is a
moronically self-destructive act; the
perpetrators are monkeys; they play with
their guns the way monkeys play with
bananas. This banana hangs comically
limp in the monkey's hand.

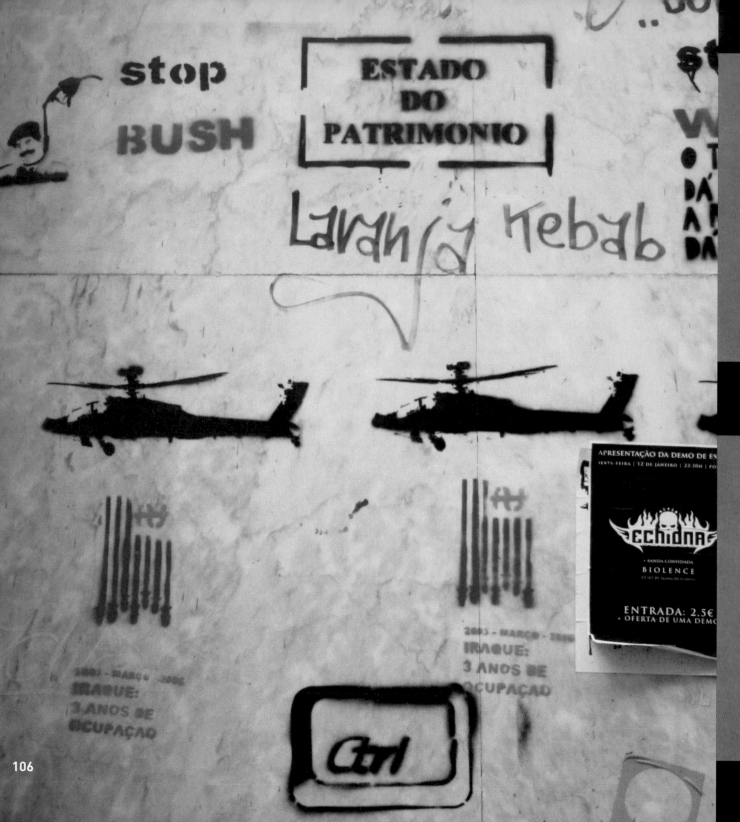

stop
BUSH

ESTADO
DO
PATRIMONIO

Laranja Kebab

2003 - MARÇO - 2006
IRAQUE:
3 ANOS DE
OCUPAÇÃO

2003 - MARÇO - 2006
IRAQUE:
3 ANOS DE
OCUPAÇÃO

Ctrl

APRESENTAÇÃO DA DEMO DE ES
SEXTA-FEIRA | 12 DE JANEIRO | 22:30H | PO

ECHIDNA

+ BANDA CONVIDADA
BIOLENCE

ENTRADA: 2.5€
+ OFERTA DE UMA DEMO

←
LISBON / PORTUGAL

STENCIL ON METAL
ARTIST/S: UNKNOWN

APRIL 10, 2007

Three stencils, perhaps by more than one artist: Saddam hanged by a gas pump pipe; the ubiquitous US helicopter gunships and the stripes of the US flag represented as daggers with the reminder that there has been 'three years of occupation'. The combined effect is strangely calm, almost analytical in its effect, and the use of dates is rare in anti-war graffiti.

→
BARCELONA / SPAIN

PHOTO COLLAGE PASTE-UP
ARTIST: UNKNOWN

APRIL 18, 2003

Aznar, the then Spanish Premier, with his War chums Tony and Dubya, taking very concentrated aim at a dove of peace. Aznar's administration was an avid supporter of the War, before being kicked out of office by the Spanish electorate on March 14, 2004. Terrorist attacks on Madrid three days earlier had killed 191. Aznar was replaced by José Luis Zapatero, whose first act as PM was to withdraw Spanish troops from Iraq.

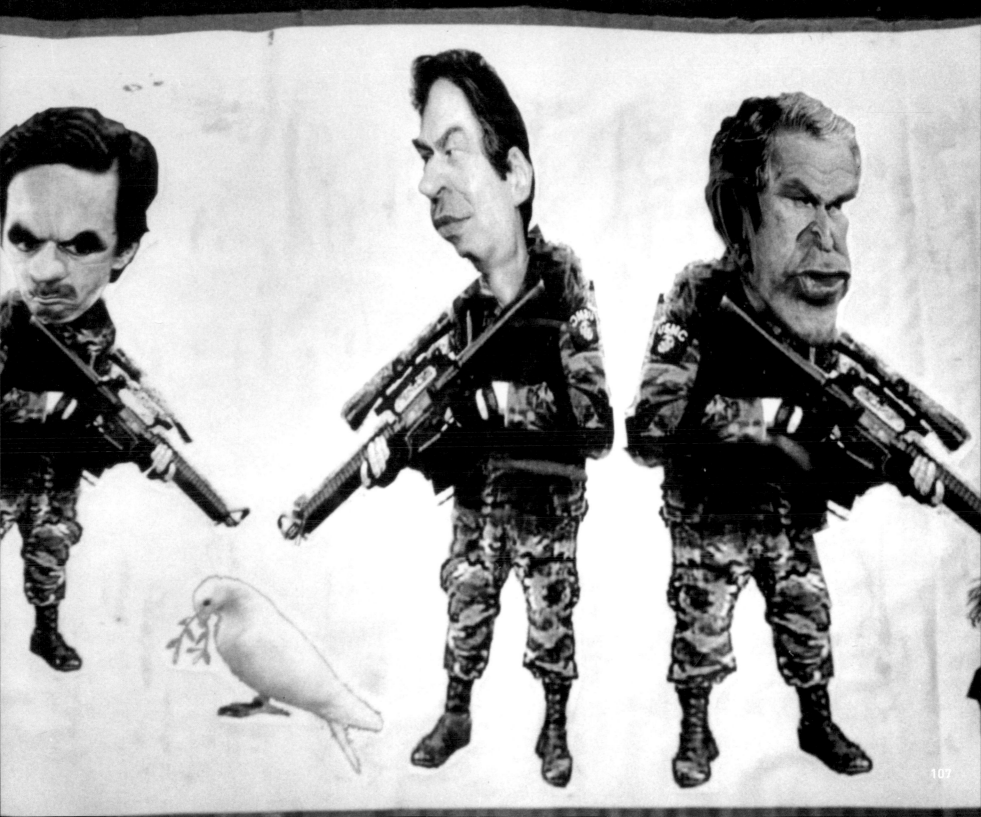

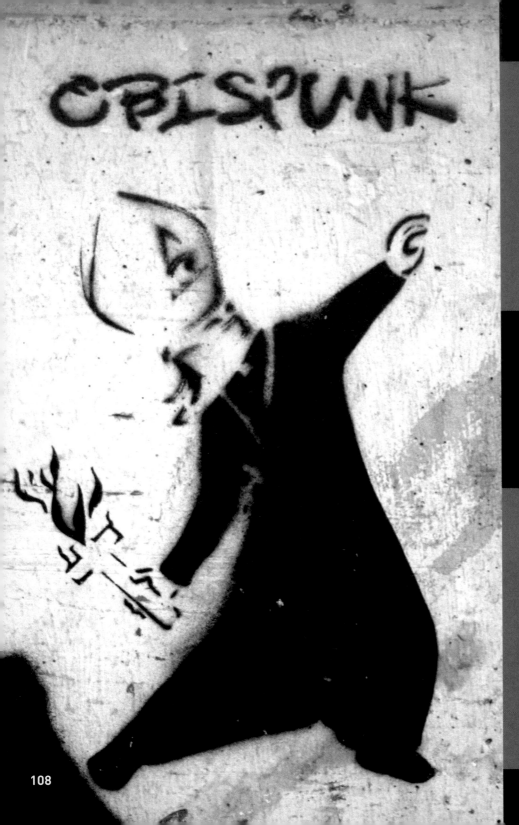

BARCELONA / SPAIN
RAVAL DISTRICT
BLACK STENCIL ON CONCRETE
ARTIST: UNKNOWN

NOV 12, 2006

A great image and a cool play on words. 'Obispo' = 'bishop' in Spanish. The flaming 'grenade' crucifix is obviously aimed at a Muslim audience, a succinct, witty comment on the West's new crusade in Iraq.

BARCELONA / SPAIN
RAVAL DISTRICT
PAINT ON BRICK
HEIGHT OF TWO STOREY HOUSE
ARTISTS: PYU, KENOR AND TOM14

JULY 4, 2006

The artists are promoting the notion of 'Calle Libre' – streets free for grass-roots expression. The layering of many artists' work is striking, each new painter respecting the last. The heart-shaped image recalls the Catholic representation of the Holy Spirit.

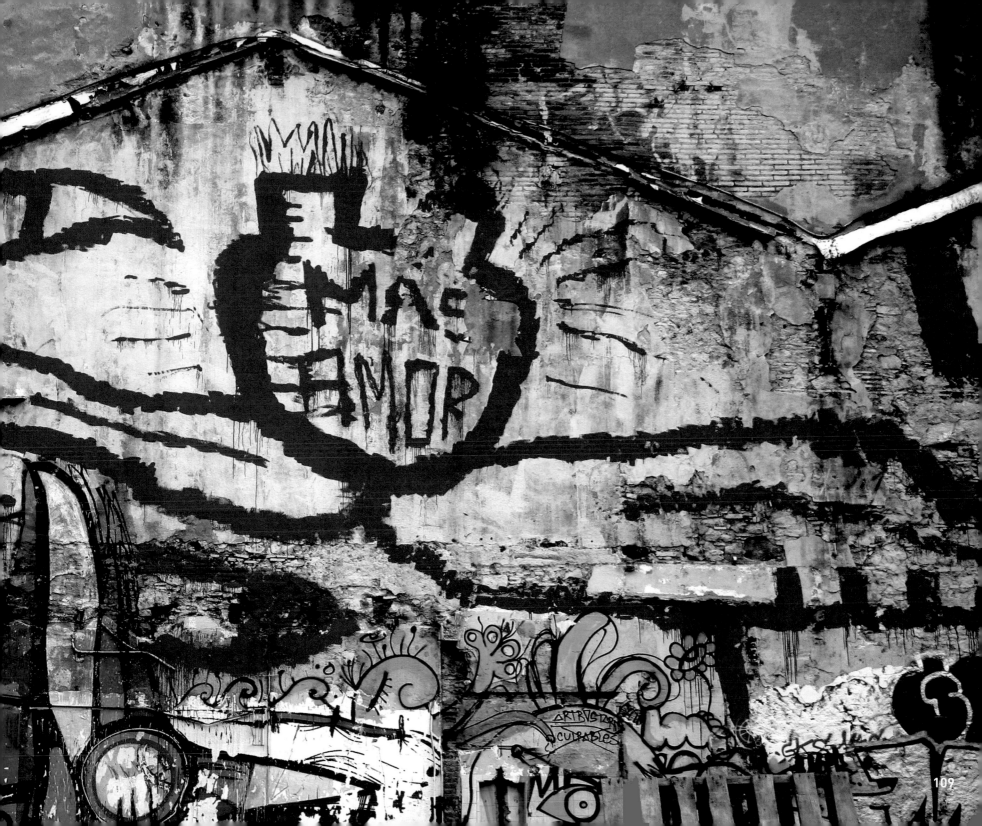

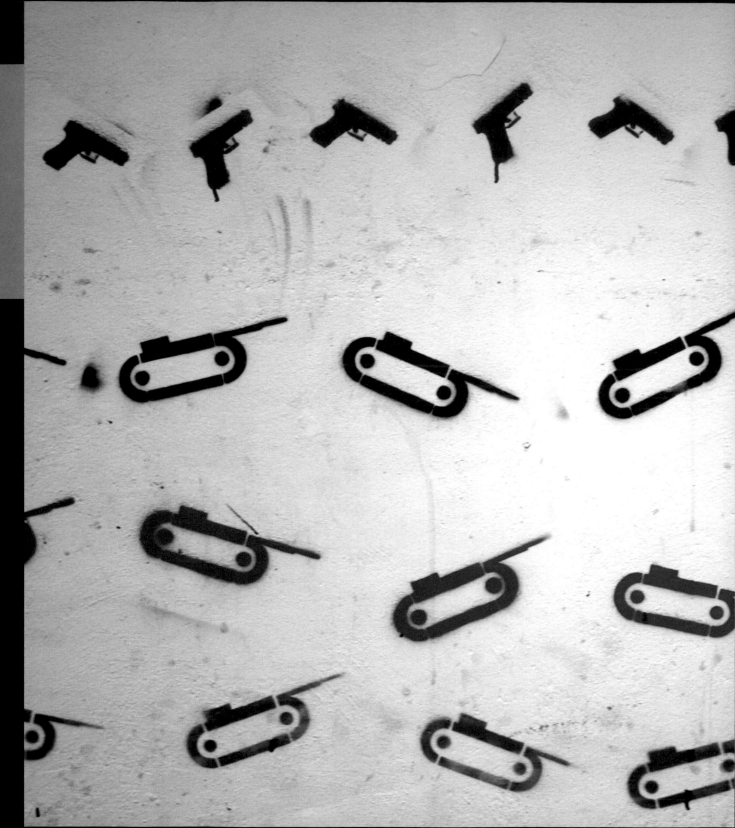

BARCELONA / SPAIN

BLACK, RED AND GREEN STENCIL ON
CONCRETE
ARTIST: UNKNOWN

NOV 12, 2006

A brilliant contrast with the child
opposite, this one turns military
weaponry into childish wallpaper;
boyz toyz – a sick joke.

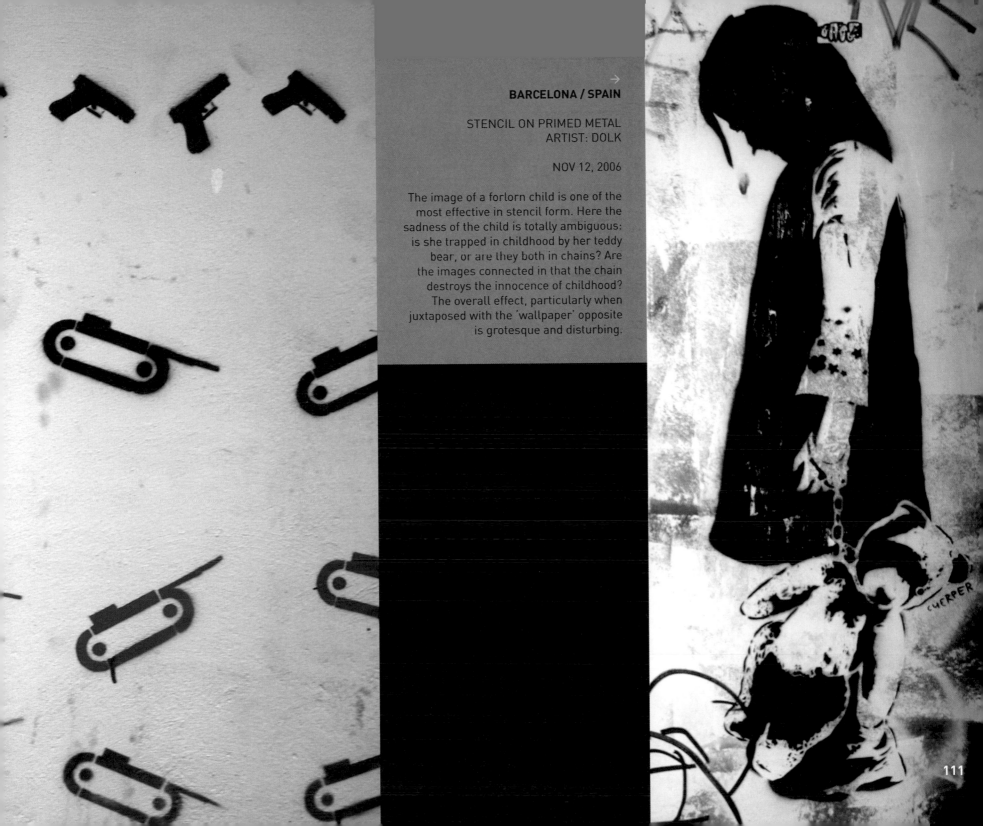

STENCIL ON PRIMED METAL
ARTIST: DOLK

NOV 12, 2006

The image of a forlorn child is one of the
most effective in stencil form. Here the
sadness of the child is totally ambiguous:
is she trapped in childhood by her teddy
bear, or are they both in chains? Are
the images connected in that the chain
destroys the innocence of childhood?
The overall effect, particularly when
juxtaposed with the 'wallpaper' opposite
is grotesque and disturbing.

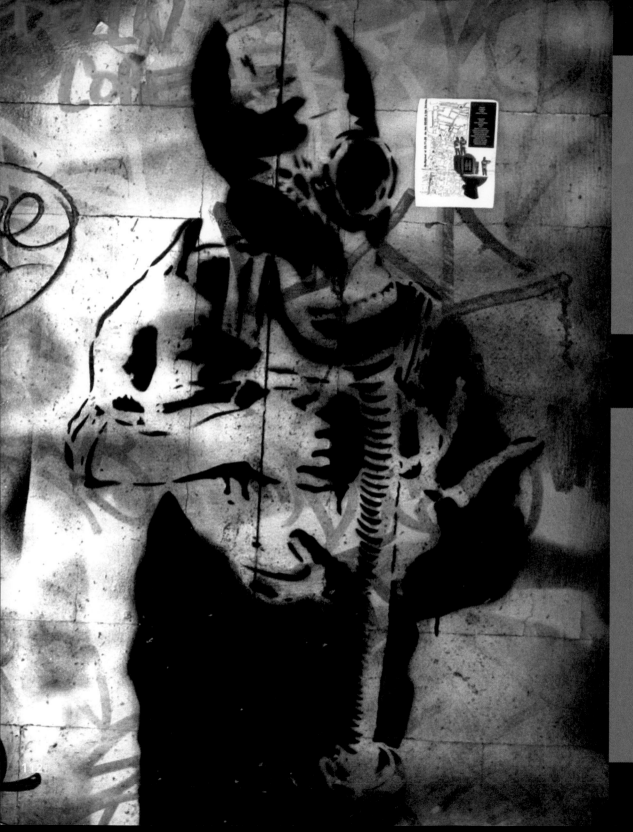

BARCELONA / SPAIN

STENCIL ON PRIMED METAL
ARTIST: DOLK

NOV 12, 2006

One of Dolk's mystery pieces. The figure
is holding the dog like a baby – a picture
of total vulnerability. He is wearing a gas
mask, yet the tube supplying oxygen is
disconnected, so that the whole thing is
pointless. Dolk seems to be getting at
the complete idiocy of creating a War on
Terror-filled world.

BARCELONA / SPAIN

STENCIL ON WOOD AND OTHER MEDIA
ARTIST: DOLK

NOV 12, 2006

A brilliantly ambiguous piece. The head
of the iron-clad figurine on the left
evokes a falcon and probably represents
the Middle East. The figure on the right is
depicted as its master – the West. They
are holding each other in an embrace,
but the West can think only of a colonial
war – represented by the hand-grenade.
There is a further twist; the suggestion
that the war is suicidal. Dolk seems to be
saying that it is the warmongers in the
West who have the death-wish, not the
al-Qaeda suicide-bombers.

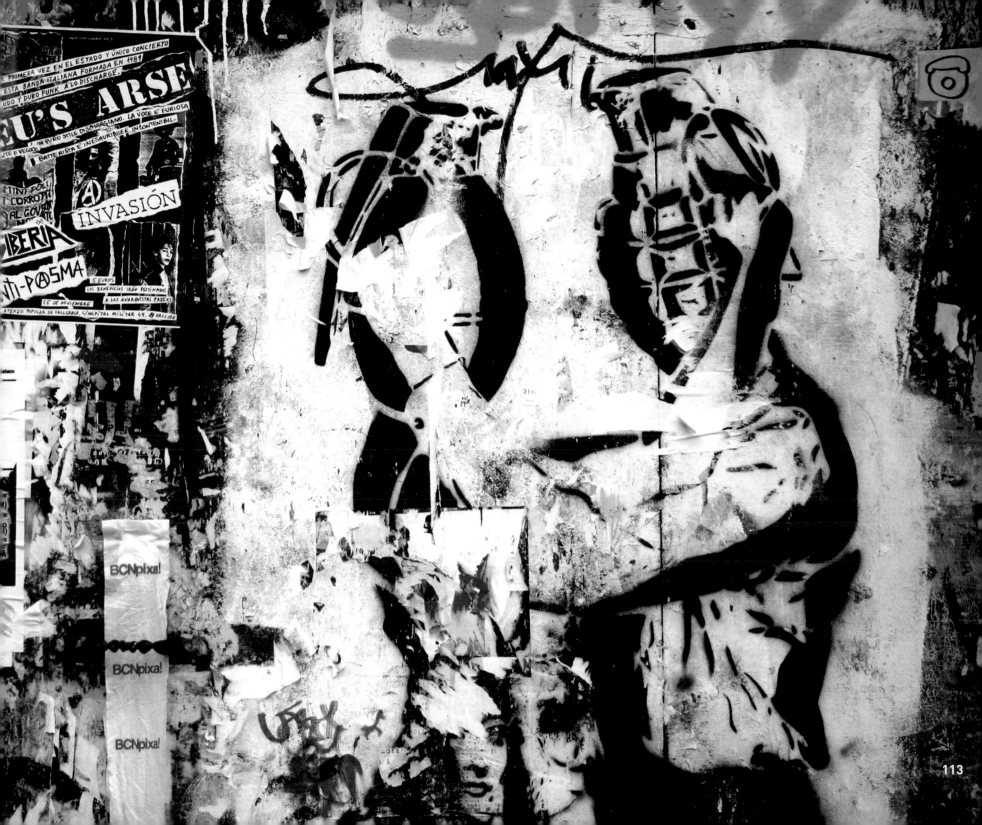

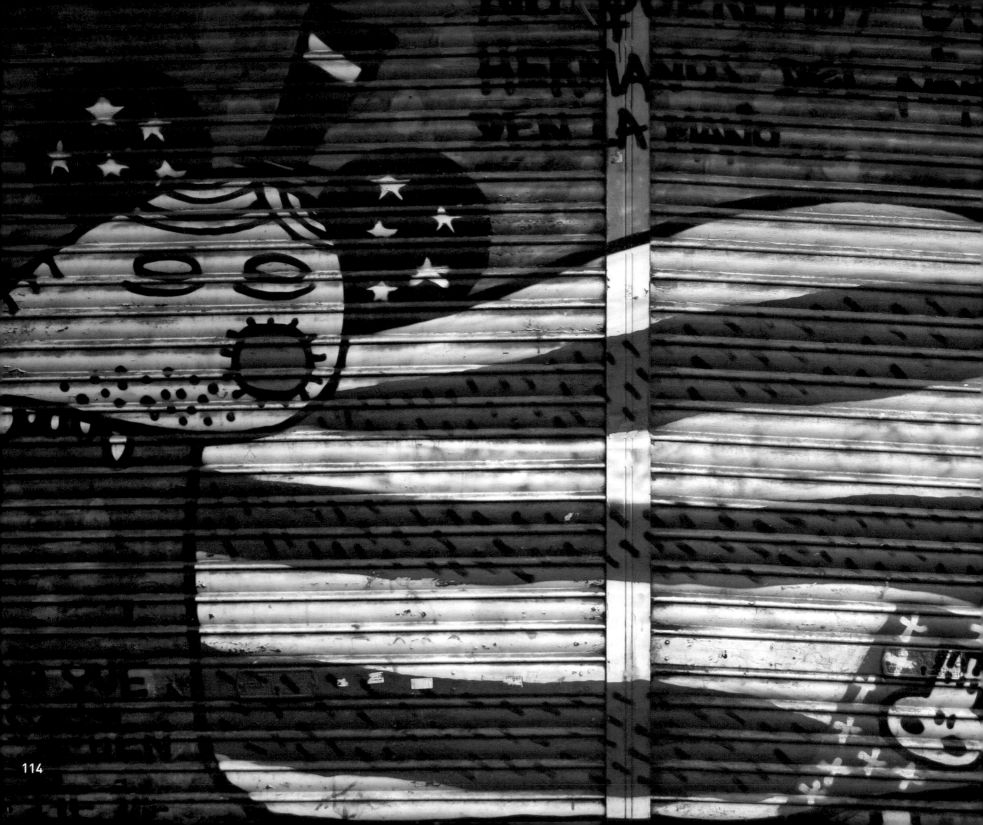

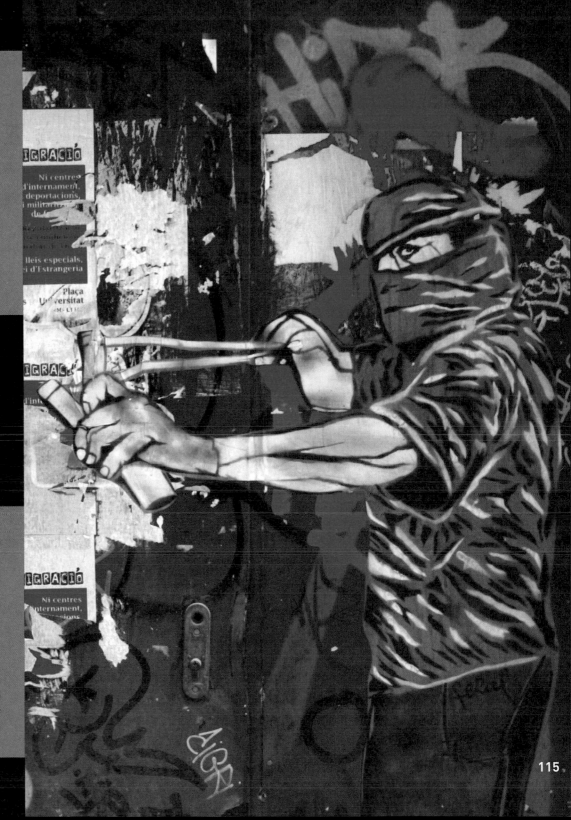

←

BARCELONA / SPAIN

SPRAY PAINT ON METAL GARAGE DOOR
ARTIST: UNKNOWN

NOV 12, 2006

A pretty in-your-face and literal reference
to US killings in the War on Terror. The
hat is Uncle Sam, the stars and stripes
speak for themselves. Possibly created by
South American artists, the slogan above
translates as 'we don't want any help
from our brothers up North'.

→

BARCELONA / SPAIN

PASTE-UP ON WOOD DOOR
ARTIST: FERAL

NOV 12, 2006

Another anti-authoritarian figure,
although in this instance the anti-
Americanism is implicit as the guy with
the catapult is wearing the standard
get-up of a typical Sandinista from the
1980s/1990s.

115

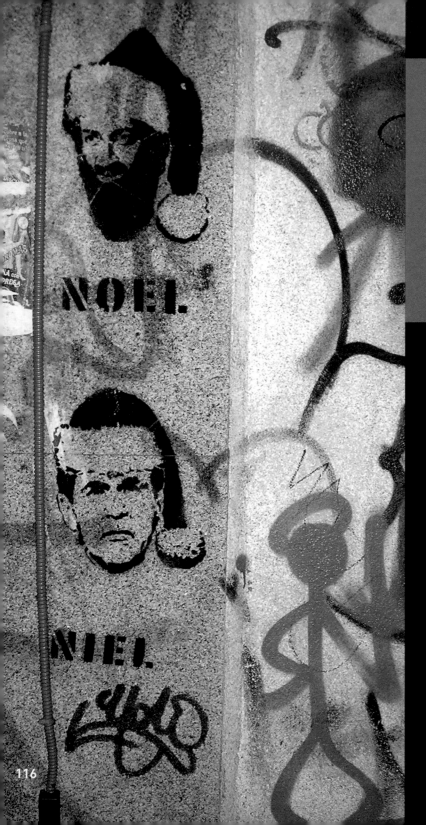

NOEL.

NIEL.

MADRID / SPAIN

STENCIL ON RENDERED WALL
ARTIST: UNKNOWN

NOV 12, 2006

A moral equivalence drawn in Spain between bin Laden and Bush. It's a brilliant play on Noel – Christmas in Spanish. No El/ Ni El translates into 'neither him, nor him'. The artist has a point: who would want either in their Christmas stocking ?

★ ★ ★ ★ ★
BUSH
HORROR

←

MADRID / SPAIN

WHITE STENCIL ON BLACK CONCRETE
ARTIST: NOAZ

APRIL 7, 2006

Unlike most street art examples, this one is totally direct and literal, but no less effective for that. The message is simply: Bush = 5-star horror. The artist succeeds in demonizing the image of the straight-talking Texan pretty effortlessly.

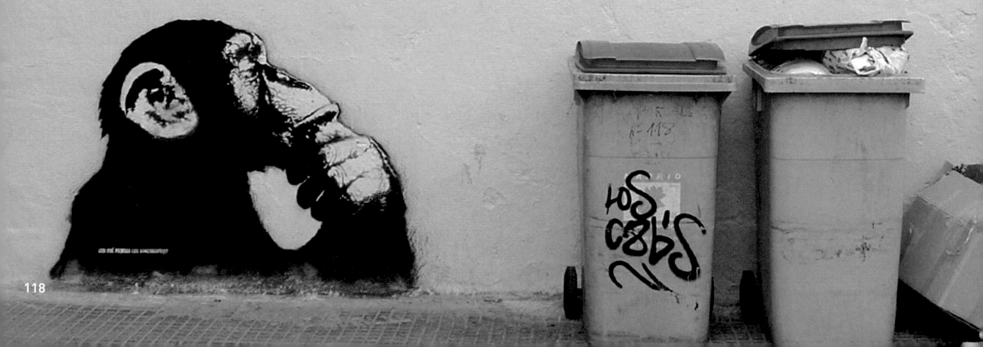

STENCIL ON CONCRETE
ARTIST: NOAZ

JAN 3, 2006

To the left the ape considers human garbage with faux philosophical intensity. Opposite is Spanish Premier, Aznar, who supported the US despite massive opposition in Spain. He gets the Mickey Mouse treatment – ridiculed as an American cartoon. Azwar is a simple play on his name – rather like the Bliar which gained currency for Blair at about the same time.

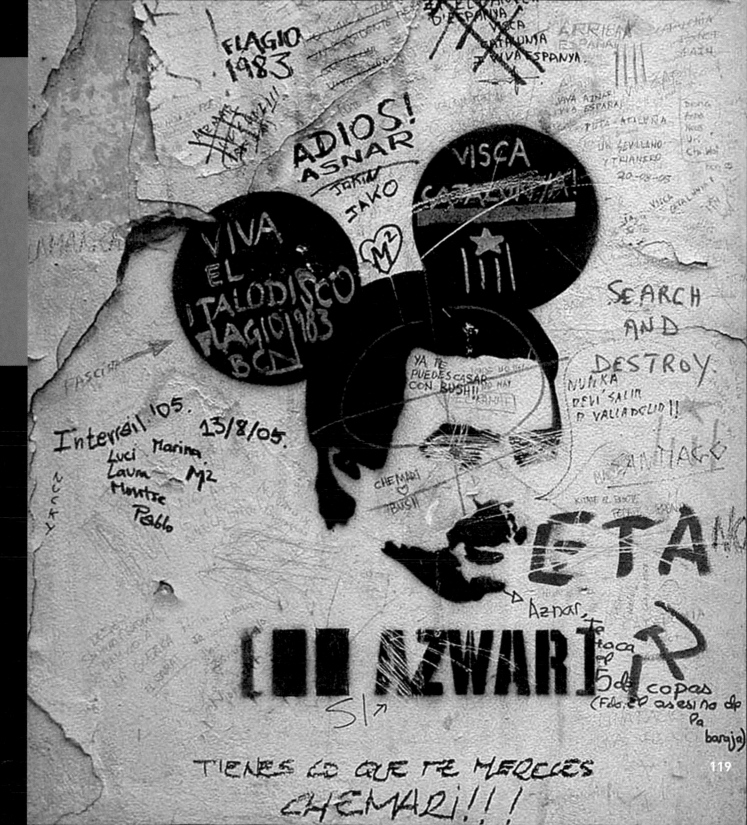

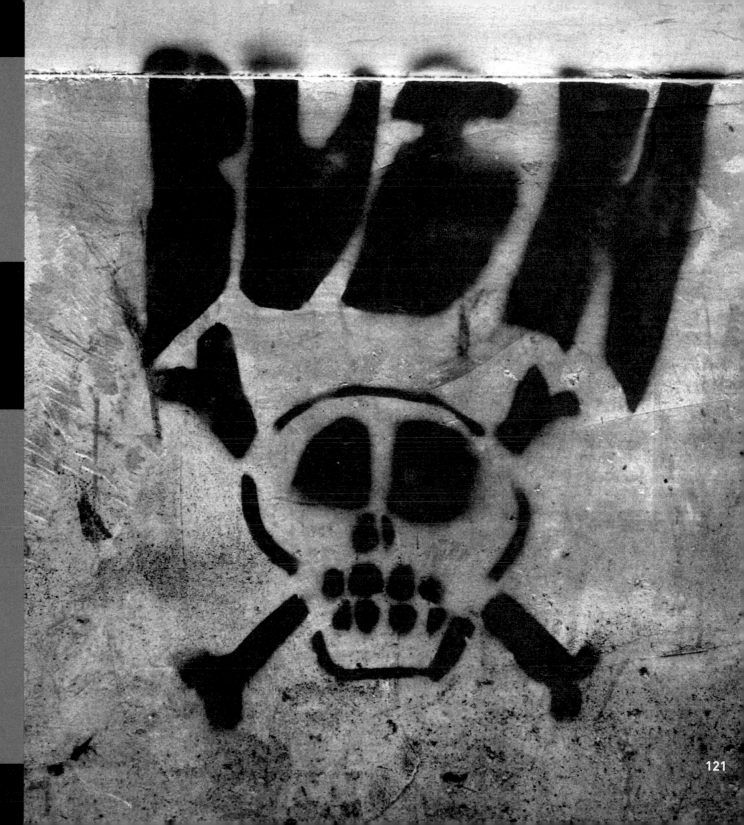

ROME / ITALY
BLUE STENCIL ON STONE
ARTIST: UNKNOWN

APRIL 29, 2005

A direct message: Bush = Death or Bush = Pirate. The artwork is rare in that most Italian street art does not comment on the political players in the War.

VENICE / ITALY

RAINBOW-COLOURED STENCIL ON CONCRETE
ARTIST: UNKNOWN

FEB 26, 2007

A rare example of street art focusing on the downstream effects of the war rather than the causes. Here the rainbow coalition flag of peace is used to highlight the deportations from Italy on the grounds of national security. The suggestion is that Muslims have been the major victims of this policy. The fact that the covered face looks like that of a terrorist carries an implicit threat. The face on the left is the Mayor of Venice, looking on and doing nothing.

AMERRYCAN CHRISTMAS

ROUFIXTE
DESIGNERS
PRODUCTIONS

←

THESSALONIKI / GREECE

PASTE-UP
ARTIST: ROUFIXTE DESIGNERS
PRODUCTIONS

DEC 22, 2006

The hideous iconic image of torture
from Abu Ghraib prison is used again to
attack the Bush war in a cruel parody of
a Christmas card. In Greece, with a long
history of opposition to US foreign policy,
anti-Americanism comes easily. This is
partly the result of Turkey, Greece's arch-
enemy, being accepted into NATO back in
the 1960s. The war on Iraq has resulted
in a whole new wave of anti-Americanism
springing up.

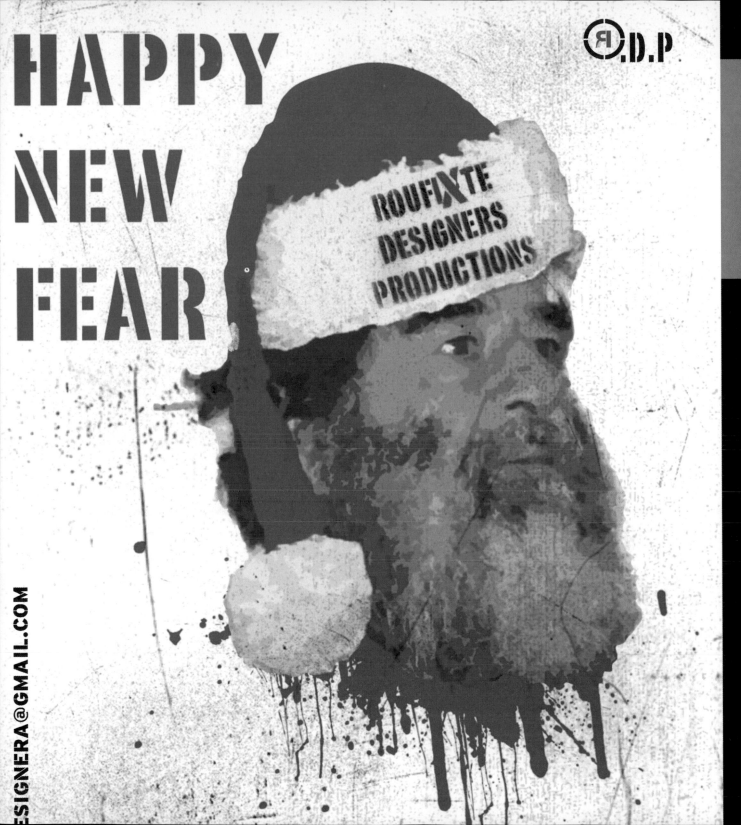

HAPPY NEW FEAR

R.D.P

ESIGNERA@GMAIL.COM

THESSALONIKI / GREECE

PASTE-UP
ARTIST: ROUFIXTE DESIGNERS
PRODUCTIONS

JAN 4, 2007

The image on the left shows an
executed Saddam in Santa Claus costume.
The legend reads 'Happy New Fear'.

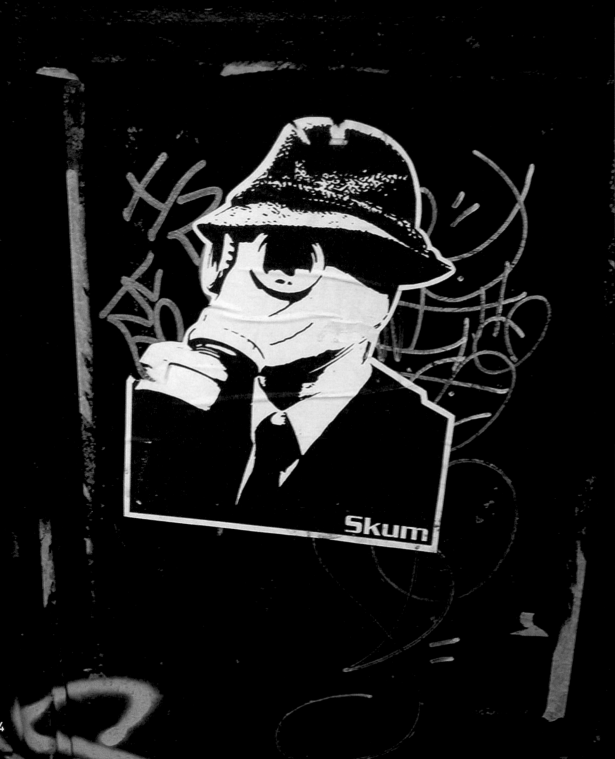

← **STOCKHOLM / NORWAY**

PASTE-UP ON METAL
ARTIST: SKUM

AUG 23, 2007

The oppressive climate of international terrorism and war is brought to the streets of Stockholm, where regular suits will be wearing gas masks.

→
STOCKHOLM / NORWAY

STICKER ON METAL
ARTIST: UNKNOWN

APRIL 25, 2007

Hilarious piece, using the style and typography found in US Etiquette books from the 1950s. Is the message that those upper middle class ladies from Stockholm need some decent action in their lives? Is a lot of opposition to the War just comfortable liberal posturing from upscale Western cities?

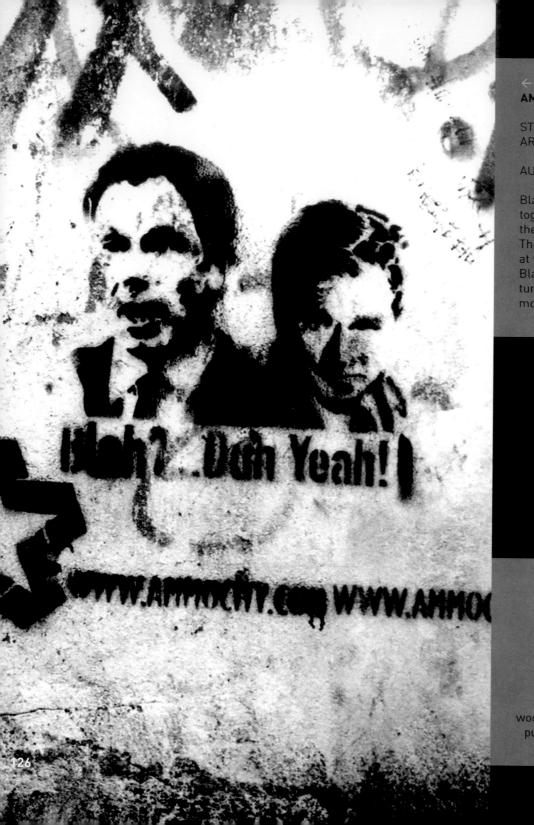

AMSTERDAM / NETHERLANDS

STENCIL ON RENDERED WALL
ARTIST: AMMOCITY

AUG 4, 2006

Blair and Bush are rarely portrayed together, surprising given how close their alliance over the War has been. This piece echoes Bush calling Blair over at the G8 Summit in Moscow with 'Yo Blair'; Blair becomes 'Blah' and Dubya turns into 'Duh Yeah'. Two uncritical, monosyllabic morons conducting the War.

AMSTERDAM / NETHERLANDS

STICKER ON BACKLIT POSTER
ARTIST: UNKNOWN

AUG 1, 2005

Bush as a classic Dutch ventriloquist's wooden puppet, spouting garbage. Whose puppet isn't made clear: the Neo-Cons'?

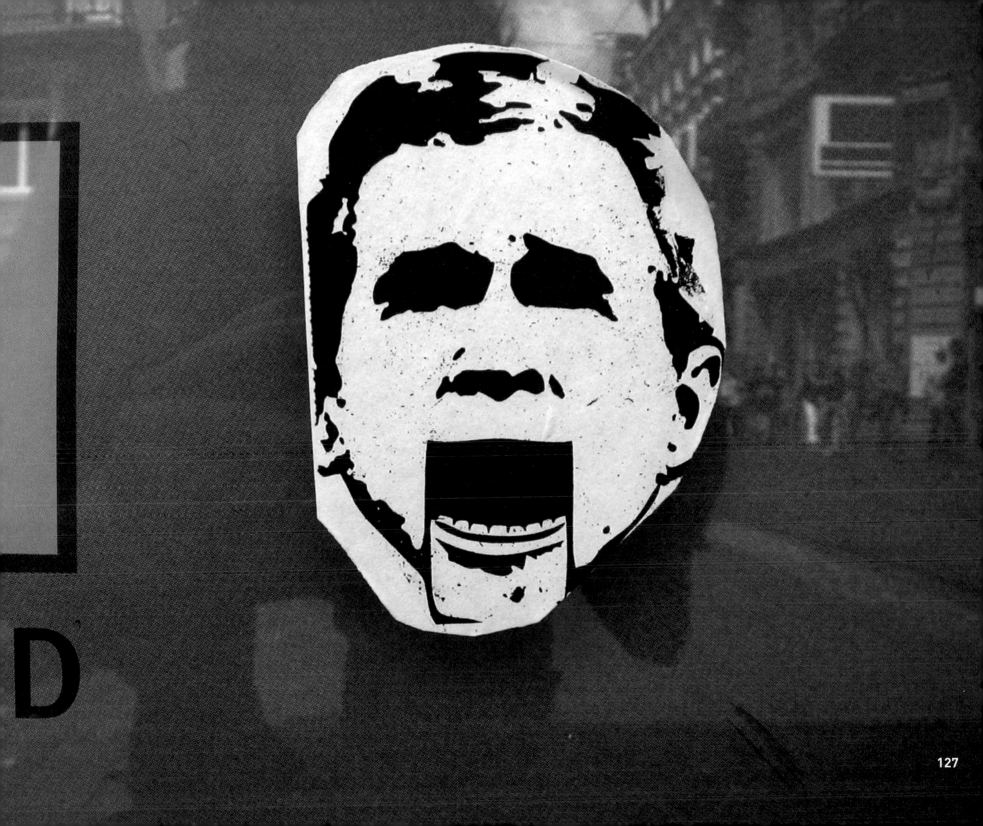

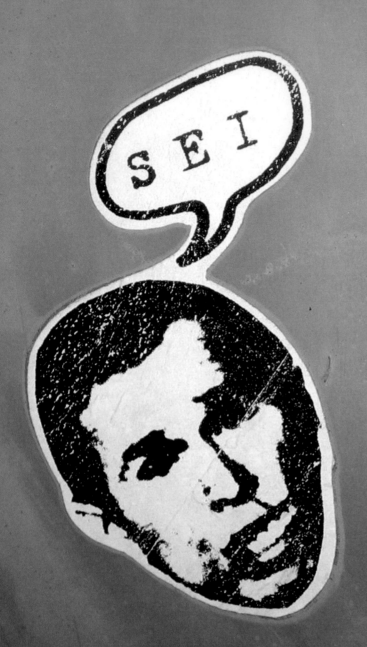

HELSINKI / FINLAND

STICKER ON ROAD SIGN
ARTIST: UNKNOWN

NOV 17, 2005

A rough image of Bush, stuck on a
Helsinki road sign, in confessional mode
(sei = I know).

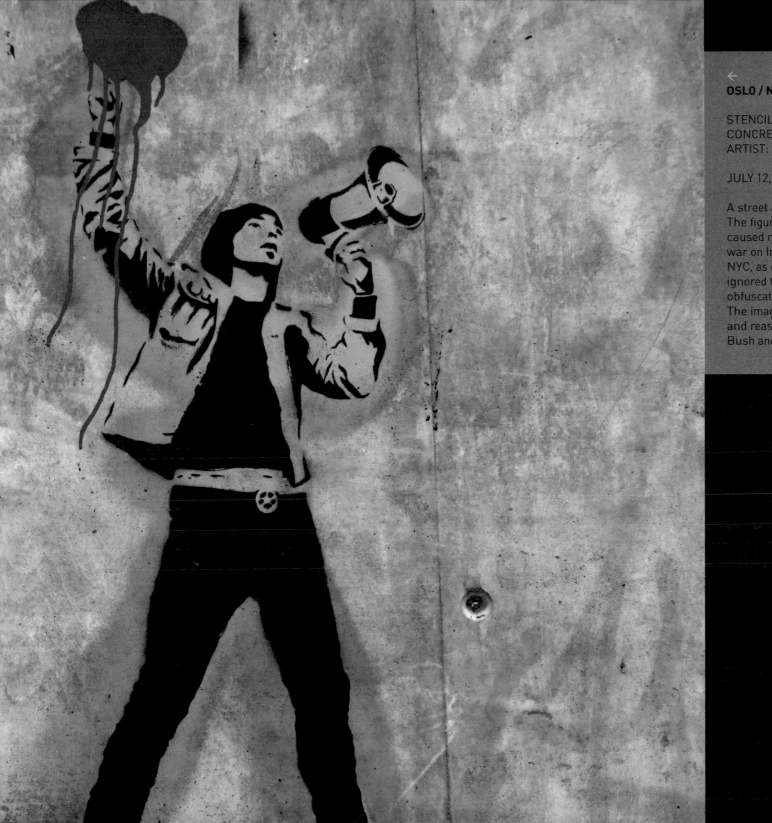

←

OSLO / NORWAY

STENCIL AND SPRAY PAINT ON
CONCRETE
ARTIST: MIR

JULY 12, 2006

A street art call to demonstrate.
The figure encapsulates the spirit that
caused millions to march against the
war on Iraq, notably in London and
NYC, as democratically-elected leaders
ignored the will of the people and
obfuscated the real reasons for action.
The image is striking for its openness
and reasonableness; compare with
Bush and Blair.

129

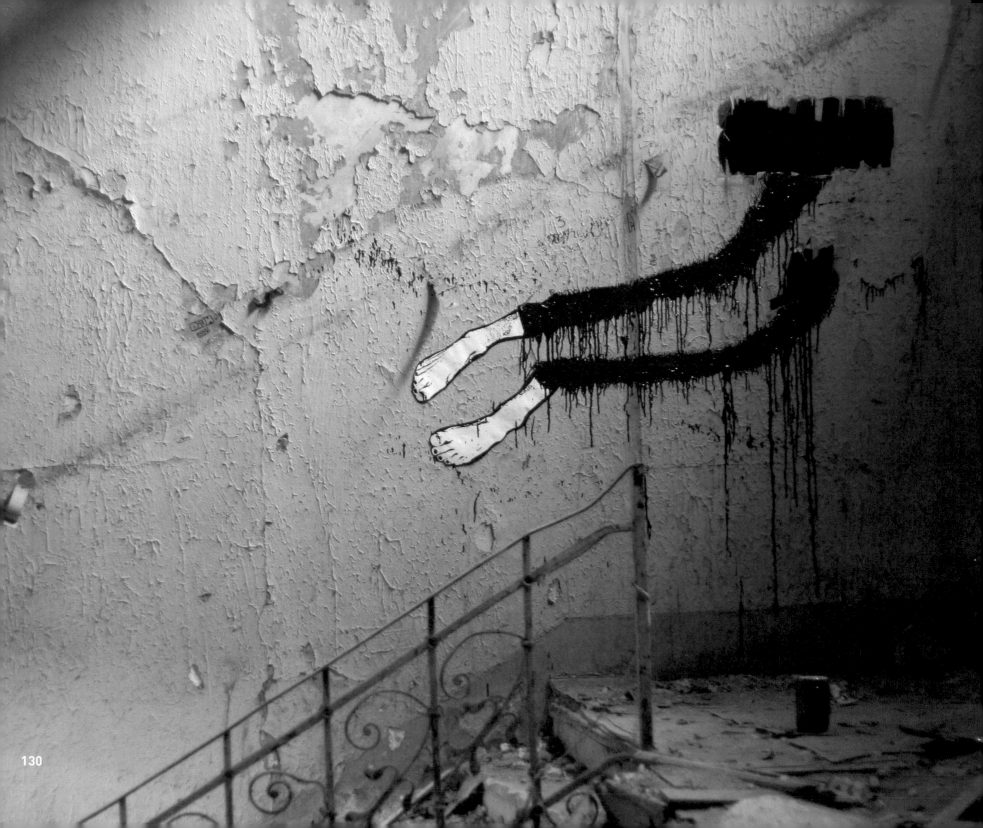

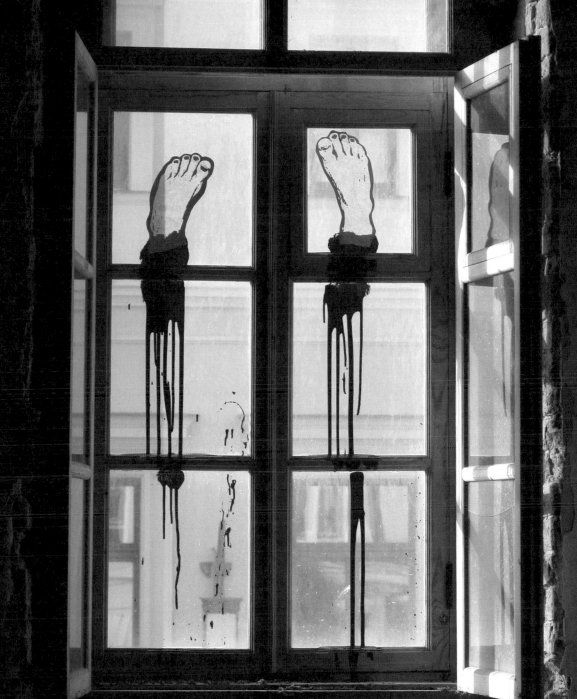

MOSCOW / RUSSIA

PAINT ON WALLPAPER AND GLASS IN
DERELICT HOUSE
ARTIST: 0331c

JULY 17, 2006

Visceral images of torture, possibly
inspired by Abu Ghraib. The fact that only
the well-drawn feet remain adds to the
sense of violence.

THE MIDDLE EAST

BASRA / BAGHDAD /FALLUJAH / TEHRAN / TEL AVIV / WEST BANK / DAMASCUS

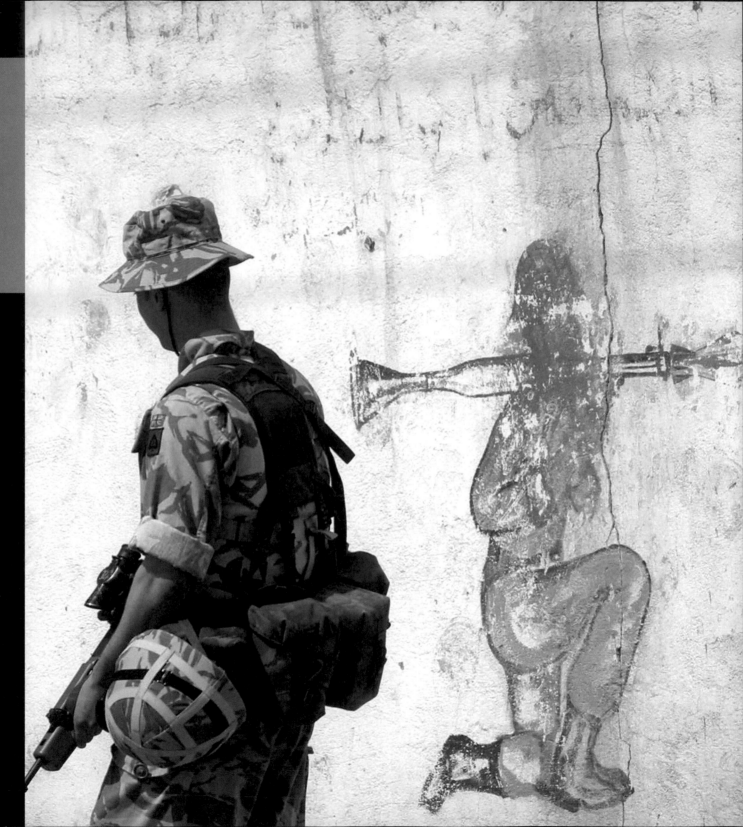

BASRA / IRAQ

PAINTING ON STUCCO
ARTIST: UNKNOWN

APRIL 11, 2005

The classic image of an Iraqi insurgent:
face covered and holding an anti-tank
bazooka ready to fire. The intent is
probably to create disquiet amongst
soldiers on patrol.

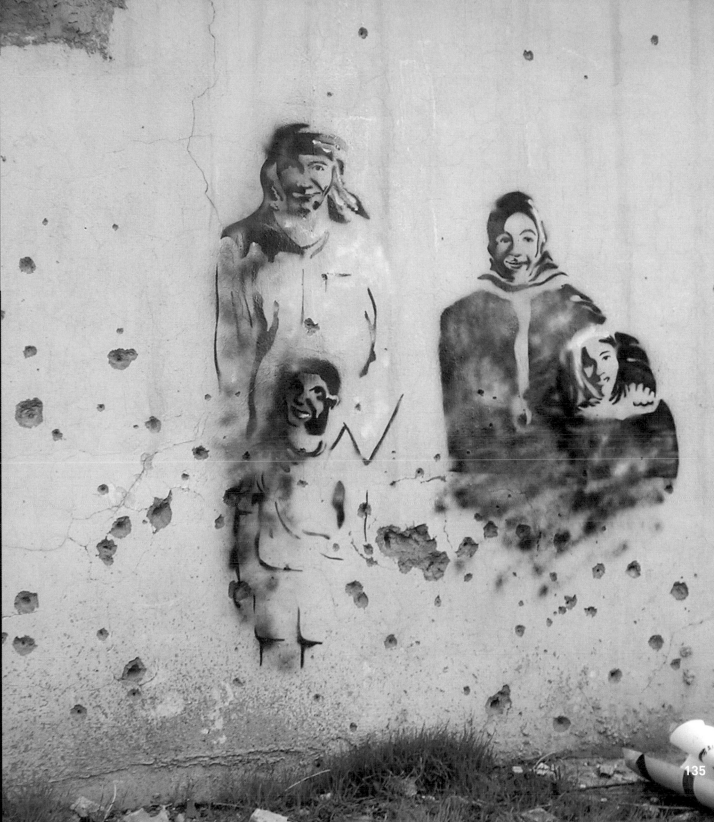

STENCIL ON BULLET-RIDDEN WALL
ARTIST: AROFISH

DEC, 2003

Arofish is an English artist who pre-dated Banksy in Gaza and has worked in Tehran as well as Baghdad. Here he uses a wall pock-marked by bullets to highlight civilian casualties in Baghdad.

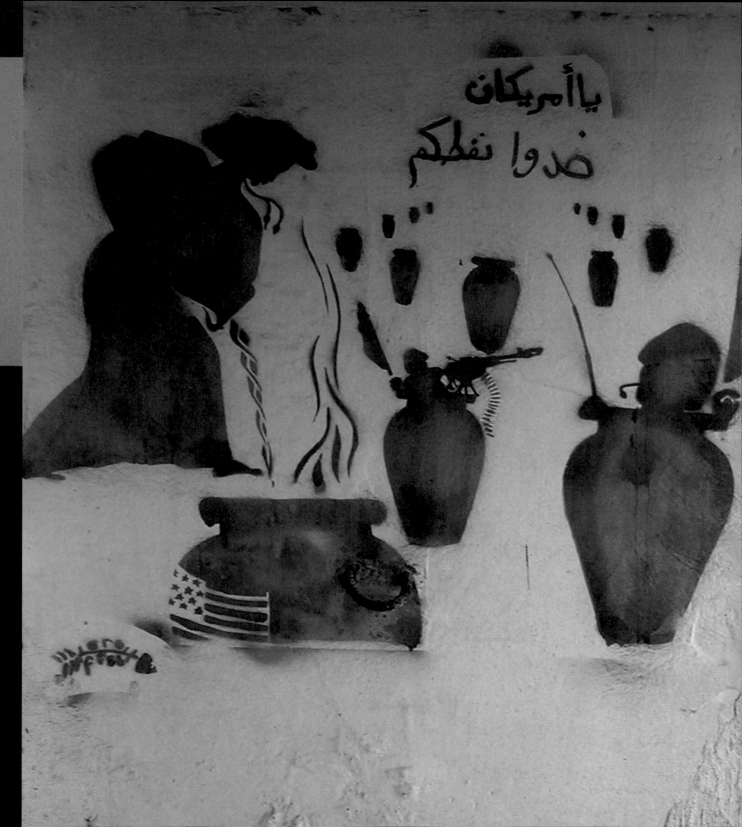

BAGHDAD / IRAQ

STENCIL ON WALL
ARTIST: AROFISH

JAN, 2004

Arofish uses the tale of Ali Baba and the Forty Thieves, to brilliant effect. The US soldiers, like the thieves, are discovered hiding in the jars. Arofish represents them as though emerging from the hatch on a tank. In the tale, Morgiana, pictured left, pours boiling oil on the thieves, killing them. The caption, presumably spoken by Morgiana, reads 'Hey American, take your oil'.

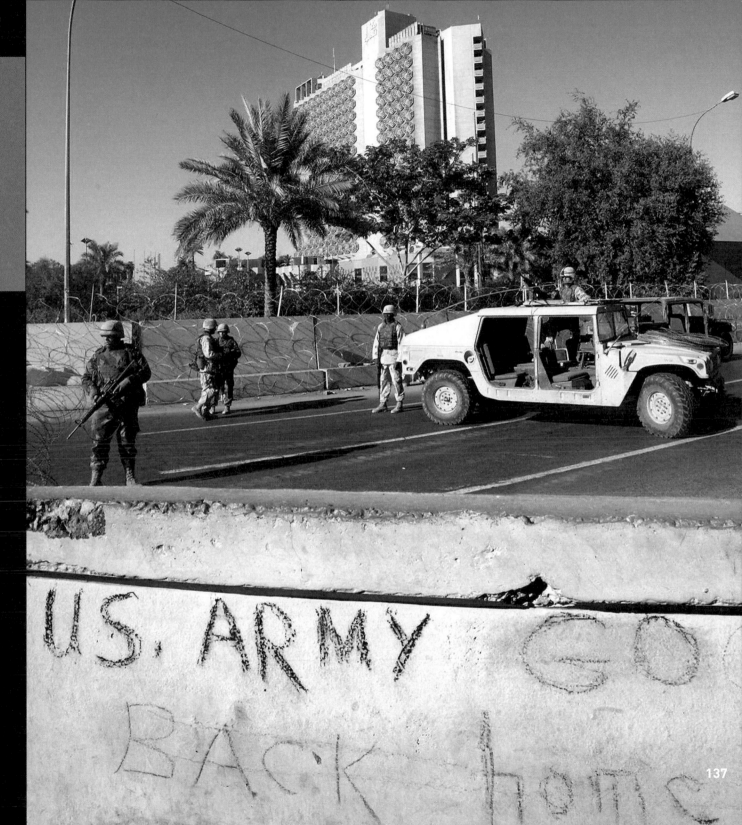

BAGHDAD / IRAQ

SCRATCHED LETTERING ON WALL
ARTIST: UNKNOWN

NOV 21, 2003

Messages like this appear all over
Baghdad. No time for clever political
allusions here. The message is probably
heartfelt, but also designed to demoralize
US troops on the ground.

With time as our witness, history will be our judge.

THE PRICE OF FREEDOM IS NOT FREE.

Nov, 04'

Enjoy your freedom? Thank an American. Marine!

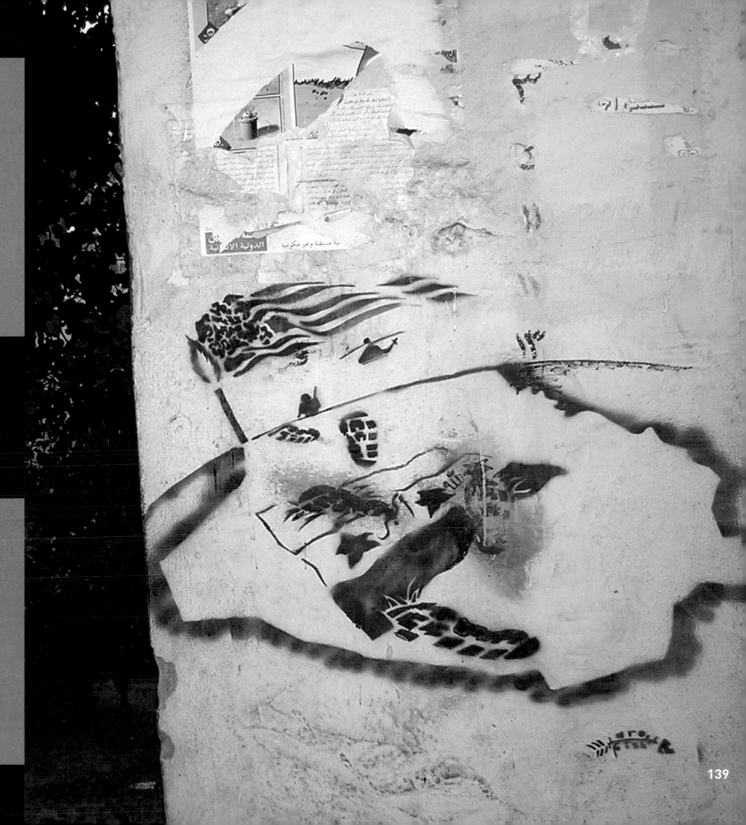

BAGHDAD / IRAQ

STENCIL ON WALL
ARTIST: AROFISH

DEC, 2003

The map of Iraq is shown occupied by the US with the Iraqi flag trampled beneath US combat boots. The gesture of whacking something with the sole of the shoe is considered a particularly vicious insult in the Middle East. Someone has been sufficiently offended to attempt to wipe out the footprints.

FALLUJAH / IRAQ

WRITING ON BATHROOM WALL
ARTIST: UNKNOWN US SOLDIER

JAN 2, 2005

Thoughts of US soldiers on the ground in Baghdad. The call to history to judge the virtue of the War is a classic recourse of those who cannot quite grasp why others are so opposed in the present. It echoes Tony Blair's response when asked to apologize for his decision to go to War.

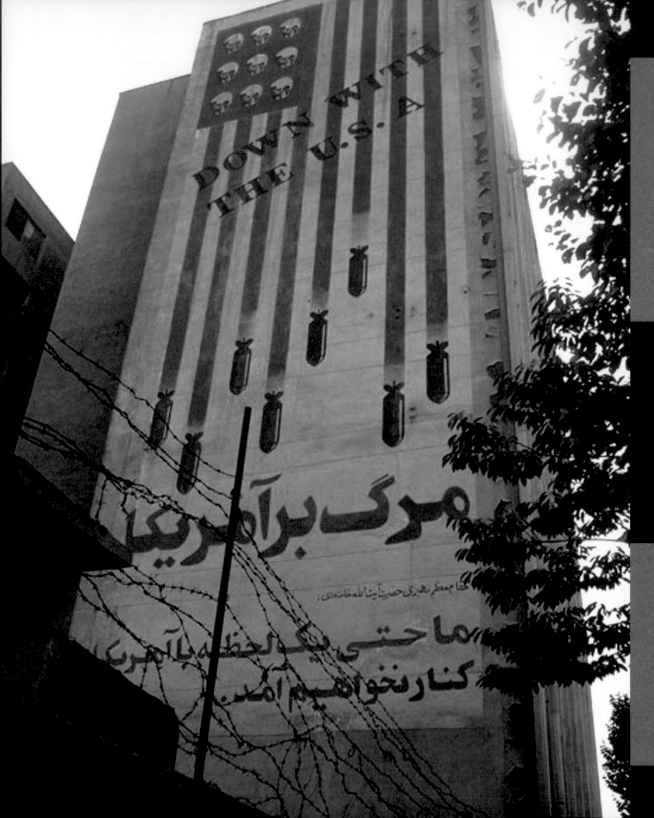

TEHRAN / IRAN
OFFICIAL PROPAGANDA MURAL
ARTIST: GOVERNMENT ARTISTS

AUG 29, 2005

The state as graffiti artist. The subversion of the stars and stripes is a pretty standard device; the effect might have been better without the words. Iranian government spokesmen have been interviewed on several occasions with this as a backdrop.

TEHRAN / IRAN

STENCIL ON CONCRETE
ARTIST: A1ONE

OCT 23, 2006

Bush as the devil. In contrast with the use of a smiling Bush to make a point about hypocrisy, GW looks pretty depressed in this one.

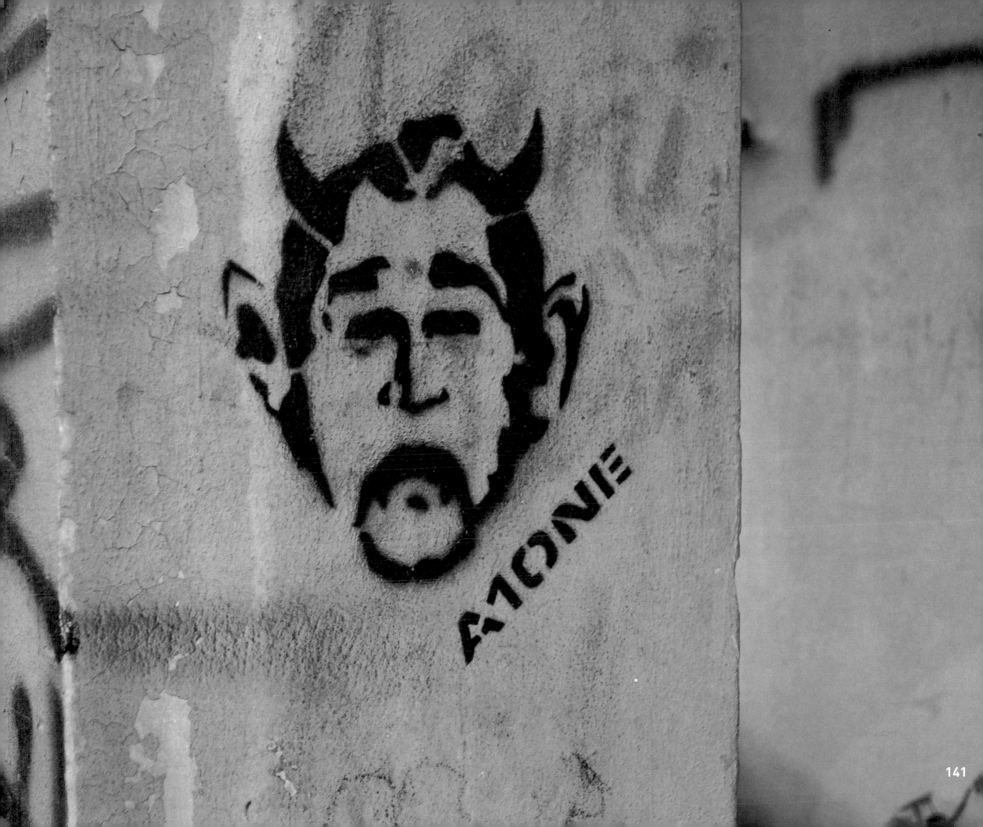

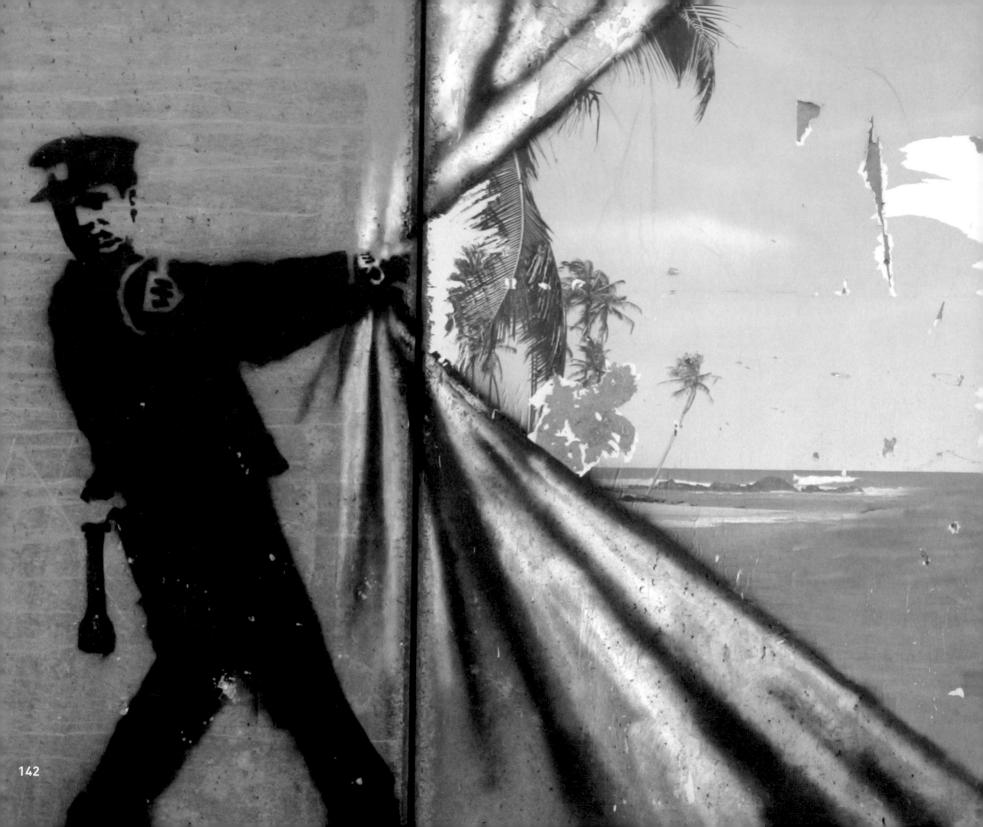

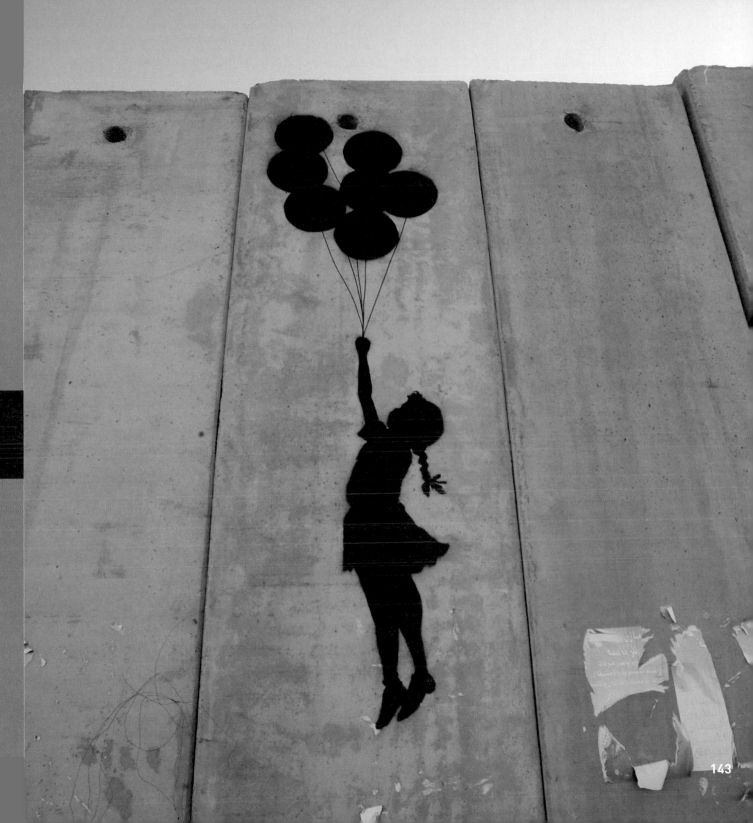

RAMALLAH / WEST BANK

STENCIL ON DIVIDING WALL
ARTIST: BANKSY

DATE: AUG 6, 2005

A cartoon schoolgirl with pigtails clutches a bunch of balloons and floats to freedom. The desire to escape the oppression of the West Bank wall, of life in a war zone, is brilliantly expressed. Banksy achieves much of his effect by imposing idealized Western images (here of the joys of childhood) in a Middle Eastern setting. It's a wake-up call to the West.

RAMALLAH / WEST BANK

STENCIL ON DIVIDING WALL
ARTIST: BANKSY

DATE: AUG 6, 2005

A figure who looks like a janitor from a 1950s Cops movie, teasingly draws back the curtain to reveal what Palestinians living in hardship are missing. Banksy gets straight to the West's hypocrisy in not addressing the living conditions which fuel desperation, which in turn fuel support for terror.

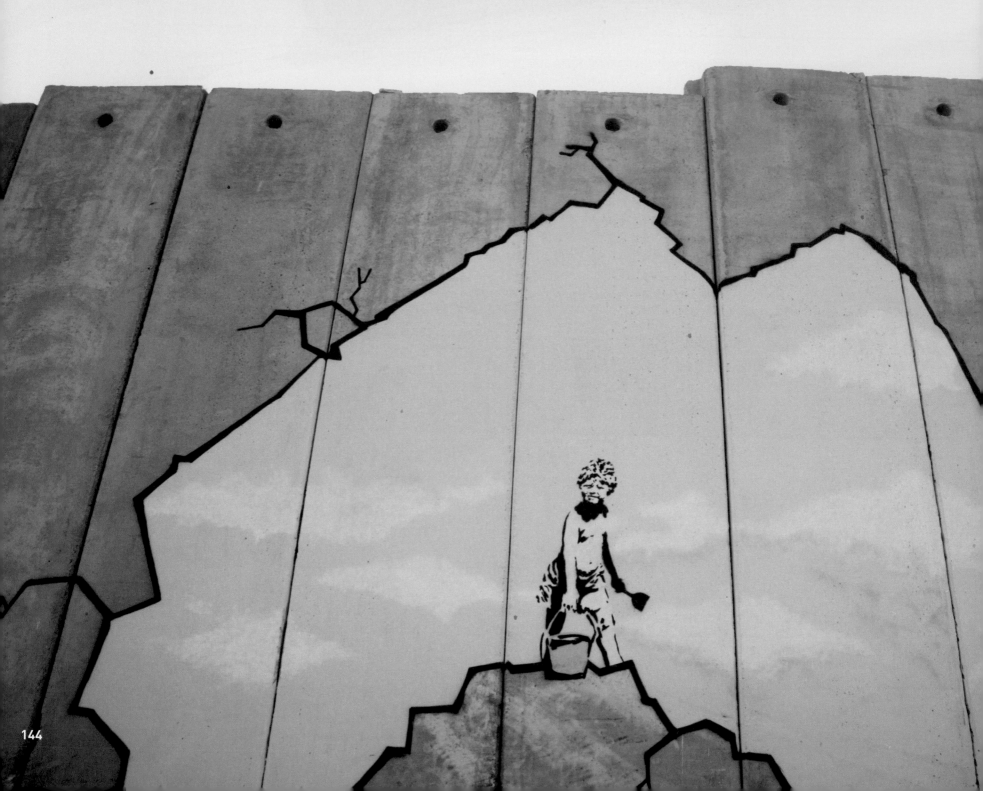

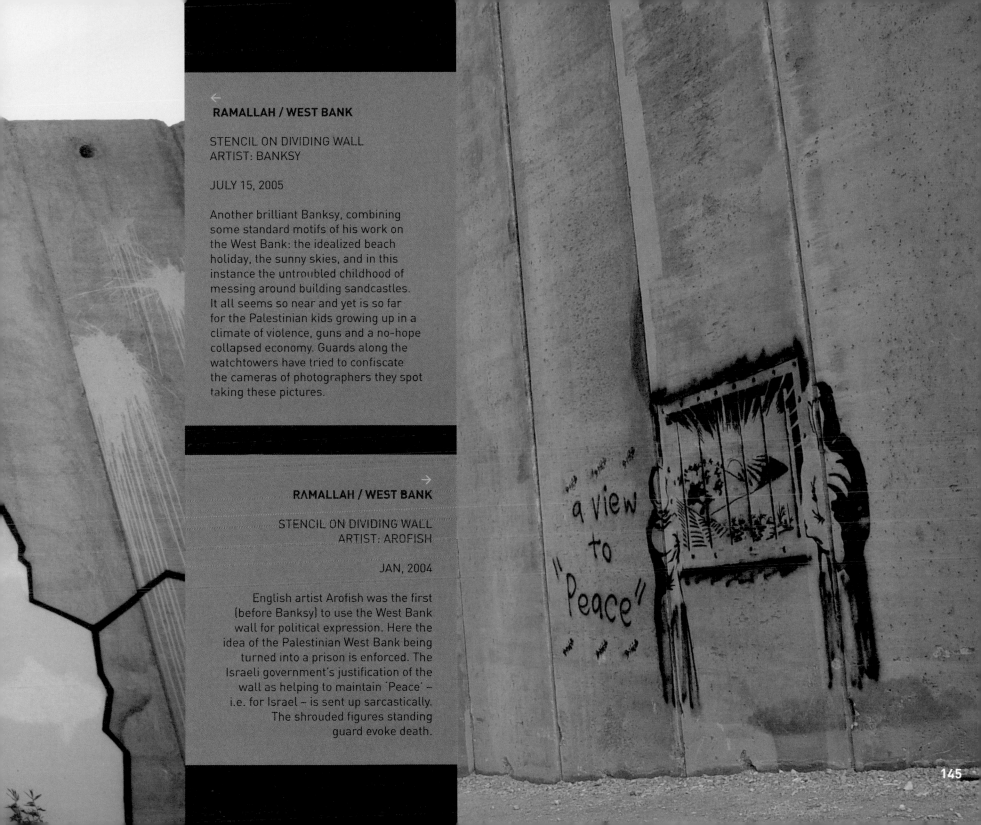

RAMALLAH / WEST BANK

STENCIL ON DIVIDING WALL
ARTIST: BANKSY

JULY 15, 2005

Another brilliant Banksy, combining some standard motifs of his work on the West Bank: the idealized beach holiday, the sunny skies, and in this instance the untroubled childhood of messing around building sandcastles. It all seems so near and yet is so far for the Palestinian kids growing up in a climate of violence, guns and a no-hope collapsed economy. Guards along the watchtowers have tried to confiscate the cameras of photographers they spot taking these pictures.

RAMALLAH / WEST BANK

STENCIL ON DIVIDING WALL
ARTIST: AROFISH

JAN, 2004

English artist Arofish was the first (before Banksy) to use the West Bank wall for political expression. Here the idea of the Palestinian West Bank being turned into a prison is enforced. The Israeli government's justification of the wall as helping to maintain 'Peace' – i.e. for Israel – is sent up sarcastically. The shrouded figures standing guard evoke death.

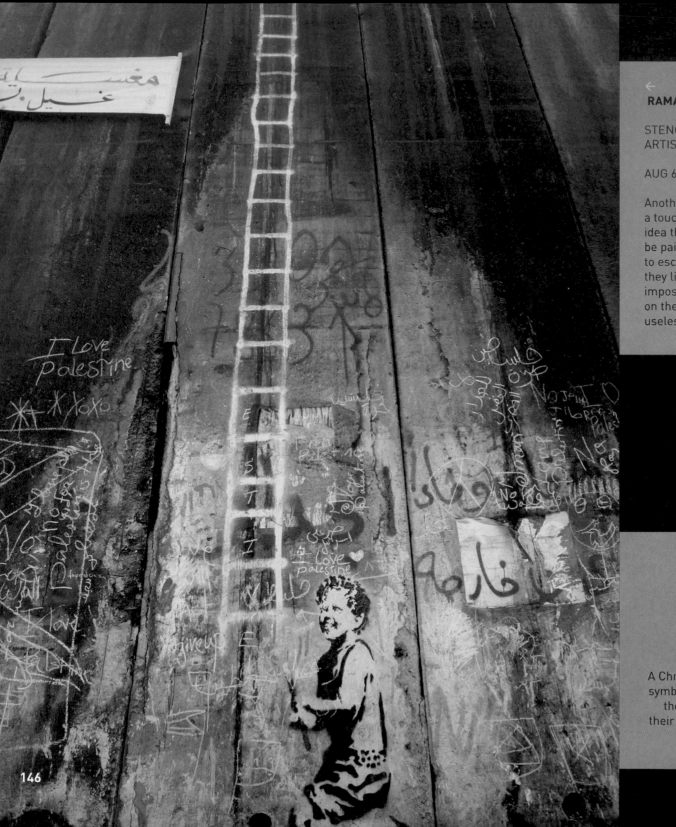

RAMALLAH / WEST BANK

STENCIL ON DIVIDING WALL
ARTIST: BANKSY

AUG 6, 2005

Another wholesome Western child with a touch of Huck Finn about him. The idea that a magical ladder could simply be painted to allow the Palestinians to escape the oppression under which they live is a visceral comment on the impossibility of their dreams. The joy on the child's face adds to the feeling of uselessness.

DAMASCUS / JORDAN

PAINT ON WALL
ARTIST: UNKNOWN

APRIL 20, 2005

A Christian message in Jordan. IHS is the symbol of Christ. This is a real voice from the Street – people want to get on with their lives, not live with an endless series of wars and instability.

IHS ☩ God is

PEACE love

سلام ᵁˢᵃ

WAR GOOD
FOR
NOTHING

ARABIS
WANT
PEACE

AUSTRALIA/THE FAR EAST

TOKYO / SYDNEY / MELBOURNE / SHANGHAI / JAKARTA / TAIPEI / HONG KONG

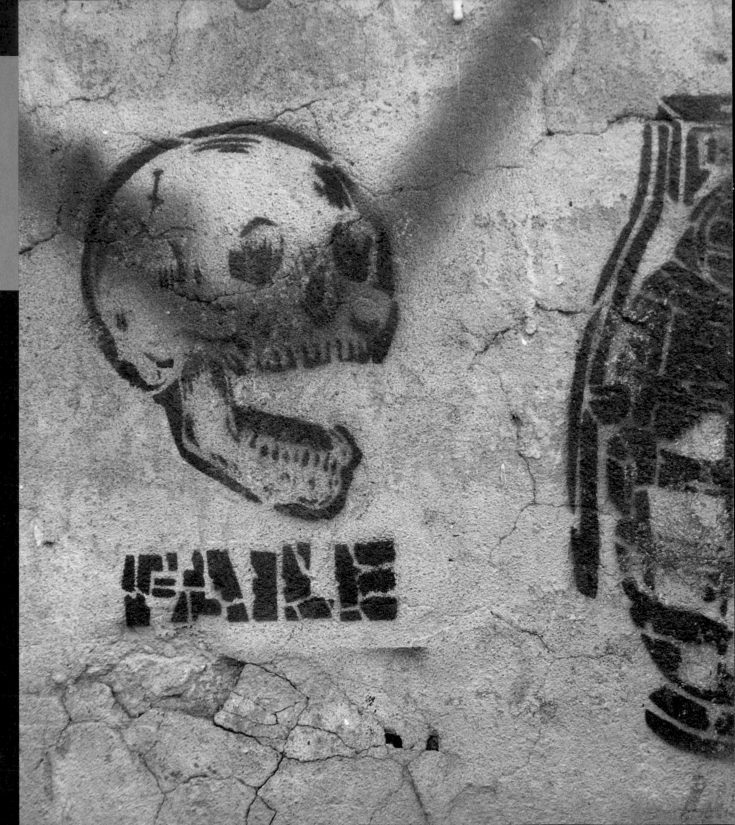

A collaboration between Faile and Bast.
The feeling is anti-war in general, but
dates from the recent invasion of Iraq. The
imagery creates a morbid mood without
an explicit message.

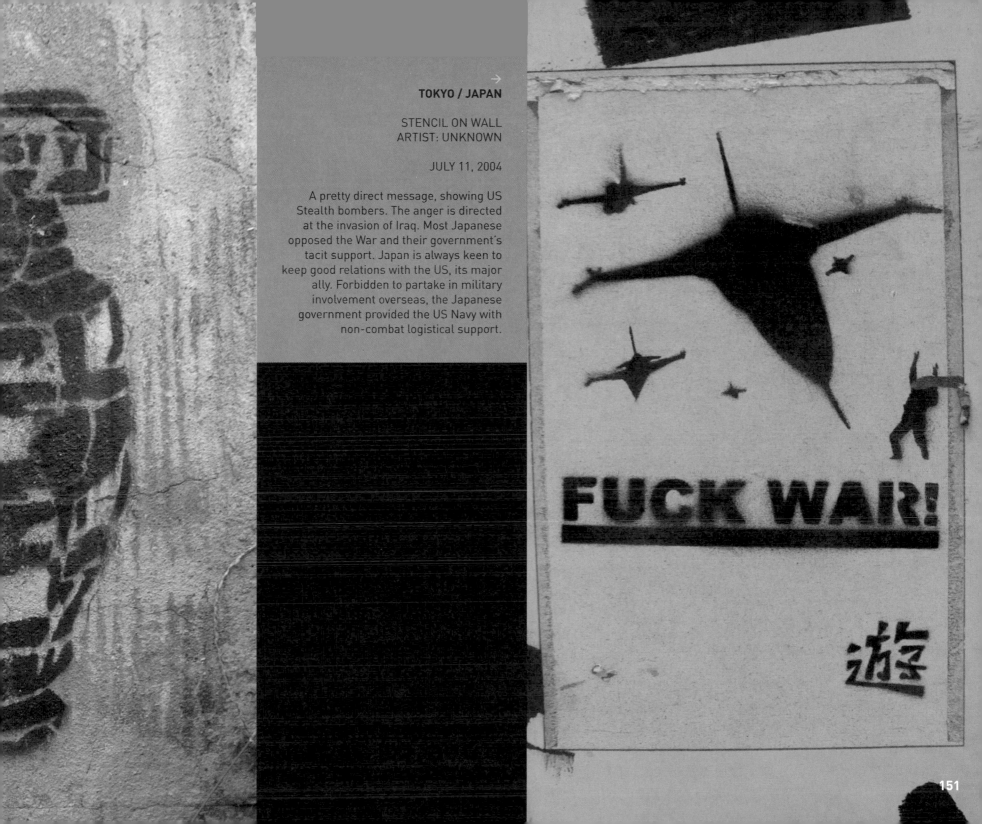

TOKYO / JAPAN

STENCIL ON WALL
ARTIST: UNKNOWN

JULY 11, 2004

A pretty direct message, showing US Stealth bombers. The anger is directed at the invasion of Iraq. Most Japanese opposed the War and their government's tacit support. Japan is always keen to keep good relations with the US, its major ally. Forbidden to partake in military involvement overseas, the Japanese government provided the US Navy with non-combat logistical support.

FUCK WAR!

遊

ちょっと待った祭り

ちょっと待ったおじさん

PSYCHEDELIC
MOTORS
http://www.geocities.co.jp/Hollywood-Studio/5935/

PSYCHEDE
MOTORS
http://www.geocities.co.jp/Hollywood-Studio/5935/

dbsk

152

TOKYO / JAPAN

STICKER ON METAL
ARTIST: DBSK

SEPT 9, 2006

A rare image, for Tokyo, of a Middle
Eastern female suicide bomber,
explosives strapped to her belt, calmly
giving the V for victory.

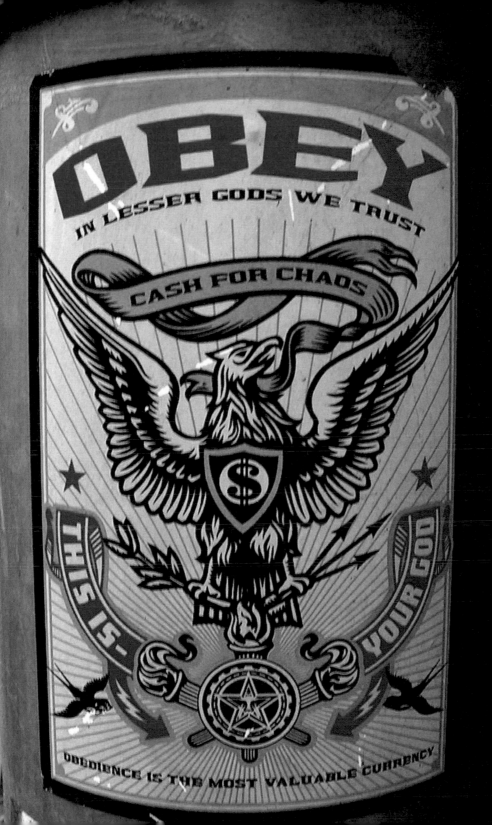

STICKER ON STEEL STREET LAMP
ARTIST: SHEPARD FAIREY

SEPT 8, 2006

Shepard Fairey in cynical mood. The OBEY giant here transmutes into the US eagle, and is subsumed in the star figure at the bottom of the image. The $ is the driving force, and 'Chaos' is a comment on the debacle in Iraq. This could be a Japanese beer label. If fits perfectly on the cylindrical street lamp.

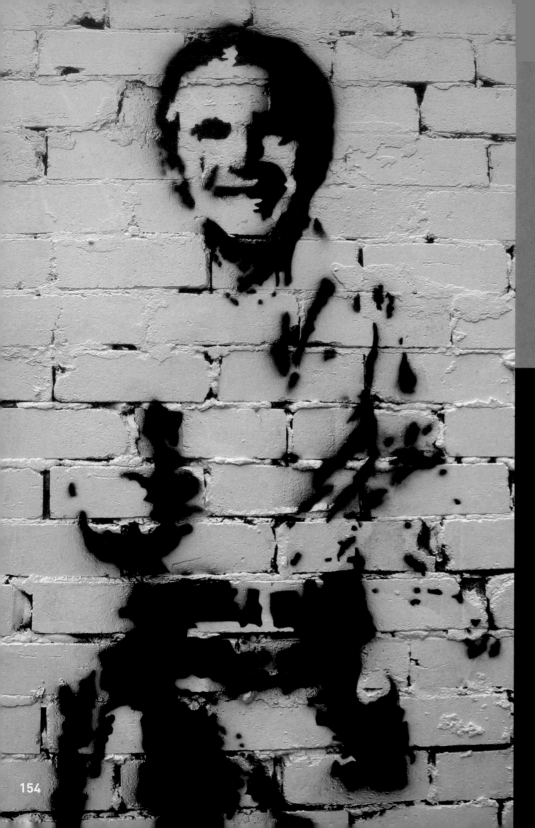

←→

SYDNEY / AUSTRALIA

STENCIL ON BRICK
ARTIST: UNKNOWN

SEPT 3, 2005

Inspired by Warhol's *Elvis*, this shows Dubya as a lone ranger, pulling his Texan weapon, ready to shoot. A trigger-happy, smiling Bush is a common theme in street art. The image multiplied also has the effect of making Bush seem like a stooge and front-man for, presumably, the Neo-Con Establishment. He is in effect reduced to little more than a grinning entertainer.

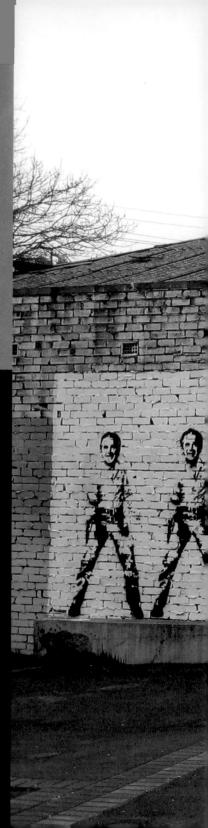

154

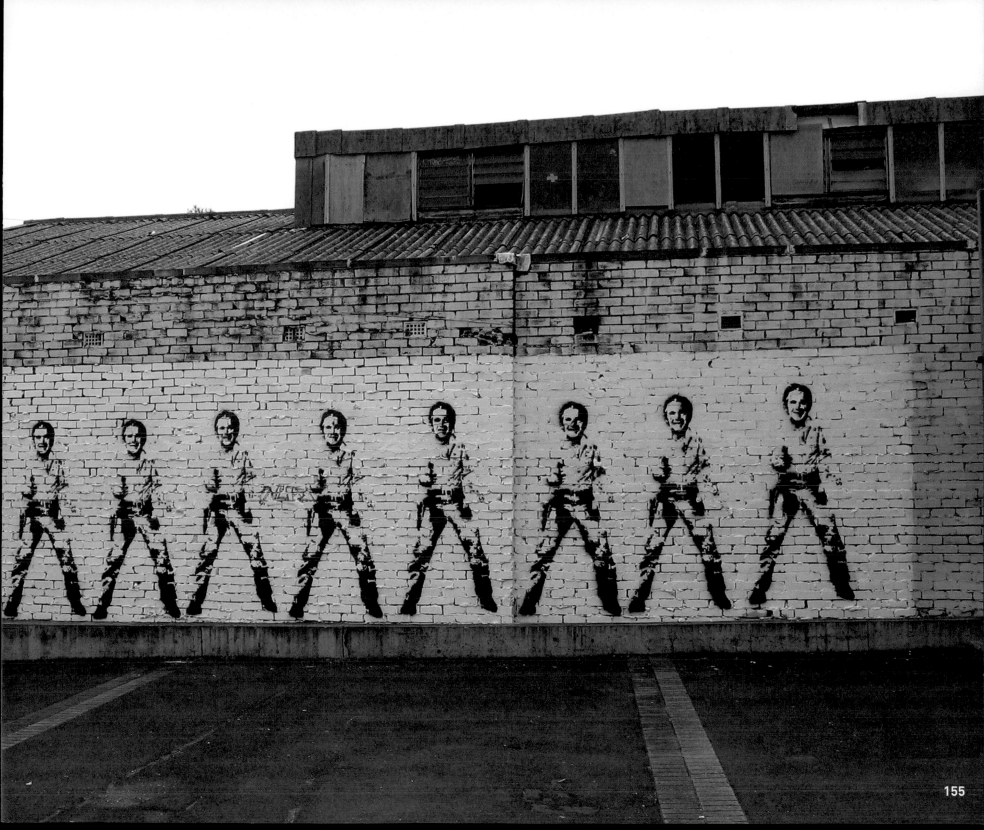

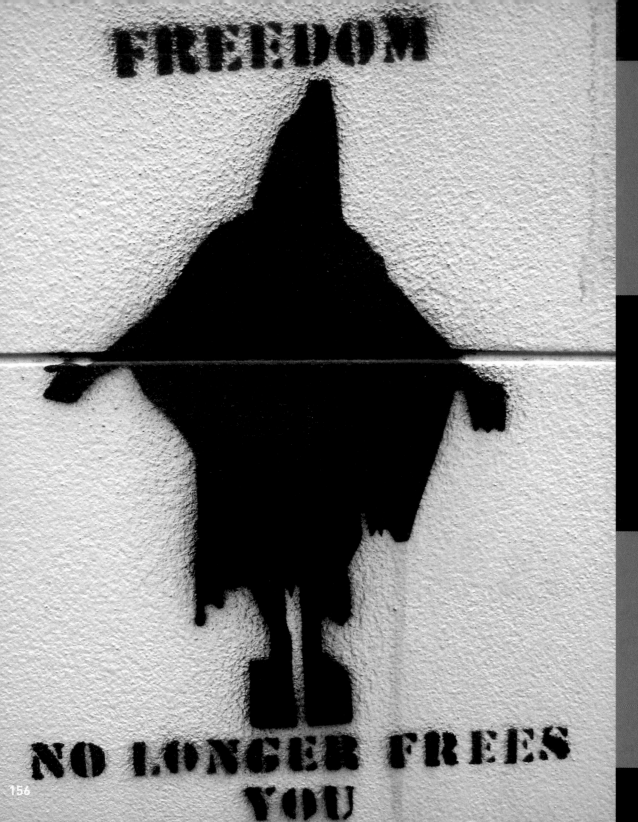

FREEDOM

NO LONGER FREES
YOU

156

←

SYDNEY / AUSTRALIA

STENCIL ON CONCRETE
ARTIST: UNKNOWN

APRIL 18, 2006

That image from Abu Ghraib prison again, showing the torture and humiliation of an Iraqi prisoner of war. The idea that the Iraqi nation has been freed by the War is sent up pretty convincingly.

→

SYDNEY / AUSTRALIA

PASTE-UP ON GRAFFITI WALL
ARTIST: UNKNOWN

OCT 6, 2004

John Howard, the Australian president, grinning idiotically, lampooned for his support for Bush. Sometimes the simplest messages are the most effective.

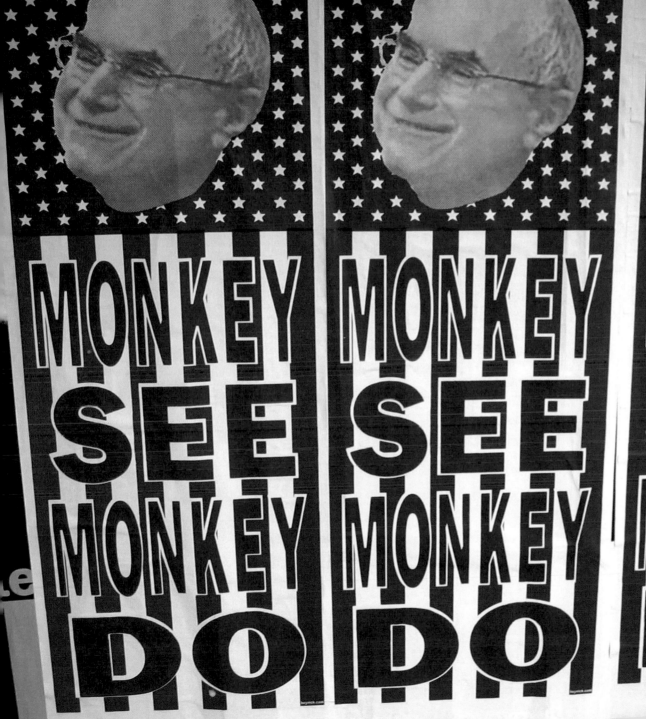
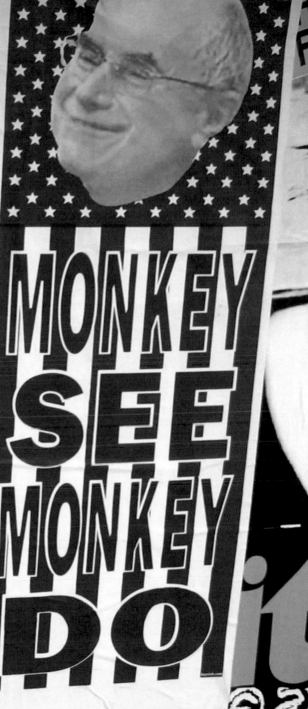

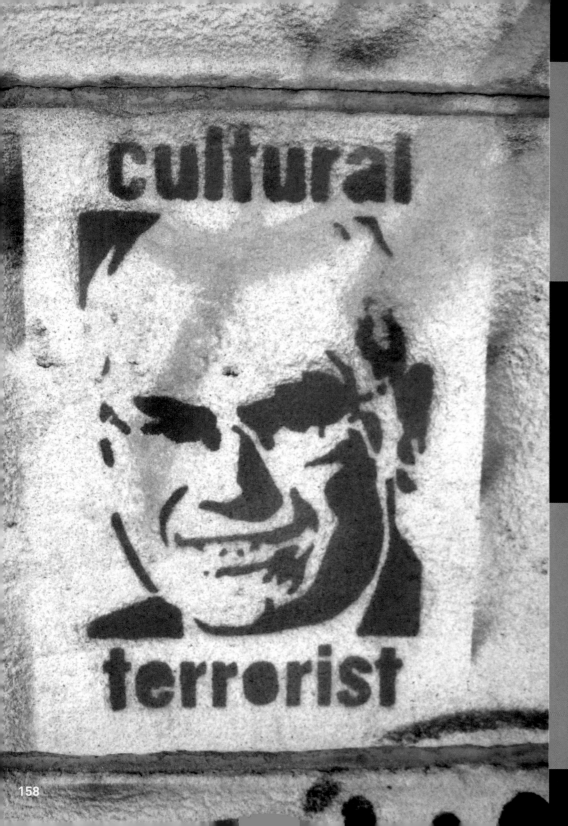

SYDNEY / AUSTRALIA

STENCIL ON SANDSTONE
ARTIST: UNKNOWN

DEC 29, 2005

A stencil of John Howard, accused of destroying true Australian culture and traditional Aussie freedom, as a result of his support for the US invasion of Iraq.

SYDNEY / AUSTRALIA

PASTE-UP ON RENDER
ARTIST: UNKNOWN

SEPT 4, 2005

This echoes the work of Happy, who portrays soldiers and tanks on the streets of Melbourne, making a military presence seem normal. These images also represent how we are losing our liberties, as a result of involvement in the Iraq War.

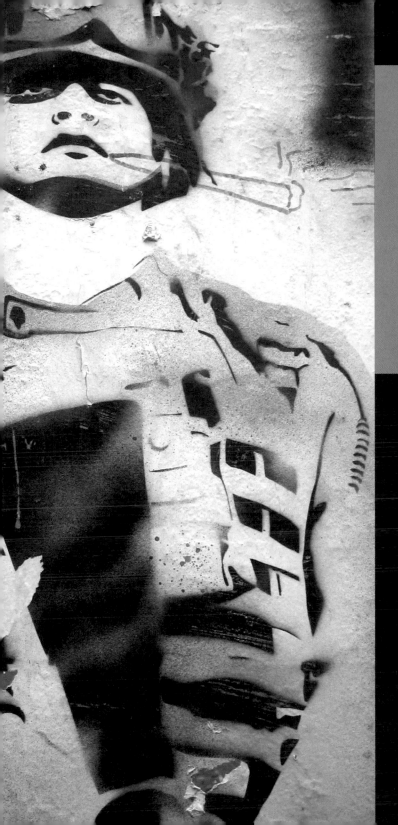

STENCIL ON CONCRETE
ARTIST: UNKNOWN

OCT 9, 2004

This stencil brings to mind the brutal death of Daniel Pearl, the *Washington Post* journalist beheaded by his Al-Qaeda sympathizer captors in 2002, in Karachi, Pakistan. The executioner is unidentified, the suggestion being that the conflict between the West and extremist Islam, which is set to go on endlessly, is against an unseen, shady enemy.

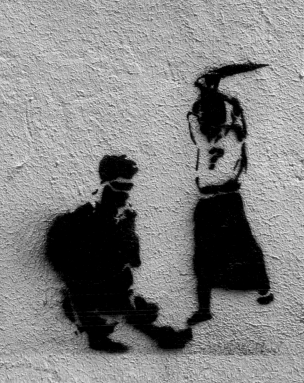

ONLY THE DEAD WILL SEE THE END OF WAR

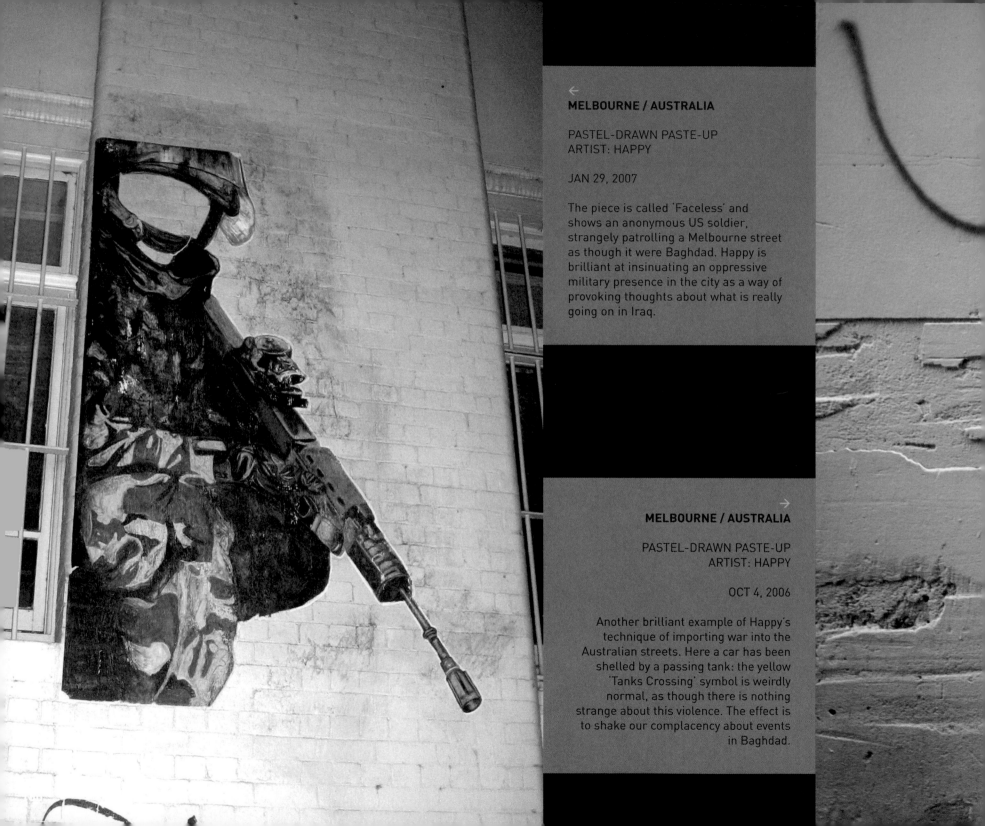

MELBOURNE / AUSTRALIA

PASTEL-DRAWN PASTE-UP
ARTIST: HAPPY

JAN 29, 2007

The piece is called 'Faceless' and shows an anonymous US soldier, strangely patrolling a Melbourne street as though it were Baghdad. Happy is brilliant at insinuating an oppressive military presence in the city as a way of provoking thoughts about what is really going on in Iraq.

MELBOURNE / AUSTRALIA

PASTEL-DRAWN PASTE-UP
ARTIST: HAPPY

OCT 4, 2006

Another brilliant example of Happy's technique of importing war into the Australian streets. Here a car has been shelled by a passing tank: the yellow 'Tanks Crossing' symbol is weirdly normal, as though there is nothing strange about this violence. The effect is to shake our complacency about events in Baghdad.

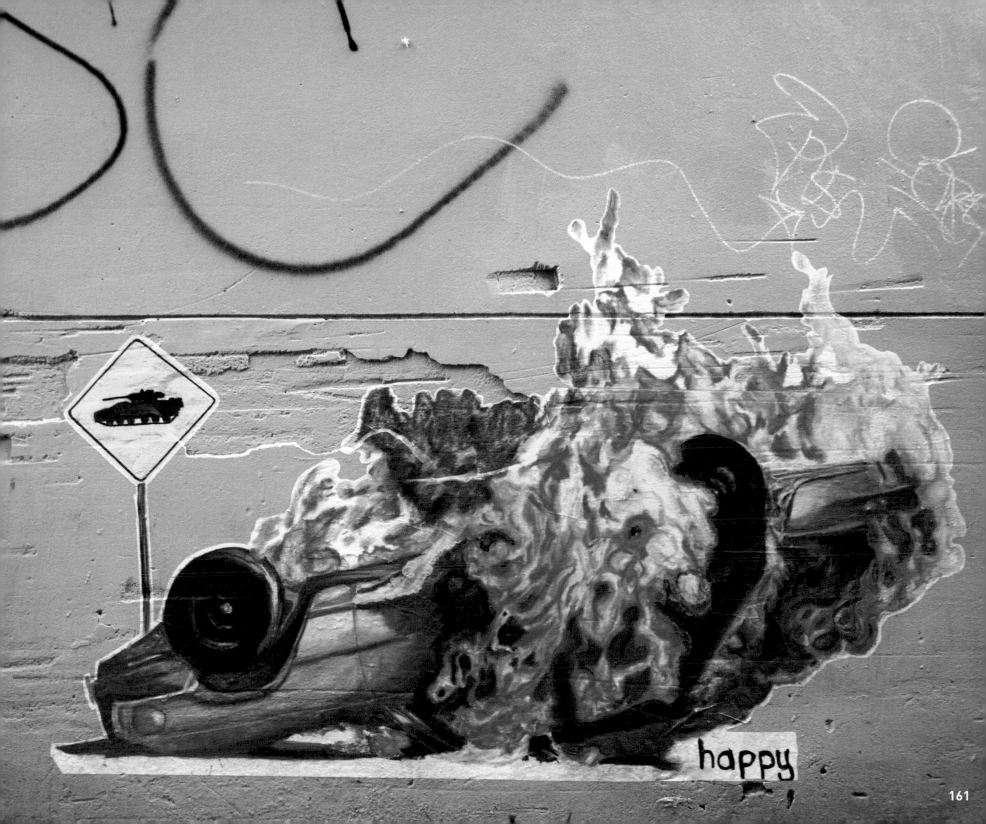

happy

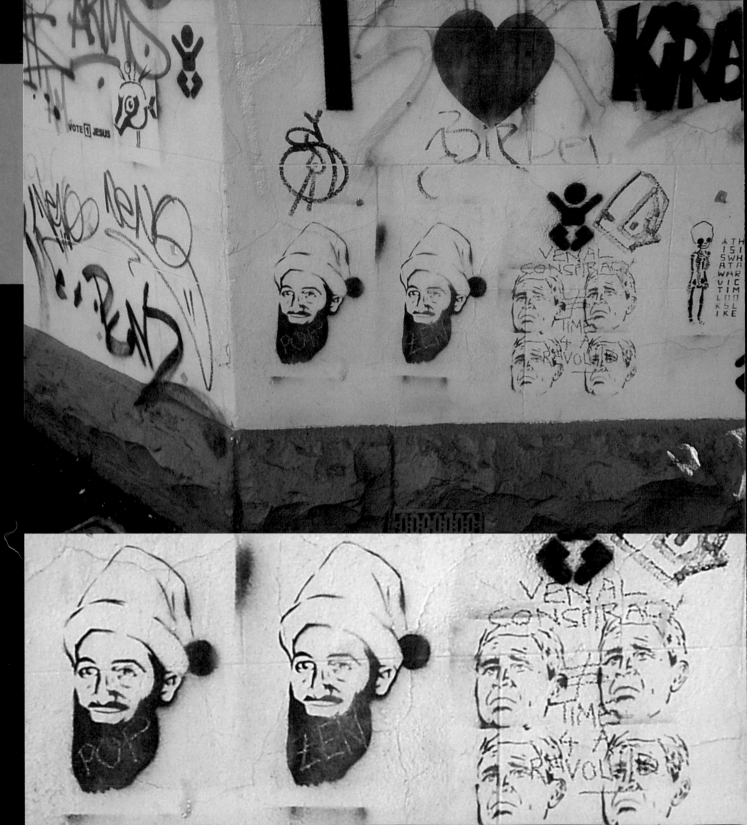

MELBOURNE / AUSTRALIA

STENCIL ON GRAFFITI WALL
ARTIST: UNKNOWN

AUG 17, 2005

Osama as Santa Claus, with four George Bushes in red outline. The caption 'Venal Conspiracy, Time 4 A Revolt' was added later.

162

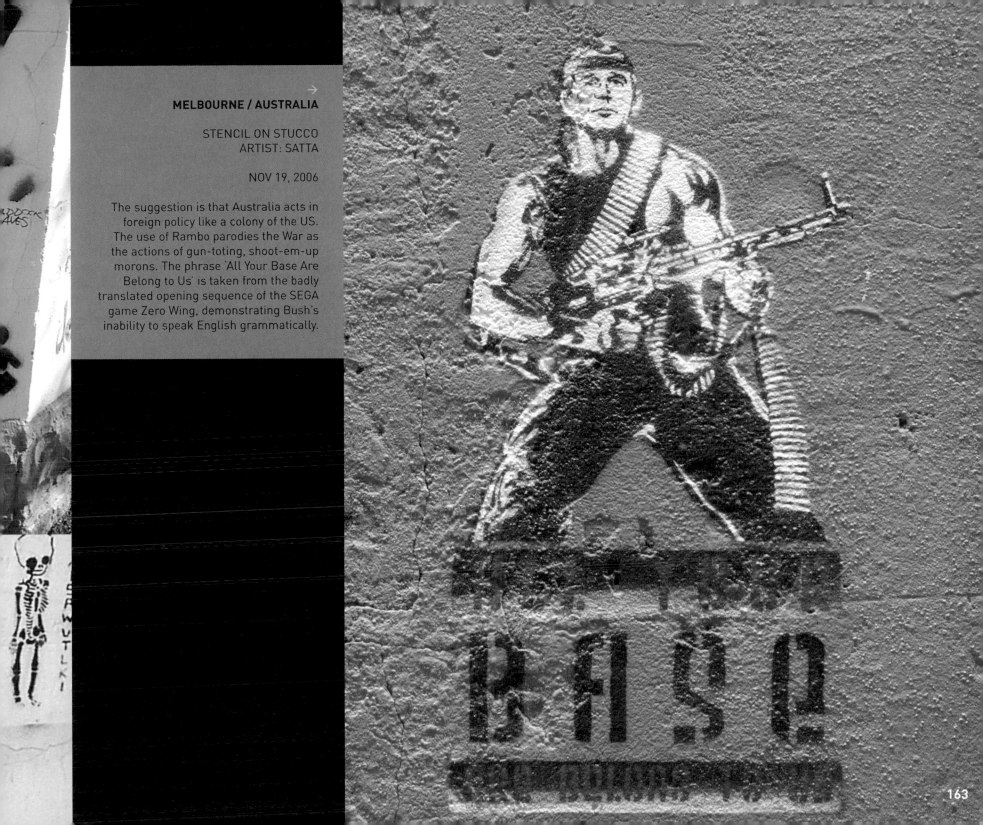

MELBOURNE / AUSTRALIA

STENCIL ON STUCCO
ARTIST: SATTA

NOV 19, 2006

The suggestion is that Australia acts in foreign policy like a colony of the US. The use of Rambo parodies the War as the actions of gun-toting, shoot-em-up morons. The phrase 'All Your Base Are Belong to Us' is taken from the badly translated opening sequence of the SEGA game Zero Wing, demonstrating Bush's inability to speak English grammatically.

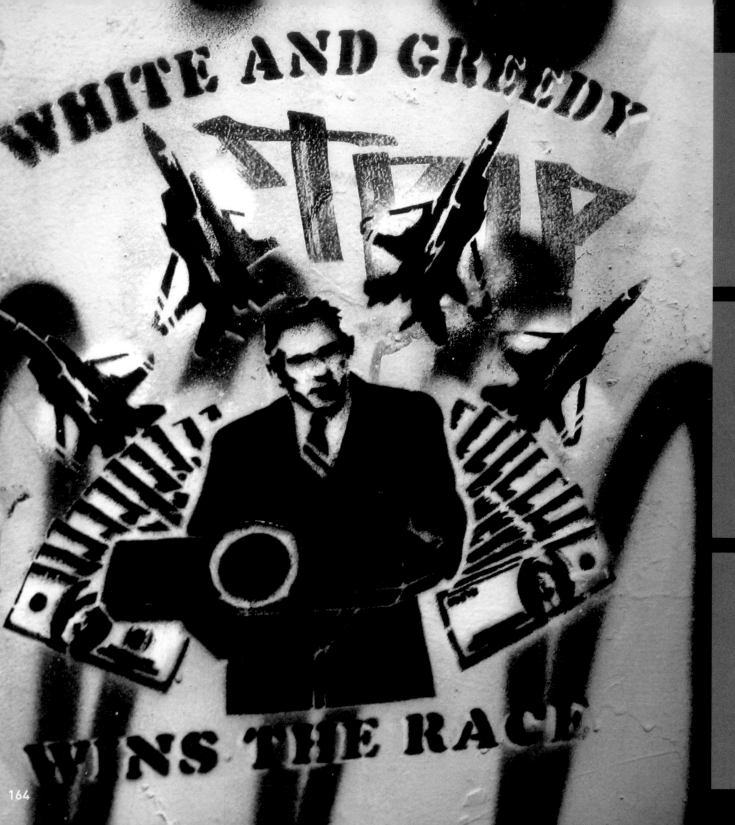

WHITE AND GREEDY
WINS THE RACE

→

MELBOURNE / AUSTRALIA

STENCIL ON GRAFFITI WALL
ARTIST: UNKNOWN

NOV 26, 2006

Brilliant use of Coke typography to get the message across. Opponents of the War in Australia were outraged that politicians ignored the fact they had no mandate for action in Iraq.

←

MELBOURNE / AUSTRALIA

STENCIL ON PAINTED CONCRETE
ARTIST: UNKNOWN

NOV 24, 2006

The corporate guy in the suit is George Bush, speaking as though at an international convention. Behind him are the 'real' 'on-brand' messages of the Neo-Cons.

→

MELBOURNE / AUSTRALIA

STENCIL ON GRAFFITI WALL
ARTIST: UNKNOWN

NOV 26, 2006

Brilliantly ironic piece by Happy, once again bringing the War to Melbourne. The use of childish colours exacerbates the effect: we really don't know what is going on on the ground.

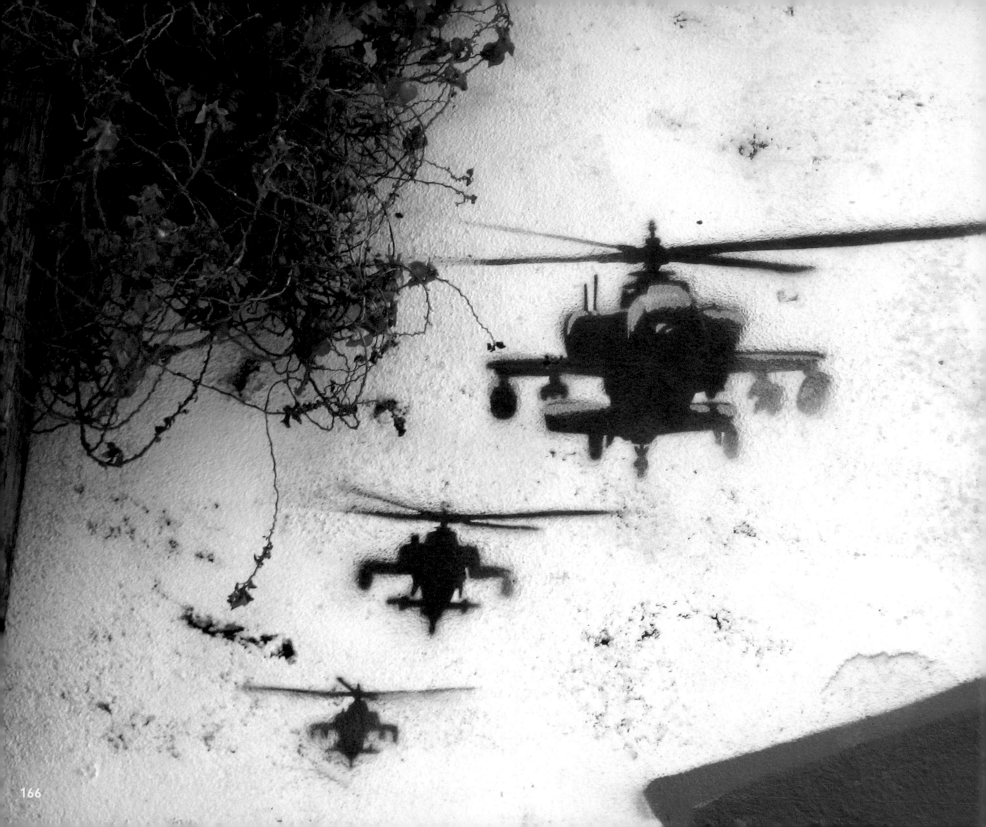

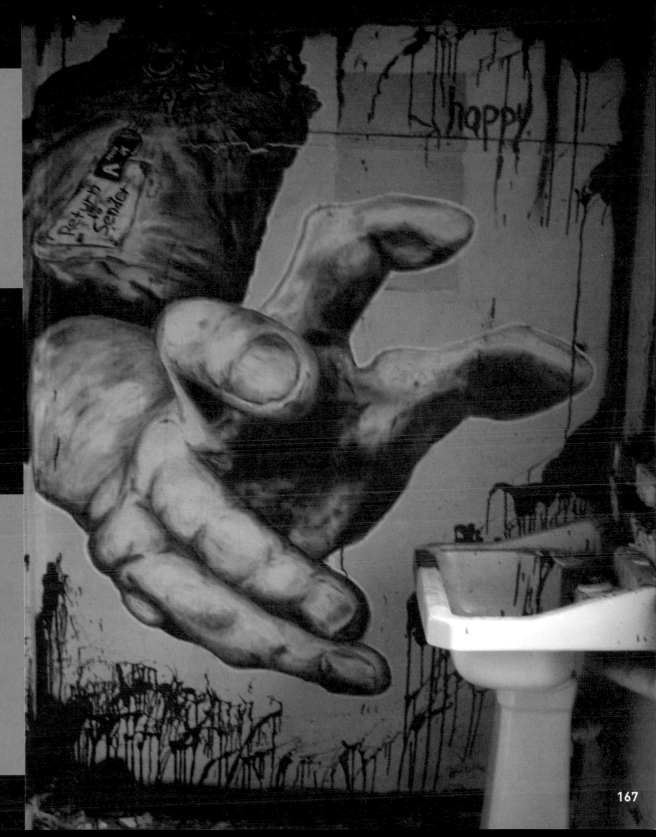

MELBOURNE / AUSTRALIA

STENCIL ON STUCCO
ARTIST: UNKNOWN

NOV 26, 2006

US helicopter gunships swoop in over Melbourne. The reality of war, rather like the Happy pieces, is brought home really effectively.

MELBOURNE / AUSTRALIA

PASTEL-DRAWN PASTE-UP
ARTIST: HAPPY

NOV 29, 2006

A Melbourne lavatory is turned into a horrific scene of torture and violence. Unusually vicious for a Happy piece, the dismembered arm of a US soldier has been prepared for postage back to the US. The imagery conveys brilliantly the power struggle in Iraq and the US desire for control.

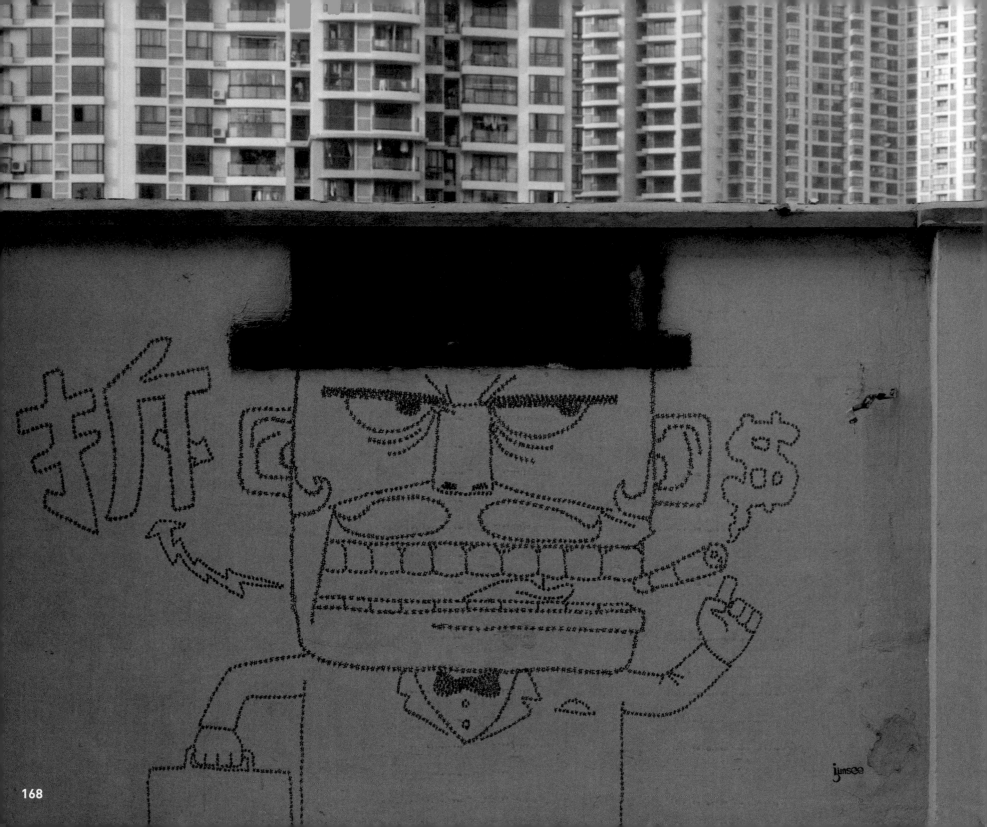

←

SHANGHAI / CHINA

PEN ON WALL
ARTIST: JIMSEE

MARCH 1, 2007

In Shanghai little graffiti is War-specific.
This is a fairly typical anti-capitalist
message.

→

MELBOURNE / AUSTRALIA

STENCIL ON METAL
ARTIST: UNKNOWN

DEC 15, 2006

Bush in the foreground, laughing with a
detonator in his hand, is about to blow
up the Taj Mahal with cases of TNT. The
use of arguably the greatest achievement
of Mughal (Muslim) architecture makes
the artist's point brilliantly: Bush's war
is a thuggish attack on Islam as a whole
– the Taj is in Agra, India not in the Middle
East. Interestingly there has been little
comment on the War in India itself,
where religious rivalry is mostly between
Muslims and Hindus.

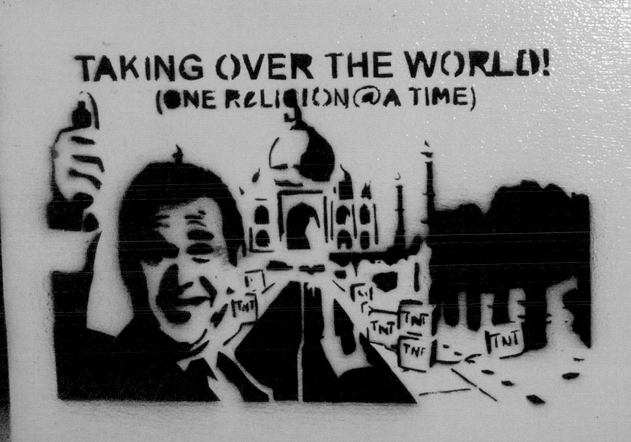

JAKARTA /INDONESIA

STICKER ON METAL
ARTIST: UNKNOWN

DEC 28, 2006

Bush being ridiculed as akin to a
chimpanzee.

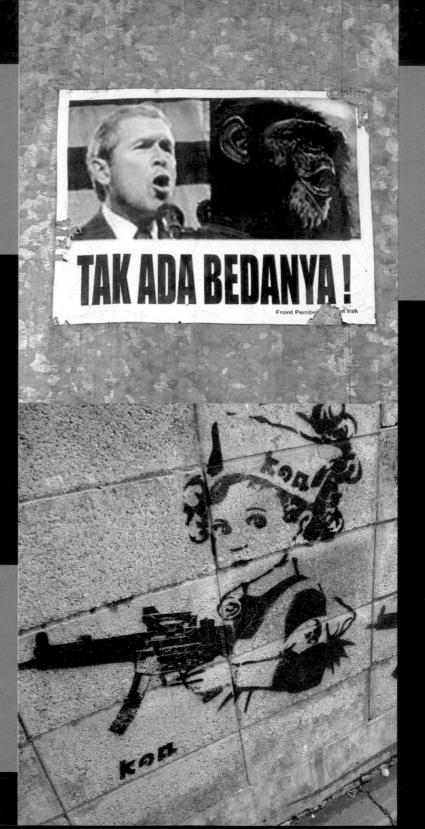

TAK ADA BEDANYA !

Front Pembe... ...m Irak

HONG KONG / CHINA

STENCIL ON MARKET WALL
ARTIST: UNKNOWN

FEB 10, 2007

A take on Batman and Robin in a Hong
Kong market. The War on Terror has
barely registered as a relevant issue in
China; for this artist the US is clearly still
the land of super-heroes.

TAIPEI /TAIWAN

STENCIL ON BREEZE BLOCK
ARTIST: KOA

DEC 7, 2006

A doll-like child plays dress-up in nurse's
apparel, her innocent gaze undermined as
she clutches a machine gun.

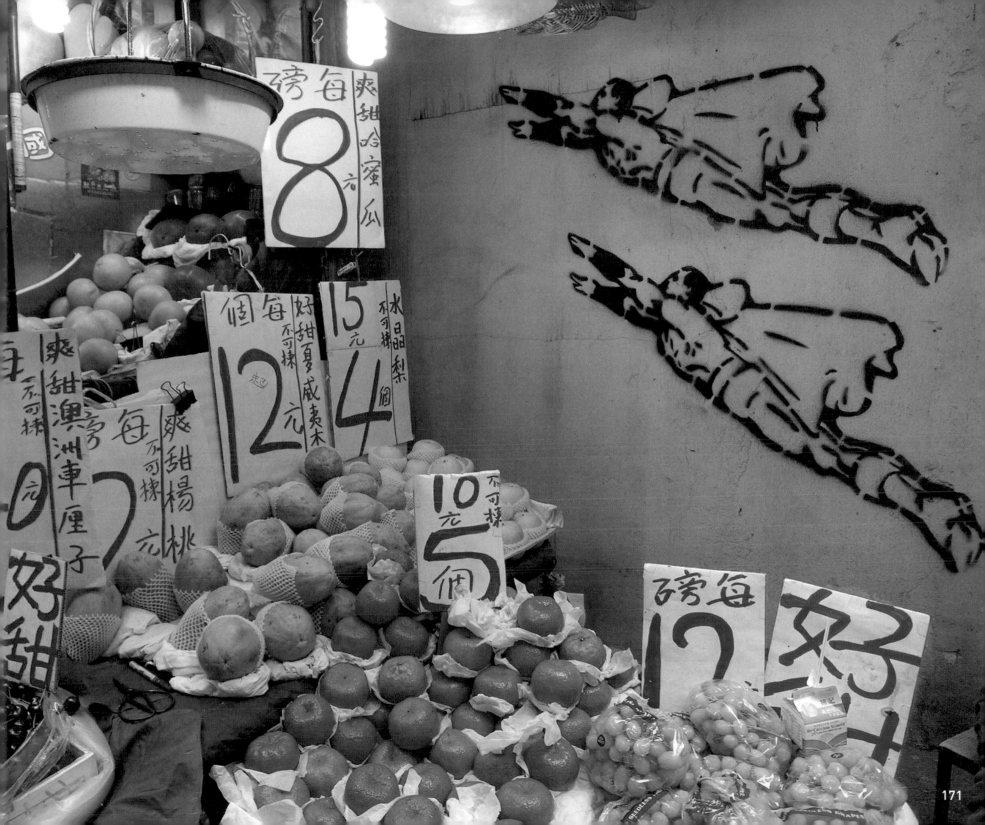

171

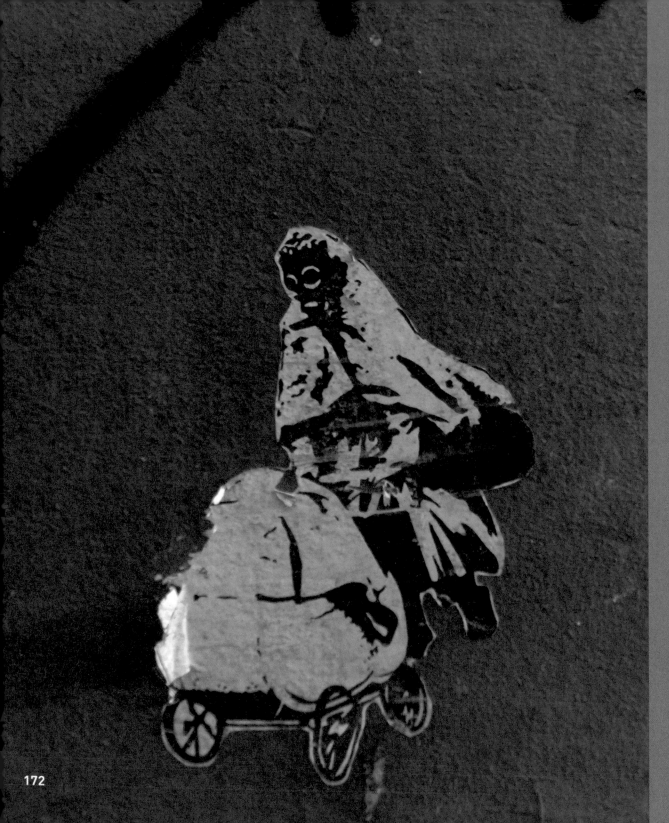

CREDITS

The aim of this book is to produce a permanent record of the global anti-war street art movement; we want to say huge thanks to all of those around the World who have given their time and energy to help put this important document together.

Most importantly, thanks to the street artists who have provoked us into thinking about what our governments are really up to, and to the photographers who have kept their work alive by documenting this movement.

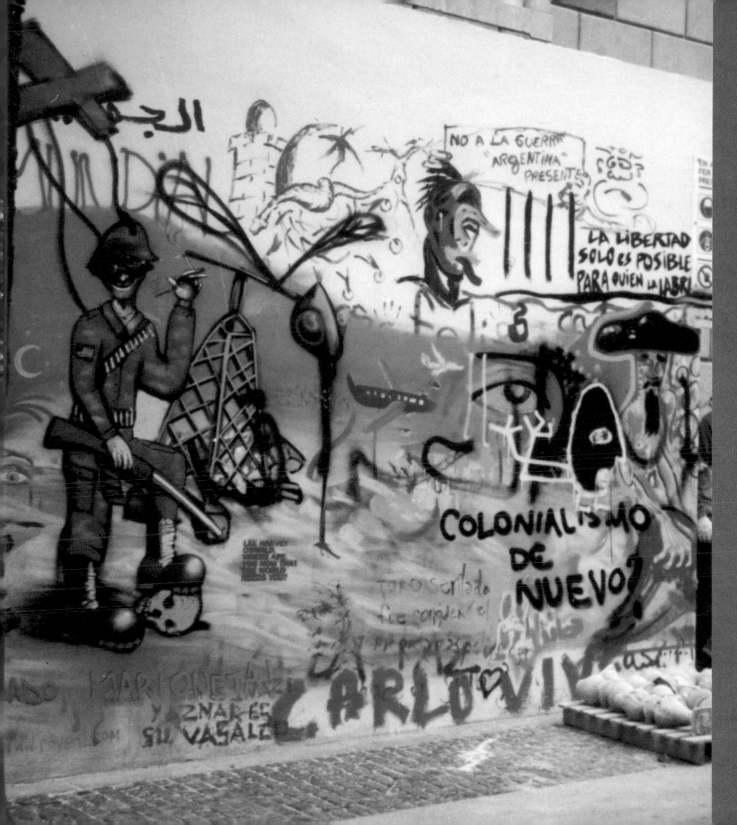

21 Glenn Arango (on flickr as 2cauldrons); 22 Glenn Arango (on flickr as 2cauldrons); 23 Kamal Nicholas; 24 Glenn Arango (on flickr as 2cauldrons); 25 Glenn Arango (on flickr as 2cauldrons); 26 Glenn Arango (on flickr as 2cauldrons); 27 Glenn Arango (on flickr as 2cauldrons); 28 Diemoniker; 29 Diemoniker; 30 Diemoniker; 31 Diemoniker; 32 Diemoniker; 33 Steve Rhodes; 34 Sarah Tollefson; 35 April Blankenship; 37 David Mathis; 39 Alan Lankin; 40 Alfonso Surroca; 41 Claire Ehrlich; 42 Daniel Lobo (daquellamanera. org); 43 Daniel Lobo (daquellamanera. org); 44 Daniel Lobo (daquellamanera. org); 45 Daniel Lobo (daquellamanera. org); 46 Giulia de Prophetis; 47 Ian Rogers; 48 Jonathan Hung; 49 Giulia de Prophetis; 50 Keith Loh; 51 David Seymour; 52 Sergio Lira; 53 William Russell; 54 Christopher Fleming; 55 Cam BsAs; 56 Cam BsAs, Cam BsAs; 57 Cam BsAs; 58 James Redmond; 59 Celeste Romero Cano; 60 Celeste Romero Cano; 61 James Redmond; 62 Michael Colbruno; 63 Michael Colbruno; 64 Erwin Morales

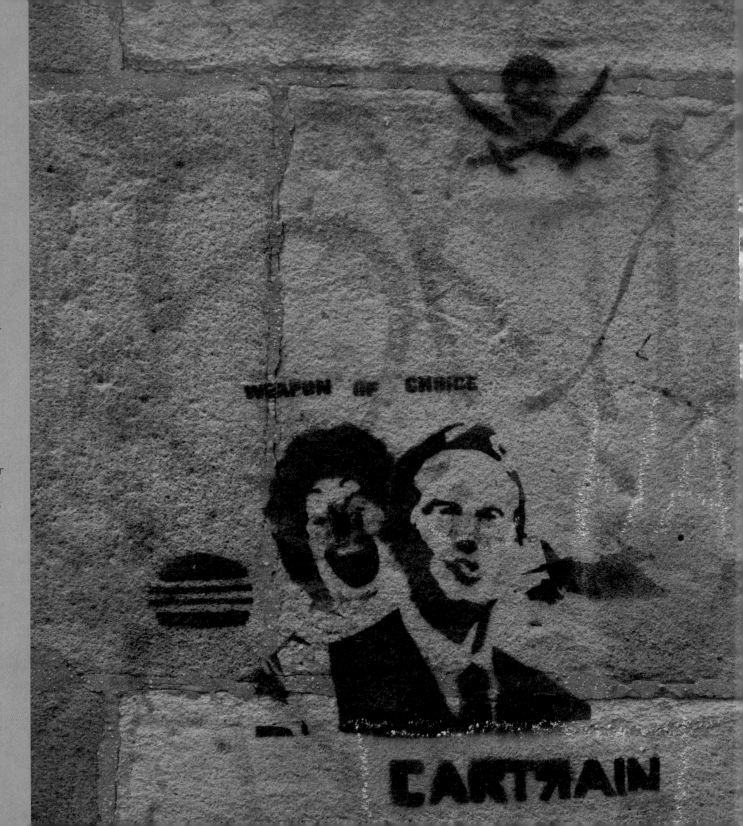

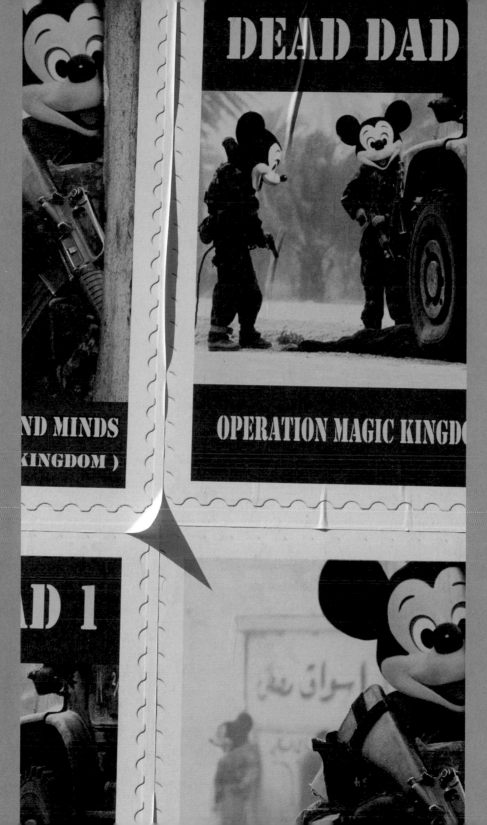

120 William Nessuno (flickr.com/photos/
williamnes/, Magnethic MetaBlog:
http://williamnessuno.splinder.com); 121
William Nessuno; 122 Roufixte Designers
Productions (roufixtedesignera@gmail.
com, flickr.com/photos/roufixte); 123
Routfixte Designers Productions; 124
Tobias Carroll; 125 Arvid Andersson; 126
Martin Lear; 127 Michele Aquila; 128
Michele Aquila; 129 Ola Erik Blæsterdalen
(olaerik.com); 130 Genya Dolomanov; 131
Genya Dolomanov

THE MIDDLE EAST
p. 134 Essam Al-Sudani/AFP/Getty
Images; 135 Arofish; 136 Arofish; 137
Patrick Baz/AFP/Getty Images; 138
Hrvoje Polan/AFP/Getty Images; 139
Arofish; 140 Karan Reshad; 141 Jan
Chipchase (janchipchase.com), 142 Marco
di Lauro/ Getty Images; 143 Marco di
Lauro/ Getty Images; 144 Marco di Lauro/
Getty Images; 145 Arofish; 146 Marco di
Lauro/ Getty Images; 147 Patrick Garvey

AUSTRALIA AND THE FAR EAST
150 Glenn Arango (on flickr as
2cauldrons); 151 Glenn Arango (on
flickr as 2cauldrons); 152 littlegirllost
(littlegirllost.com); 153 littlegirllost
(littlegirllost.com); 154 BDW; 155 BDW;

156 BDW; 157 BDW; 158 BDW; 159 BDW,
BDW; 160 Sam Difference; 161 Andrew
J Cosgriff; 162 Sam Difference; 163 Amy
Gray; 164 Sam Difference; 165 Sam
Difference, Sam Difference; 166 Sam
Difference; 167 Happy (flickr.com/photos/
happyone/); 168 Charlie Xia; 169 Crispin
Reedy; 170 Mayu Shimizu (flickr.com/
photos/mayu/), Mayu Shimizu (flickr.com/
photos/mayu/); 171 Yuko Kootnikoff

CREDITS PAGES
172 Eleanor Mathieson; 173 Patricia Low;
174 Tom O'Hanlon; 175 Glenn Arango (on
flickr as 2cauldrons)

With thanks to Heather Hampson
and Ray Grasso.

We would like to keep documenting this
movement: if you come across or have
photographed interesting street art we
would love to hear from you; email us at
streetart@rebellionbooks.co.uk.

Visit rebellionbooks.co.uk for updates.